The Best of
Flower Painting

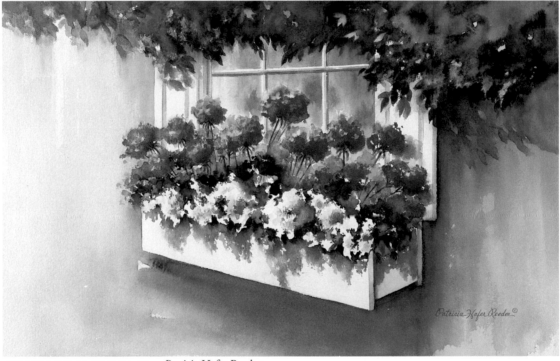

"Nantucket in Bloom II" Patricia Hafer Reeder
Watercolor, 12⅜" x 19⅜" (32cm x 49cm)

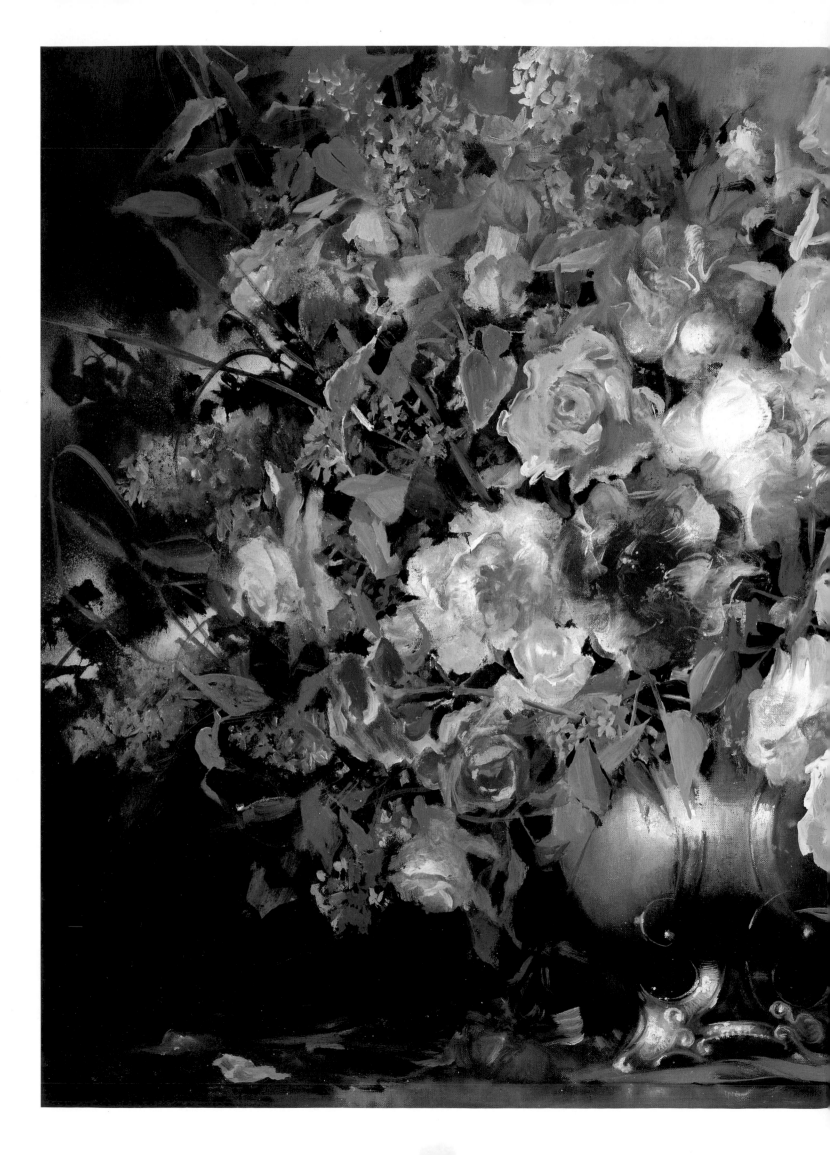

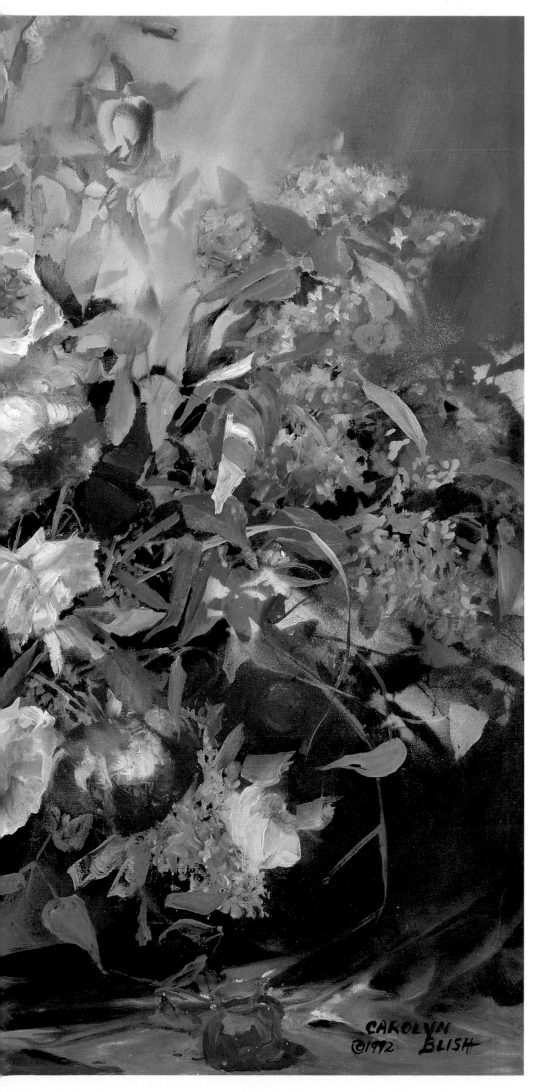

The Best of
Flower Painting

EDITED BY

Kathryn Kipp

NORTH LIGHT BOOKS
CINCINNATI, OHIO

"HEAVEN SCENT" Carolyn Blish
Oil on canvas, 24" x 30" (61cm x 76cm)

Dedication

To my mom, Elizabeth Kipp, with love and thanks.

Acknowledgments

I am deeply grateful to the North Light Books editorial team for your help and support: Greg Albert, Marilyn Daiker, Rachel Wolf and David Lewis. Many thanks to Sandy Kent for her classic and elegant design. And a huge round of applause for all the gifted artists who submitted their work for consideration. This book is for you.

—Kathryn Kipp, editor

Overleaf:

About "Heaven Scent," artist Carolyn Blish says:

"While I was rushing to catch a train out of New York City, my peripheral vision caught this elegant antique vase in a store window. I began sketching the vase while throngs of people flowed past.

"As I sketched, I could 'see' the finished painting in my mind's eye: A rich, dark background would balance the lighter values of the flowers, pushing them forward in an explosion of color. The touch of antiquity in the vase would lend a more formal, regal note.

"The flowers would have to be old fashioned . . . perhaps roses and lilacs. There would be blurred, muted edges, an ephemeral quality, a memory of the haunting fragrance of lilacs and roses in their fleeting moment of perfection.

"The genesis of 'Heaven Scent' was now complete . . . but my train had left without me!"

01 00 99 98 97 5 4 3 2 1

Library of Congress Cataloging-in-Publication Data

The Best of flower painting / edited by Kathryn Kipp

 p. cm.

 Includes index.

 ISBN 0-89134-777-1 (alk. paper)

 1. Flowers in art. 2. Art—Technique. I. Kipp, Kathryn.

N7680.B46 1997

704.9'434—dc20 96-9433

 CIP

Edited by Kathryn Kipp
Designed by Sandy Conopeotis Kent
Cover art: "Lilac" by Jean Grapp, oil on panel, 12½" x 18" (32cm x 46cm), private collection.

The permissions on pages 142-144 constitute an extension of this copyright page.

North Light Books are available for sales promotions, premiums and fund-raising use. Special editions or book excerpts can also be created to specification. For details, contact the Special Sales Manager, F&W Publications, 1507 Dana Avenue, Cincinnati, Ohio 45207.

Table of Contents

"Gold and Indigo"
Hedi Moran
Oil on canvas
16" x 12"
(41cm x 30cm)

Welcome...

to the premier edition of *The Best of Flower Painting*, a celebration of some of the finest representational floral painting being done today. The artists whose work is presented here all have several qualities in common: They are, of course, wonderfully talented and technically accomplished. They work in a variety of mediums including oil, watercolor, pastel, acrylic, colored pencil, serigraphy, etc. But beyond that, they have all succeeded at finding refreshing ways to render a timeless subject.

Here you'll see an amazing variety of floral expression, such as the monochromatic drama of Sandra Sallin's white roses; the cheeky playfulness of Stanley Maltzman's wild daisies; or the classic sentiment of Joseph Sheppard's flower shop.

Floral painting requires the technical expertise of fine portraiture, careful attention to the principles of design and composition, an exquisite sense of color and light, and an unabashed love for the subject matter. The artists presented here tell you in their own words the stories behind the paintings, the sources of their inspiration, and the techniques by which they brought their floral subjects to brilliant life.

We invite you to wander slowly through these pages as you would through a garden. Linger here, quiet your soul and let these beautiful paintings delight and inspire you.

David Schatz

Here in Oregon's Willamette Valley are the two largest iris growers in the U.S. Each spring the display gardens of these growers are overwhelming. The mass of color begs to be painted. I love the way light bounces off of some petals or shines through like stained glass to change the color of other petals. On these irises, colors vary from the white glare of full sun to a deep dark purple in the shadows to yellow and orange in the centers.

I paint watercolors in an unusual manner. I apply color with one brush and then with another brush that carries clear water I move the paint around. By varying the amount of water on the second brush I can pull out highlights or make smooth gradations. As a result the section that I am working on is finished *alla prima*. A half finished painting looks much like a partially finished jigsaw puzzle with part of the painting done and the rest still the white of the paper.

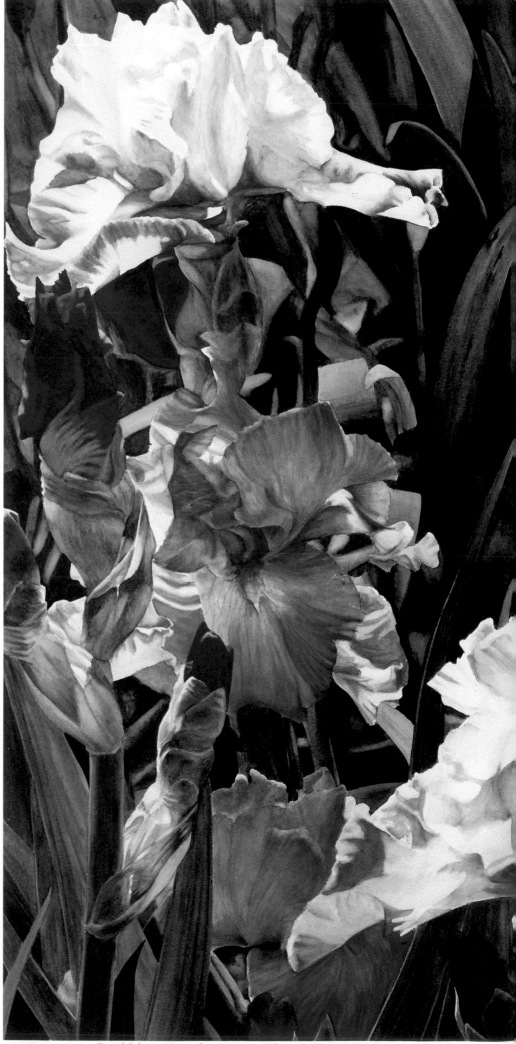

"PURPLE IRIS" David Schatz, Watercolor on paper, 19" x 28" (48cm x 71cm)

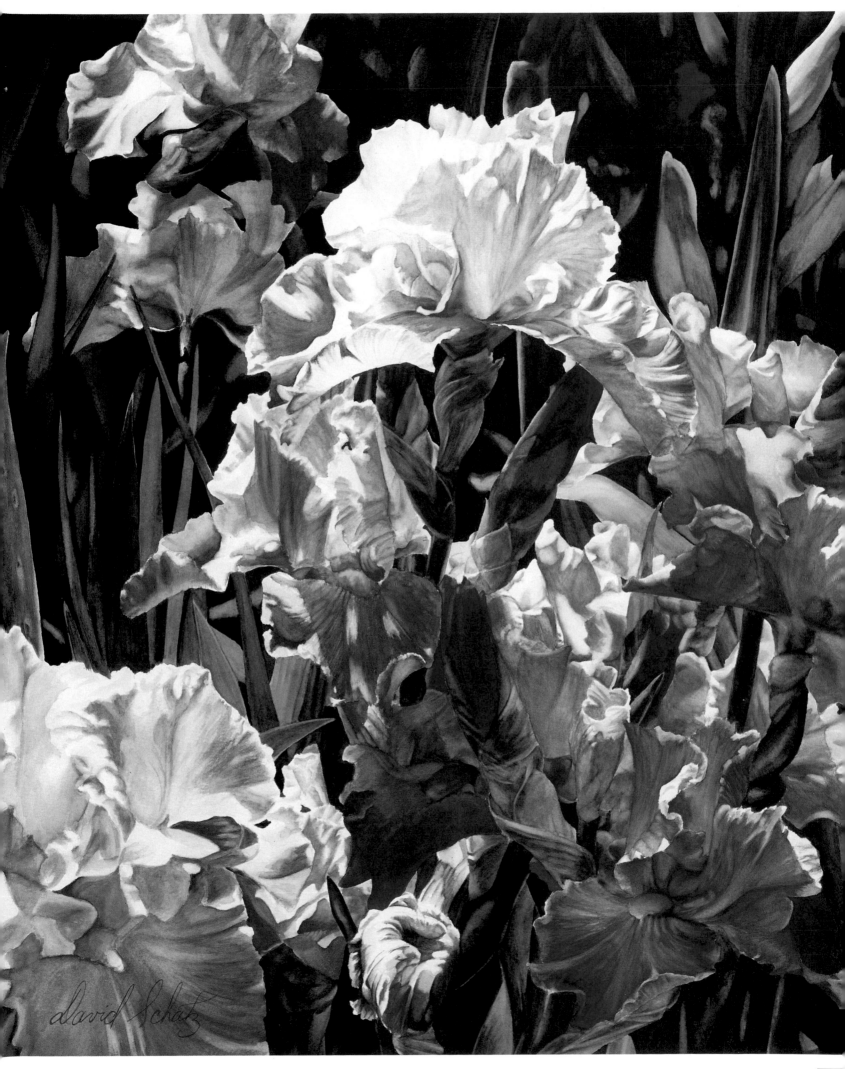

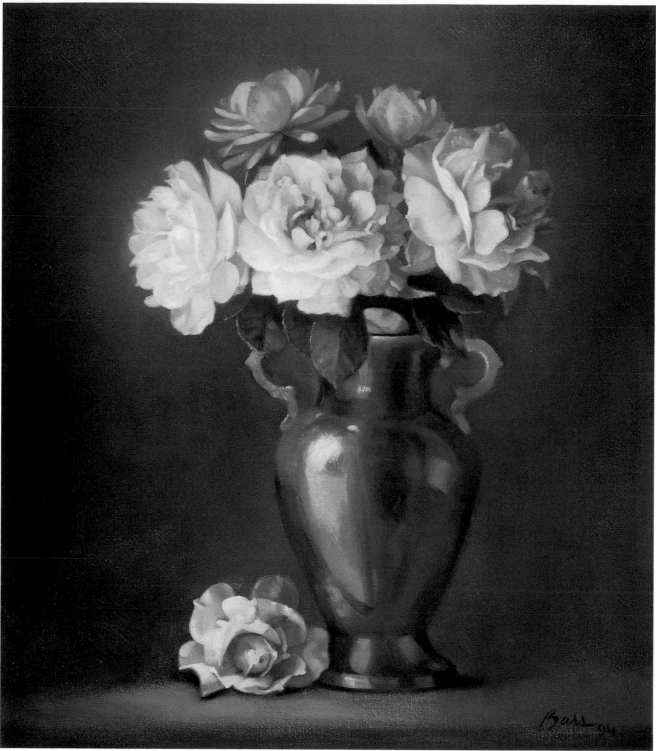

"ROSE D'OR" Lyndall Bass
Oil on linen, 16" x 14" (41cm x 36cm)

Lyndall Bass

I have a fascination with the way a simple ordinary vase of flowers can be magnificent. In reflecting on the nature of magnificence, I chose a monochromatic theme because of the austerity and dignity of it. It is no accident that a flower bed of wide-ranging color is often referred to as a "riot," and this mood is the opposite of that. The yellow of these roses is a cool one with silvery highlights and deeper color only near the center. I used yellows throughout the work, but the ones in the vase and background are the warm hues. The darkest darks are in the leaves because yellow never gets very dark without losing identity.

This painting has a complete light gray grisaille under the overlay of color. In order to manage the slight variations of tone that describe the intricate anatomy of these roses, I felt I needed the underpainting. The yellow in the roses is not really transparent, but is pulled over the underpainting thinly and, at times, achieves a darker tone because of the gray showing through.

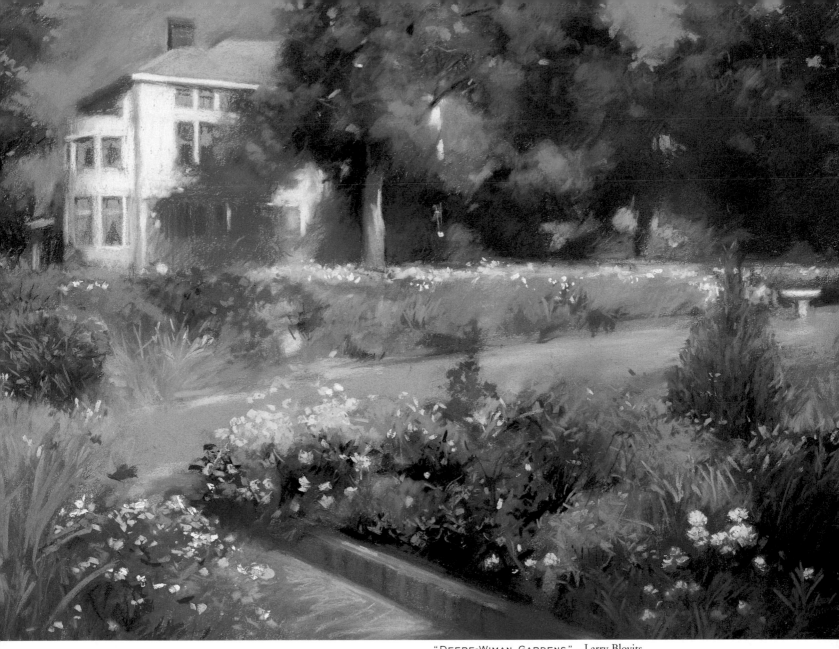

"DEERE-WIMAN GARDENS" Larry Blovits
Pastel on Canson Mi-Teintes paper, 18" x 24" (46cm x 61cm)

Larry Blovits

"Deere-Wiman Gardens" is the result of teaching a workshop at the Deere-Wiman Estate in Moline, Illinois. The magnificence of the gardens and the exploding colors of the flowers filled me with a sense of artistic excitement. I decided to create a pastel as realistic as possible in the foreground and gradually fade it out to an impressionistic background. I wanted the viewer to take a visual walk in the gardens as I had.

I started off using the semi-hard Nupastels, then switched to the somewhat softer Rembrandt, Grumbacher and Girault pastels before ending up with the softer and richer (in amount of pure pigment) Schmincke and Sennelier pastels in the final layers. The brighter final colors contrasted nicely with the lower intensity colors underneath.

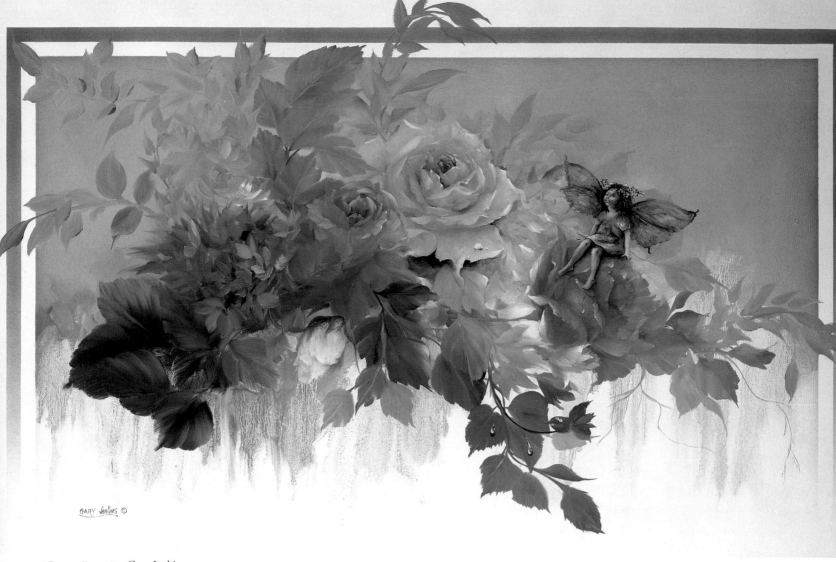

"ROSE FAIRY" Gary Jenkins
Oil on canvas, 24" x 36" (61cm x 91cm)

Gary Jenkins

I have always wanted to paint a floral with a Rose Fairy. I think, late at night when it is very quiet, fairies come out and play among the roses. I painted the Rose Fairy off to the side so she is not the focal point. I wanted the viewer to find her after looking at the rest of the painting.

Shakespeare refers to the rose more than forty times in his writings; 250 rose varieties were grown by Napoleon's Empress Josephine in her garden. The rose is truly the queen of flowers, and is one subject I never tire of.

My medium is oil. Oil fulfills my need to push and pull paint around the canvas. I use portrait-grade canvas to achieve a smooth finish, and work wet-into-wet to achieve lost and found edges. The colors I use are mainly Floral Green, Floral Sienna, Floral Orange, Floral Pink, Floral Blue, Floral Crimson, Floral Yellow, Floral Mauve, Floral Red, Floral Black, Floral White and Misty Grey. My brushes are soft sable blends that have very precise edges and fine points.

Some special colors were used in "Victorian Roses," such as Floral Misty Magenta, Floral Crimson, Floral Mauve and Floral White. The oil paints were a very soft consistency for easy blending of colors. The lights were applied very dry for crisp highlighting and backlighting. The dark background adds a dramatic effect.

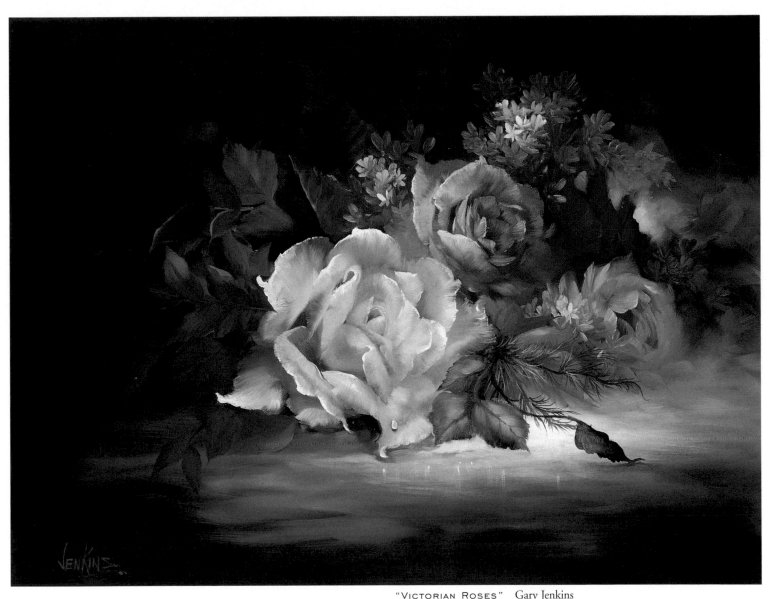

"Victorian Roses" Gary Jenkins
Oil on canvas, 18" x 24" (46cm x 61cm)

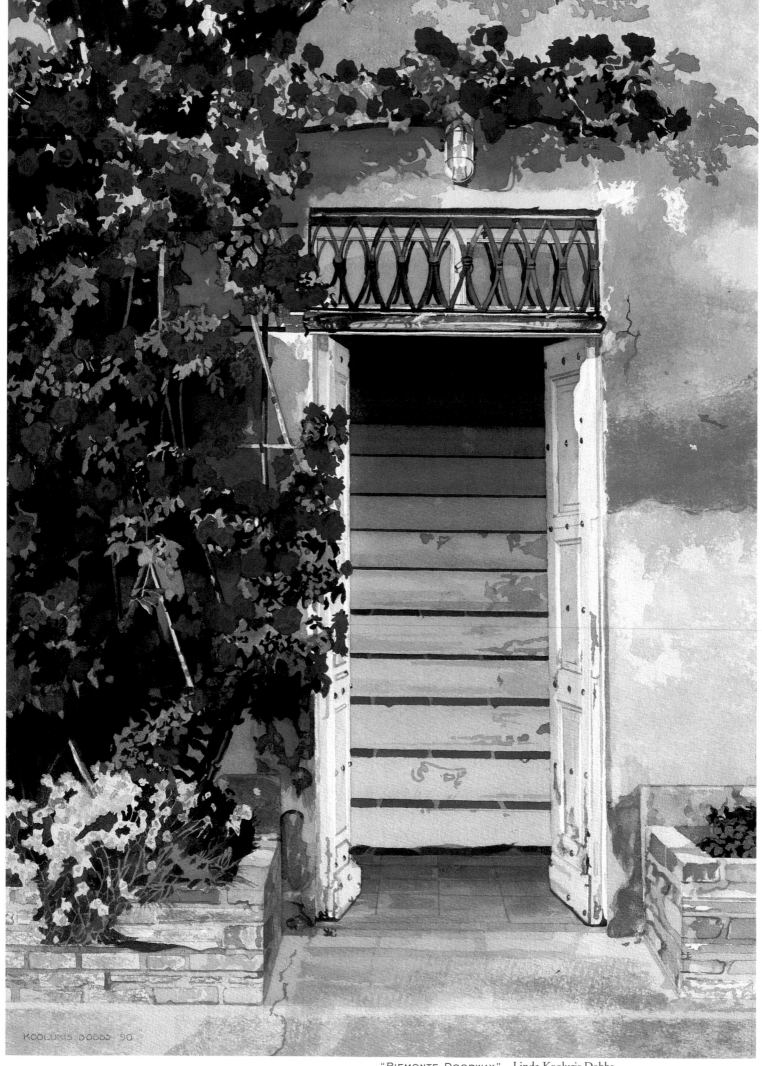

"Piemonte Doorway" Linda Kooluris Dobbs
Watercolor and acrylic on Arches 300-lb. rough paper, 29¼" x 20" (74cm x 51cm)

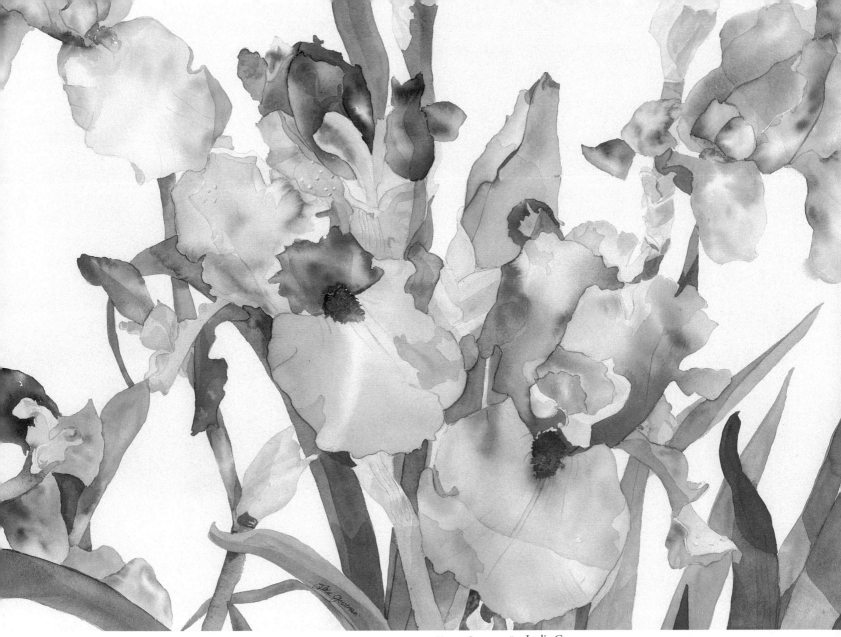

"Iris Garden" Leslie Gerstman
Watercolor on Arches 140-lb. cold-press paper, 22" x 30" (56cm x 76cm)

Leslie Gerstman

Many people dismiss floral paintings as "decorative art," not worthy of serious consideration. Some distinguished artists and judges arbitrarily eliminate florals from national shows, assuming the content to be "trite," seeking what they consider to be more creative, original expression. It is a mistake to believe that creativity is limited by subject matter.

All original expression comes from within. Flowers arouse an instinct to protect them, to appreciate them. Their tenderness kindles a sense of compassion and understanding. Like life, their beauty is fleeting.

After sketching in the center flower from a photo reference, I used a wet-into-wet painting approach, brushing each outlined area with water, and floating in a variety of analogous colors. I did not stretch the paper, so that I could lightly bend or tilt it to direct the flow of pigment. As the painting progressed, I drew in more flowers to develop and strengthen the composition, paying particular attention to the edges of the paper and the negative shapes of the white background. I mixed the greens, adding some of the flower color into the leaves and stems. After the initial layer of paint had dried, I applied liquid mask with a calligraphy pen to create the hairs on the beard, the dew drops, and the lines in the petal sheaths of the center flower. Then I added additional layers of color to these areas. I used Cobalt Blue for the cast shadows on the flower petals.

Linda Kooluris Dobbs 🌿

I'm a romantic. I can't help myself. I fall in love with flowery subjects completely and with abandon. When we arrived at Odalengo Piccolo in Piemonte, these roses were burning against the back of an ochre farmhouse. The air was thick with the scent of April in Italy. The shadows were long and soft in the afternoon light. I knew I had to capture this first vivid impression before thought overtook instinct.

The receding shadow on the stairs was created by at least thirty layers of glazes of alternating complementary colors. I used Winsor & Newton lightfast colors like Cadmium Yellow Deep and Scarlet Lake. The built-in texture of the Arches rough paper was further enhanced by sponging and varied brushstrokes. Color saturation of the roses was increased with acrylic. Detailed areas were carefully selected, as one can have too much of a good thing.

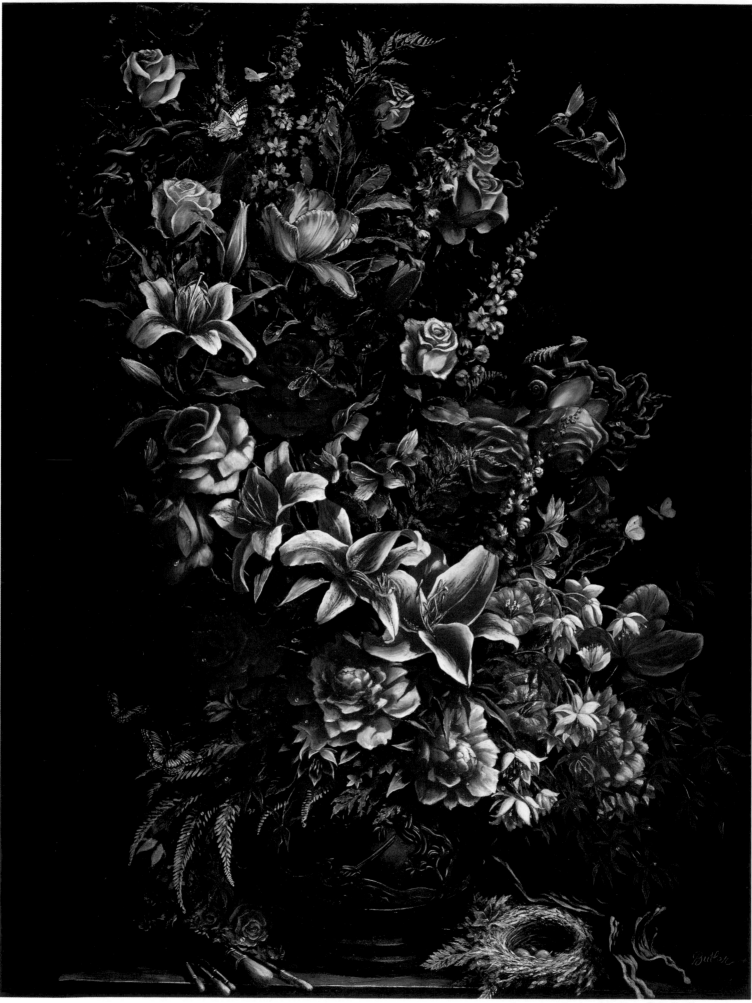

"THE TREASURES OF VENUS" Russ Butler
Oil on canvas, 48" x 36" (122cm x 91cm)

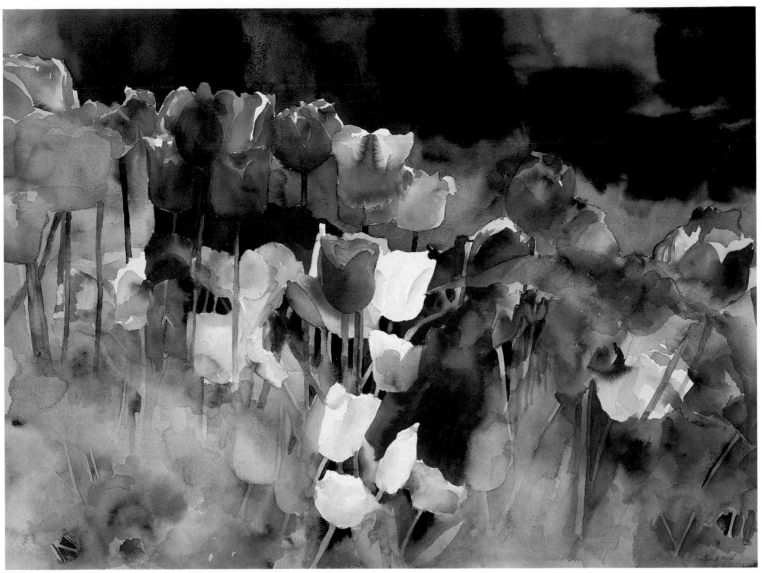

"MARINA TULIPS #32" Pat Fortunato
Watercolor on Waterford 140-lb. cold-press paper, 22" x 30" (56cm x 76cm)

Russ Butler

A commissioned work, "The Treasures of Venus" was painted to resemble the work of the seventeenth-century Flemish masters. Individual fresh flowers were purchased, picked or stolen during the months of work, and were painted in (and sometimes out again) one by one as the painting evolved. There is a love theme in "The Treasures of Venus" that is repeatedly portrayed by the pairing of selected flora and fauna throughout the piece.

The most important aspect of painting I exploited in "The Treasures of Venus" is the use of glazing. By applying thin layers of transparent paint I was able to achieve the glow of sunlight on and through the petals. The underpainting took the majority of time, but when the foundation was laid and the glazes started to be applied, magic was in the air!

For instance, a deep velvety rose began with a light peach tone and then multiple layers of Cadmium Red and Alizarin Crimson (and even Hooker's Green for shadows). I discovered that glazes of Hooker's Green here and there added to the naturalism of the picture, especially with background flowers. Glazing is a long and tedious process, but the resulting radiance and illusions of form are well worth the effort.

Pat Fortunato

I was at the Erie Basin Marina in Buffalo when I spotted these tulips, but it wasn't until I knelt down and got a worm's eye view that I really saw this composition. I felt like I was in the middle of the display. The colors seemed to blend together in some areas and were very hard-edged in others.

Florals allow an artist to play around with a vast array of hues. They also allow for a loose rendition where imagination can take over. Nothing can portray this better than watercolors.

Starting with dry stretched paper, I do most of my paint mixing right on the paper so some of the colors can blend together. This makes for more vibrant color combinations. I used Thalo Crimson mixed with a touch of Aureolin Yellow for the peach tulips, and Thalo Crimson, Permanent Magenta and Permanent Blue in various combinations for the pink to purple tulips. Manganese Blue mixed with various yellows is excellent for foliage. Quinacridone Gold by Daniel Smith mixed with blues or greens makes beautiful earthy greens.

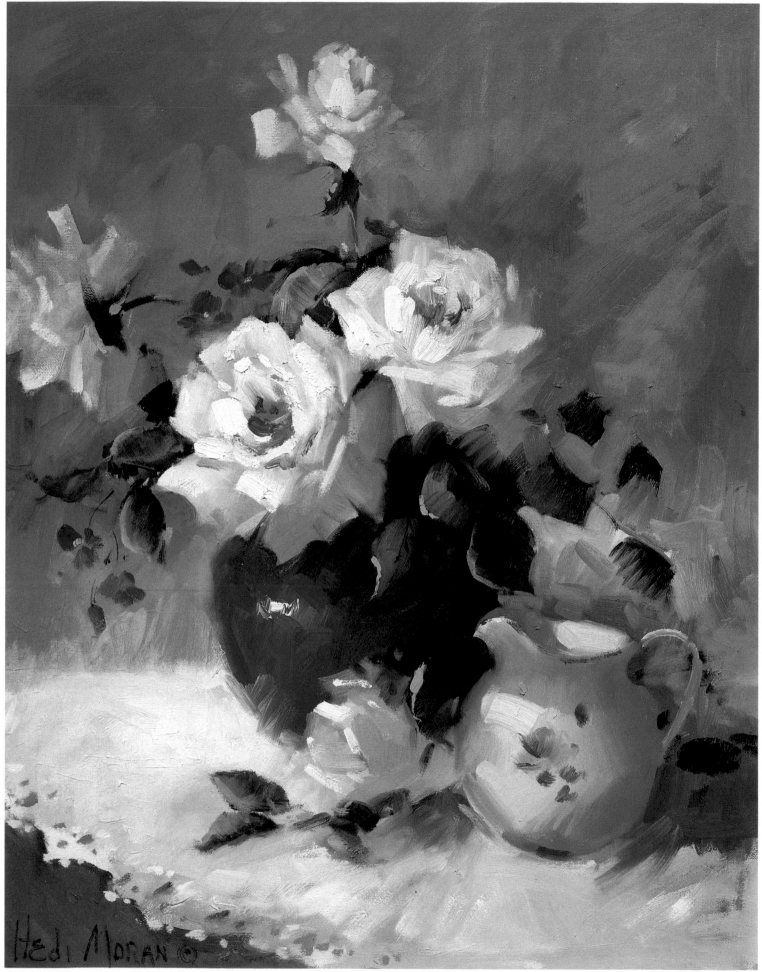

"CREAM PITCHER" Hedi Moran
Oil on canvas, 20" x 16" (51cm x 41cm)

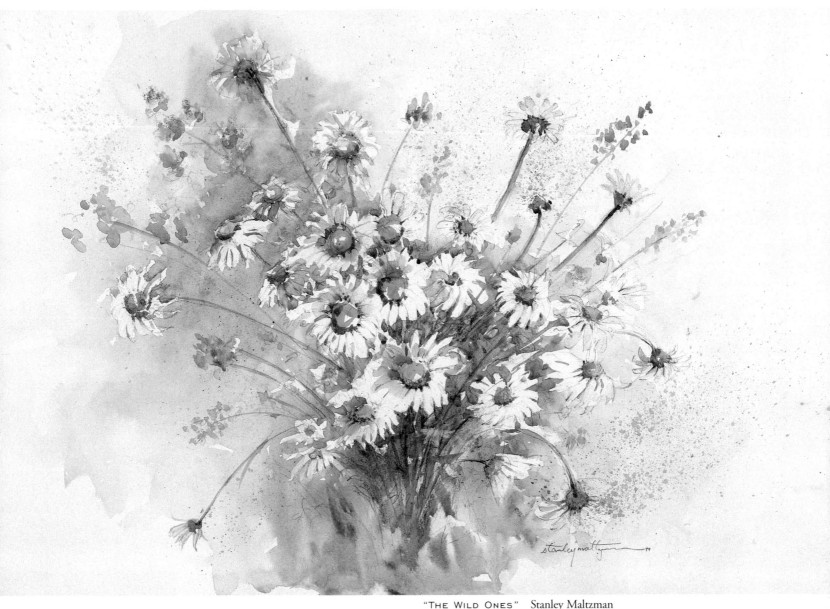

"THE WILD ONES" Stanley Maltzman
Watercolor on Rising 4-ply museum board, 14½" x 22" (37cm x 56cm)

Hedi Moran

A favorite book of mine is Lewis Barrett Lehrman's *Freshen Your Paintings with New Ideas.* In it, he suggests taking an old painting that was not working and either "kill it or cure it." "Cream Pitcher" made its way out of the back of the closet and was hopefully cured.

The roses had been grown by my mother, and I had painted them in her vase, with her creamer. However, I lost sight of the fact that I was creating a painting, not being a camera—and the painting was not working. The original vase did not read well. To cure the painting I changed the vase completely and forgot the sentiment attached to the original vase. This painting, like all my others, was a journey, a battle, a challenge, a frustration and a joy.

Winsor & Newton's Indian Yellow is always my base for yellow flowers and for sunlit areas in landscapes. No earth tones ever appear in my floral paintings.

Stanley Maltzman

Have you ever walked through a field covered with hundreds of daisies, some glowing in the sun while others are swaying and dancing to the beat of the wind? The beauty and freshness of this scene inspired me to paint "The Wild Ones."

The most practical way for me to capture the spirit of these flowers was to work in the studio. My reasoning was simple: I would not be distracted by all the action around me. Reluctantly (I do not like to disturb nature), I picked a bouquet of daisies that included various other wildflowers growing in the same field.

I loaded my no. 10 round brush with water and painted all around the loosely sketched daisy shapes. Then Raw Sienna, Olive Green, Hooker's Green, Cobalt Violet and Blue were dropped into the water, allowing them to mix on the board. This preserved the white of the board for the daisies. Stems and some spattering were the last touches for the fresh look I wanted to portray.

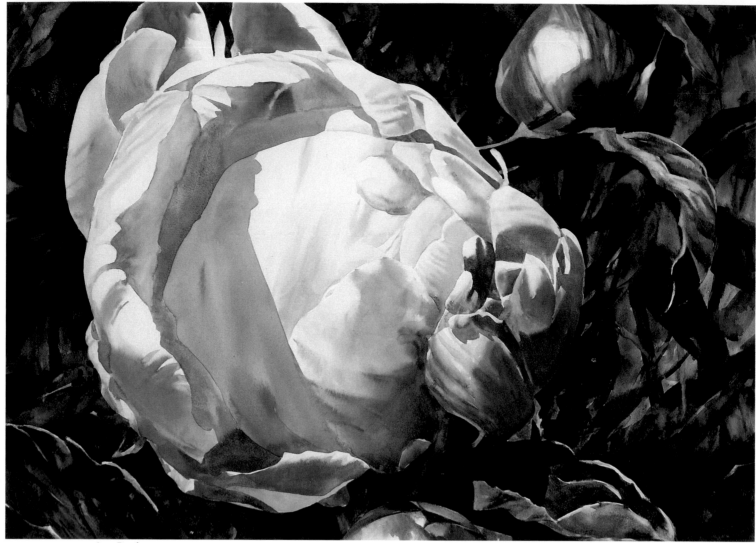

"EMERGENCE" Ann Pember
Watercolor on Bockingford 200-lb. cold-press paper, 21" x 29" (53cm x 74cm)

Ann Pember

My peonies this spring produced exceptionally beautiful flowers. As the buds began to unfold, I was fascinated by the wonderful shapes. I photographed the process at intervals and studied in particular the way the light played on and through the petals. I chose a few photos of a bud just opening for reference.

I decided to paint "Emergence" on Bockingford paper because of the beautiful washes it allows, and because its whiteness enhances the nuances of color in the flower. It is also a very forgiving surface and will take scrubbing out without damage. The whites are saved by painting around them carefully. I prefer not to mask: I don't like the mechanical look it produces, which needs softening.

"Peony Unfurled," the second painting in a series of unfolding buds, captures the light shining through petals and creating interesting shapes. I dramatized the colors I observed, enhancing the blues and subtle colors, connecting passages almost like a puzzle. I was especially taken with the feeling of delicacy and wonderful color changes within each petal. It reminded me of the fragility of life and I wanted to honor that.

"Peony Unfurled" was made on Waterford 300-lb. paper, which produces lovely color mixtures and paint quality. Washes were controlled by pre-wetting an area and floating paint into it. I prefer to get the color right on the first application if possible: it has a freshness unequaled by other means. My pigments included mostly non-staining transparent paint by Winsor & Newton: New Gamboge, Permanent Rose, Antwerp Blue, Cobalt Blue, Winsor Green and Raw Sienna.

The third in a series of opening peony buds, "Peony Perfection" further explored my interest in light and its effect on form. It is more sunbathed than the previous works, yet contains subtle colorations. Like the others, the flower is contrasted with a fairly dark background. I am fascinated by the abstract forms this type of lighting produces and I use a close-up point of view for a dramatic effect. Flowers are a subject I know well as a long-time gardener. This rather intimate way of looking at them reflects my involvement.

As with the other florals, I chose to paint "Peony Perfection" in a direct way, pre-wetting areas and floating in pigment, letting it mix on the paper. Whites were painted around, and some edges were softened for a feeling of form. Some petals were linked together and painted as one shape to improve design or soften a passage.

"Peony
Unfurled"
Ann Pember,
Watercolor on
Waterford 300-lb.
cold-press paper,
21" x 29¼"
(53cm x 74cm)

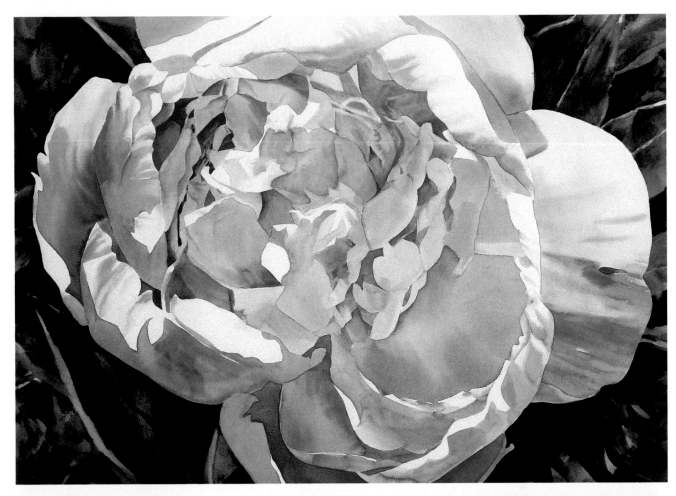

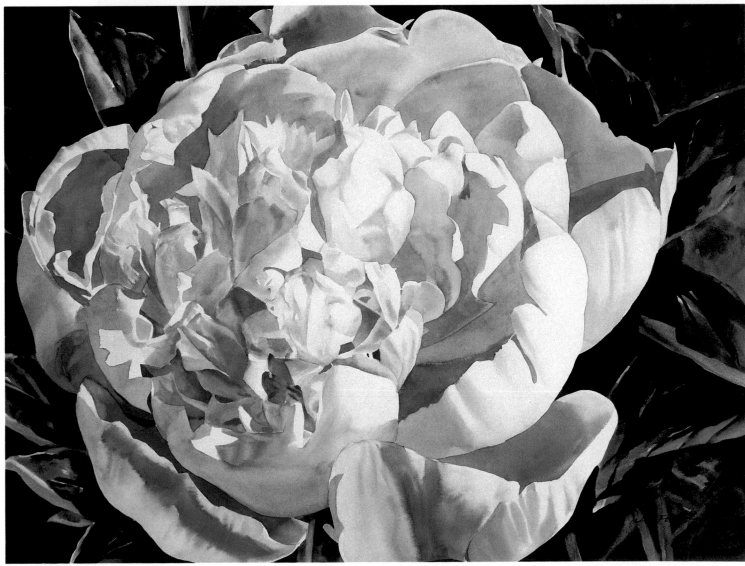

"Peony Perfection" Ann Pember, Watercolor on Waterford 300-lb. cold-press paper, 21" x 29" (53cm x 74cm)

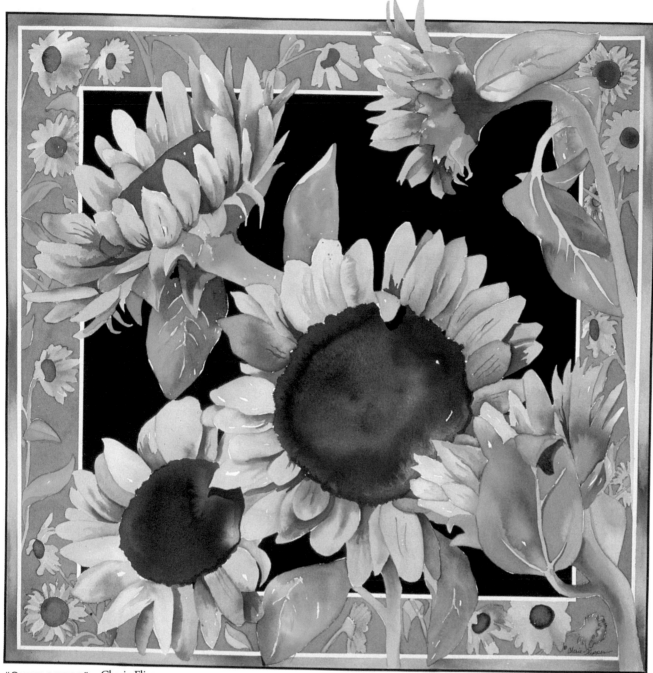

"SUNFLOWERS" Cherie Flippen
Transparent liquid acrylics on cold-press watercolor paper
20" x 20" (51cm x 51cm)

Cherie Flippen

I was commissioned by a clothing company to create a series of floral paintings to be reproduced on a line of T-shirts and tote bags. As my first creation for this series, "Sunflowers" has proved to be one of the most popular designs ever for the clothing company.

I chose bright, cheery colors in shades of golden yellow and orange for the petals, deep and bright greens for the leaves and stem, and deep rich brown with a splash of violet and red for contrast for the centers of the flowers. I added a contrasting border of smaller sunflowers against a field of sky blue.

I use transparent liquid acrylics and work by wetting just one section of the painting, allowing the colors to bleed into one another and leaving sections of the white paper underneath to show through as highlights.

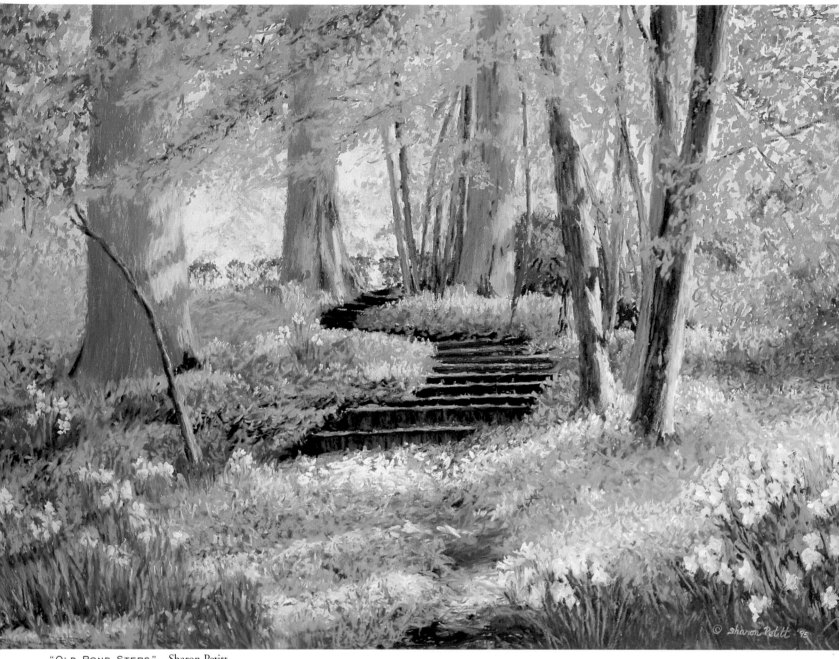

"OLD POND STEPS" Sharon Petitt
Pastel and gouache on sanded paper
16" x 22" (41cm x 56cm)

Sharon Petitt

This is part of a very special garden that originally belonged to the master gardener of Colonial Williamsburg. His home was built into a wooded hillside with both formal and natural gardens. He even cut away branches in the tallest trees so the light patterns would be interesting—talk about a painter's dream!

The biggest challenge was to make sense out of a composition that was almost entirely green. I exaggerated the *S* shape in the steps and framed it with the vertical lines of the trees to give the sense of serenity that I felt. The diagonal light rays repeat the *S* shape, and the daffodils and Virginia bluebells add a much needed touch of color.

I worked out my composition with a gouache underpainting. The tree darks are mixtures of violet, Chinese Orange and Ultramarine Blue. The steps and ground lights are yellow or orange. All other darks are Ultramarine Blue. The sky is the color of the paper itself.

Now, the fun part—the pastels! I start by doing the medium and dark areas first, layering in siennas, purples, blues and greens. The light areas and daffodils are done last.

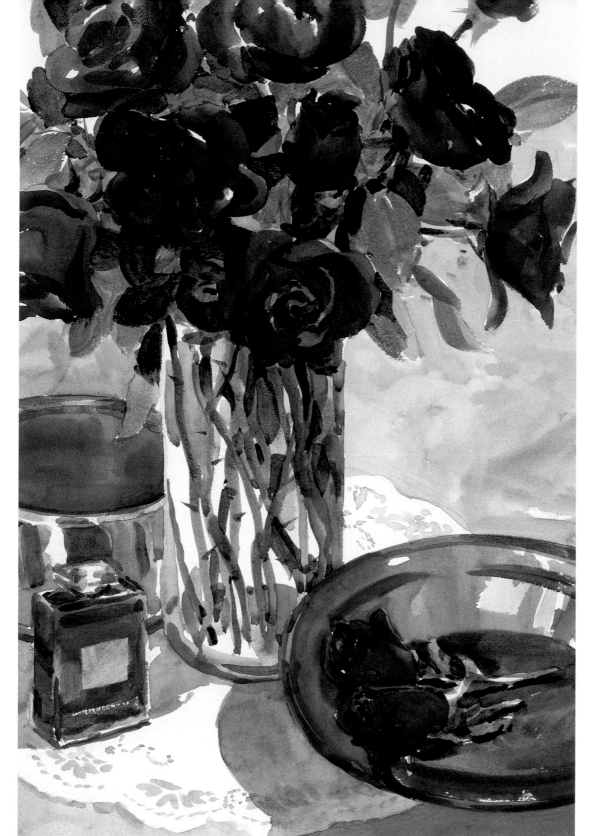

"SPRING ROSES" Carl J. Dalio
Transparent watercolor on
Lanaquarelle 140-lb. cold-press paper
20½" x 14½" (52cm x 37cm)

Carl J. Dalio

Ah, young love! These beautiful red roses were only a portion of the one hundred red roses received by my teenage son from a high school classmate. Being aware of how young love can fade as well as how quickly fresh roses can wilt, I wanted to relate the beauty of the moment. I gathered other subject matter related in concept, texture and color. Arranging these objects in a pleasing composition, I illuminated the still life with an incandescent lamp and daylight from a nearby window.

Immediately attracted and challenged by the rich, velvety texture and deep red color of the rose petals, I used the appropriate medium

of watercolor to paint in a manner dictated by this slice out of time: directly and spontaneously!

I used a large brush (no. 14 Richeson) and mixtures of Winsor & Newton Permanent Rose, Ultramarine Blue and Cadmium Red to achieve the richness of rose petals. Simple washes of Cobalt Violet and Raw Sienna brushed wet-into-wet created the background and carved out the paper doily shape. Saved white paper helped relate the effects of clean water in a clear glass vase. Essential use of complements (deep reds in roses, deep ultramarine blues in bowl) communicates the powerful glow of intense, jewel-like color.

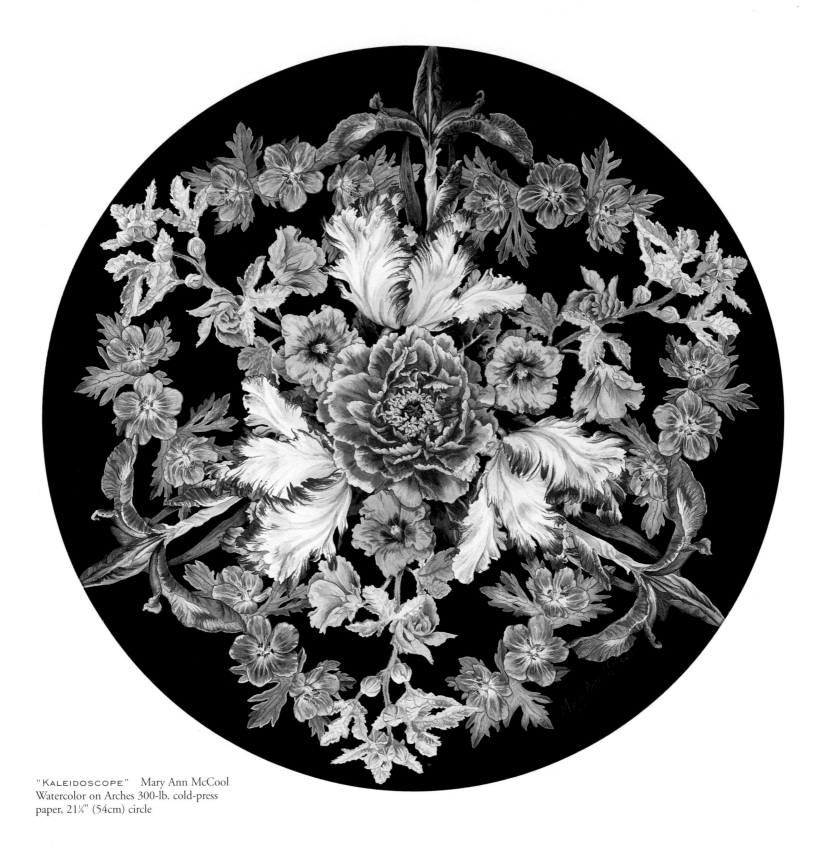

"KALEIDOSCOPE" Mary Ann McCool
Watercolor on Arches 300-lb. cold-press
paper, 21¼" (54cm) circle

Mary Ann McCool

Looking at a flower catalog through a kaleidoscope, I was fascinated by the patterns it produced. Since then I have done a whole series of kaleidoscope paintings. It was a challenge to decide which flowers and leaves to lighten so they would pop forward, and which to make darker so they would recede into the background.

My colors included Winsor Yellow, Cadmium Yellow, Yellow Ochre, Burnt Sienna, Cadmium Red, Alizarin Crimson, Indigo, Ultramarine, Cobalt Blue, Manganese, Winsor Blue, Viridian, Chromium Oxide, Neutral Tint, Permanent Rose and Cobalt Violet.

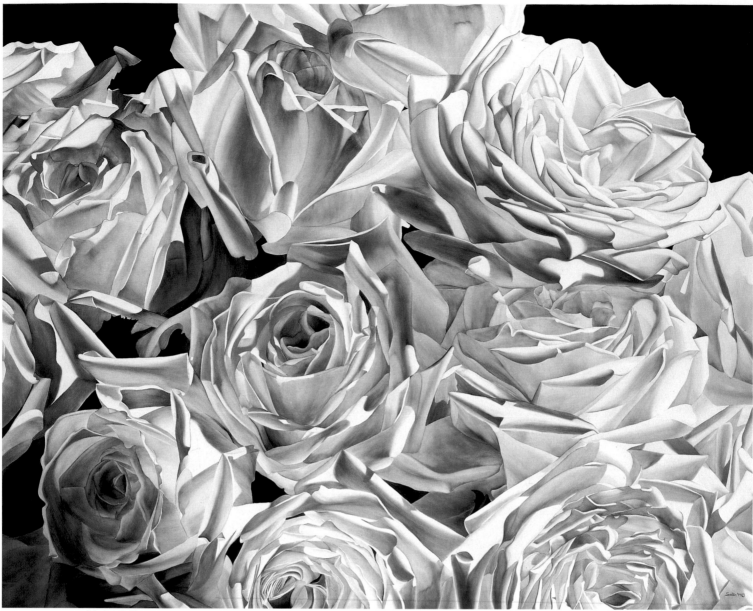

"SHADOWS" Sandra Sallin
Oil on canvas over panel, 30" x 37½" (76cm x 95cm)

Sandra Sallin

One evening, as I drove home from an art show opening, I became aware of the street and its shadows lit by old-fashioned lamps. The late night subtlety of color and pattern was reduced to a monochromatic vision, the power of which stunned me. I was seeing color in black-and-white shapes. I immediately wanted to translate these images into paintings. I wanted the whites of flowers to emerge from shadows, to radiate, to suddenly confront the world.

In working with a monochromatic color scheme, I created a luminous palette of whites, blacks and grays. Thus, my gray is not solely gray, but a blending of Lefranc's Space Blue, Winsor & Newton's Flesh Tint, Naples Yellow and Winsor White. My black is not merely black but a combination of Alizarin Crimson, Phthalo Green, Ultramarine Blue and Cassel Brown mixed with a little Lamp Black. The white of the gessoed canvas shining through imparts a glow and radiance to the images.

Each petal is finished one at a time and becomes virtually an individual painting. I rarely glaze after a petal is completed. If glazing is required, it is to darken a value. After applying the paint, I brush the excess away, leaving the white of the gessoed canvas to glow through the very fine layer of pigment. It is a reductive process, resulting in floral images that are infused with an inner light.

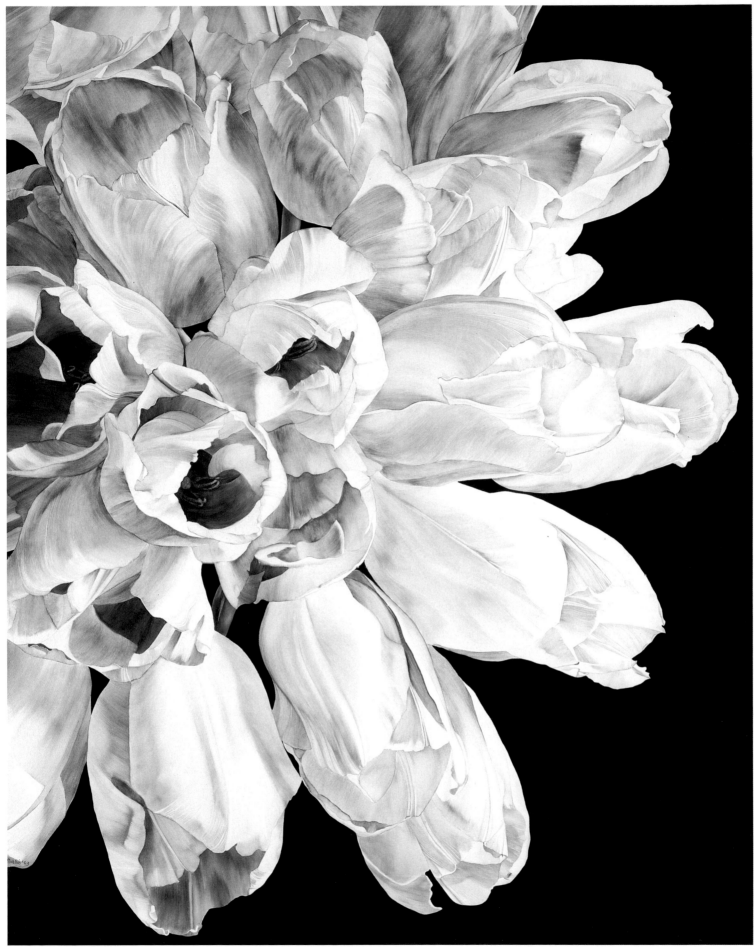

"WHITE HARVEST" Sandra Sallin, Oil on canvas over panel, 30" x 24" (76cm x 61cm)

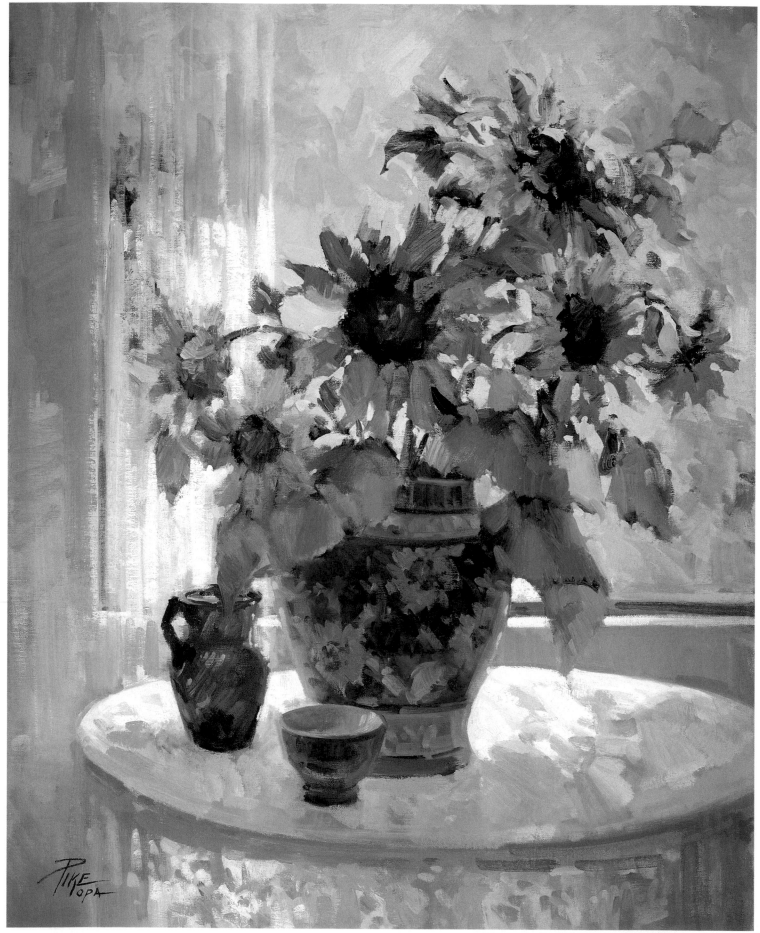

"BACKLIT SUNFLOWERS" Joyce Pike
Oil on linen, 30" x 24" (76cm x 61cm)

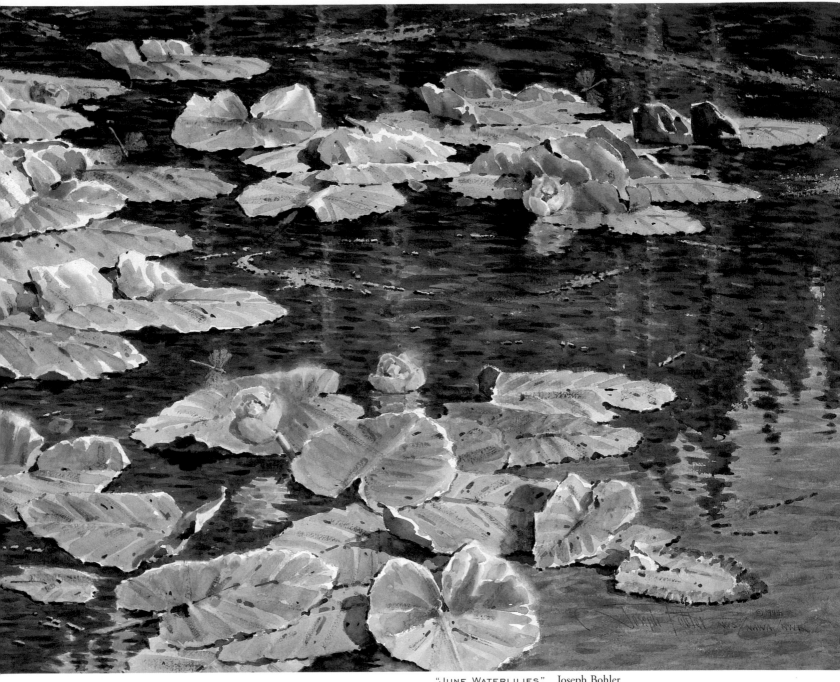

"JUNE WATERLILIES" Joseph Bohler
Transparent watercolor on Arches 300-lb. cold-press paper
30" x 40" (76cm x 102cm)

Joyce Pike

Bright early morning sun through my studio window inspired me to paint these backlit sunflowers. Backlighting puts everything in shadow with only a rim of light visible around the objects. Stronger light will hit some areas such as the table and curtain. The flowers form a pattern with some in full view, and others turned toward the light.

I work alla prima and use my no. 10 filbert bristle brush to block in large shapes. I place shadows first, reserving the strong lights for last. Usually, I place a touch of light in the beginning to give me a key as to how light to go.

Joseph Bohler

I've painted several waterlily paintings during my career but this pond, located below Signal Mountain in the Grand Teton National Park area, caused me to abruptly apply my brakes and pull off the side of the road. A bull moose came out of the brush on the far side of the pond and began grazing near the water's edge. This, I told myself, is why I became an artist!

Back in the studio, after drawing the images on my watercolor paper, I used mask on the edges of the waterlilies. Then, with my 2-inch ox hair flat brush, I used a wet-into-wet approach for the greens in the water using Prussian Green, Permanent Rose, Burnt Sienna and Cadmium Red. Next, I painted Ultramarine Blue and Cobalt Blue in the sky area. I scrubbed out the dragonflies with a hog's hair bristle, and dropped Cerulean Blue into the body and wings. The waterlilies are a lighter version of Prussian Green and Winsor Yellow, and the yellows are Winsor Yellow and New Gamboge.

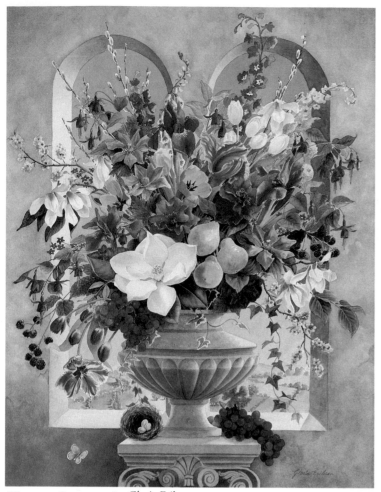

"FLORAL CREATION" Gloria Eriksen
Watercolor on Arches 140-lb. cold-press paper, 28" x 22" (71cm x 56cm)

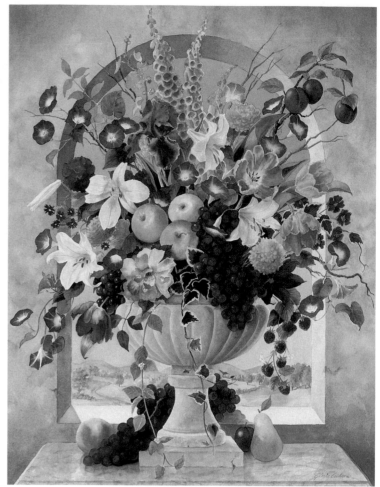

"FLORAL ABUNDANCE" Gloria Eriksen
Watercolor on Arches 140-lb. cold-press paper, 28" x 22" (71cm x 56cm)

Gloria Eriksen

The spiritual inspiration and theme of "Floral Creation" was one glorious season of creation, where all flowers and fruit bloom and ripen at once in a never-ending display of God's provision for humankind. Summer and fall flowers are mixed with winter fruits and spring blossoms.

In "Floral Abundance" I wanted to portray my love of flowers with a joyful celebration of color, variety and energy.

Each leaf, flower and fruit was researched with great care in order to achieve realism. The challenge was in not having any fresh flowers to arrange in such a wild variety, so I relied on inspiration, imagination, and my years as a floral artist, plus my books and photographs.

Some of these books contain reproductions of the old Dutch Masters' floral paintings, which helped inspire me in that direction.

To achieve a balance in composition, emotion and shapes, I contrasted the flowers with the restful pastoral view out the window. I found that by setting the arrangement in an arched window that the arch, trailing leaves and curved bowl created a sense of movement, leading the eye through the painting and linking all elements harmoniously.

The background wall was painted with two or three layers of color, then scrubbed with a bristle brush and blotted with a paper towel.

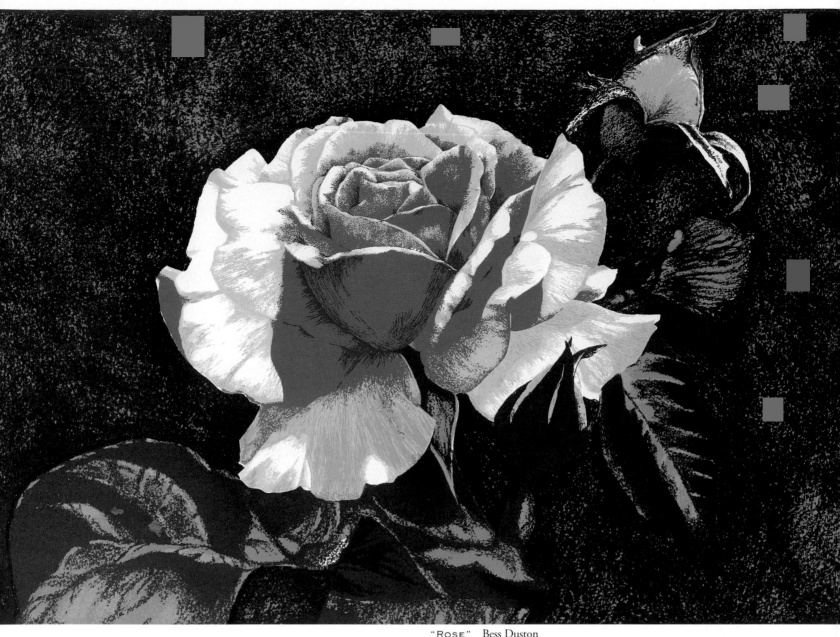

"ROSE" Bess Duston
Screen printing on paper, 14" x 20" (36cm x 51cm)

Bess Duston

This piece is representative of much of my work in serigraphy. I usually try for strong contrasts as well as a feeling of transparency within the flower. This particular rose had all of that.

Screen printing is the process I use to make my limited edition serigraphs. For each color in the serigraph, I make a black drawing, using pen and ink or a black pencil or crayon on a transparent material. Using a light-sensitive emulsion on my screen, I transfer the drawing to the screen. I usually begin with the lightest color in the flower as I print the edition. In order to achieve a full range of values and colors, I keep my inks very transparent. The darker background is added about three-fourths of the way through the edition to help me see how the balance is.

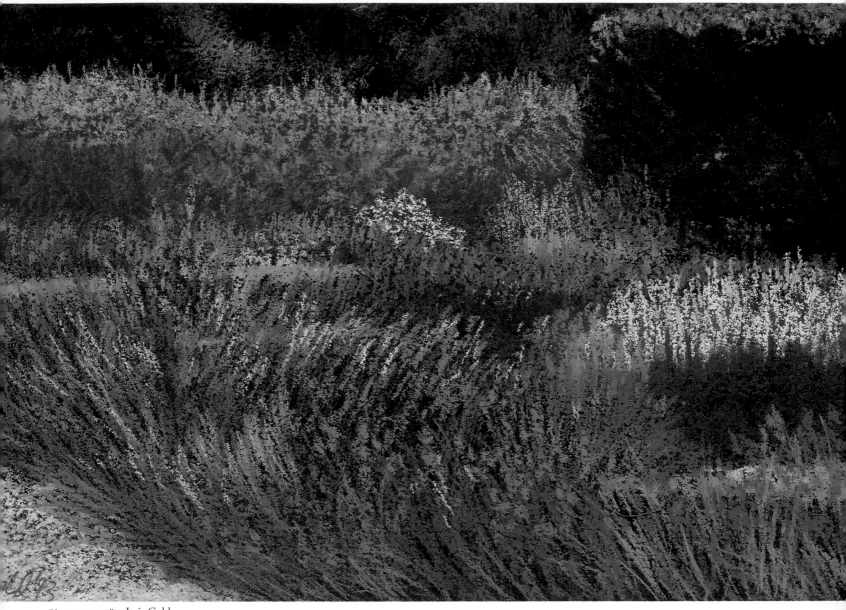

"LAVENDER" Lois Gold
Pastel on paper, 7" x 10" (18cm x 25cm)

Lois Gold

I painted the garden in "Lavender" to invite the viewer to see the garden en masse and not as individual blossoms. I chose to depict an abstract garden landscape, and contrasted the linear qualities of the grasses and lavender against the cube-like forms of the hedges.

I started "Lavender" with a black-toned paper to give depth and contrast to the final image. I sketched the outlines of the composition with a yellow Othello pencil, and then laid in the initial darkest colors blending them forcefully into the paper. I used Diane Townsend and Arc-en-Ciel pastels for the bottom layers, and then Nupastels and Othello pencils to depict the precise edges of the grasses and stalks. I saved the soft Schmincke and Sennelier pastels for the final brilliant highlights.

Sharon Hinckley ✍

My flower paintings grow the way a flower garden itself grows. I "grow" one flower for a while, then move to another and another, and then move back again. Sometimes, one flower will be completely finished first and the surrounding flowers added later. "Garden Gala" was painted on a bright, sunny day.

My palette consists of these colors: Opera, Winsor Violet, Alizarin Brown Madder, Raw Sienna, Lemon Yellow, New Gamboge, Cadmium Orange, Alizarin Crimson, Scarlet Lake, French Ultramarine Blue, Cobalt Blue, Manganese Blue, Antwerp Blue and Emerald Green.

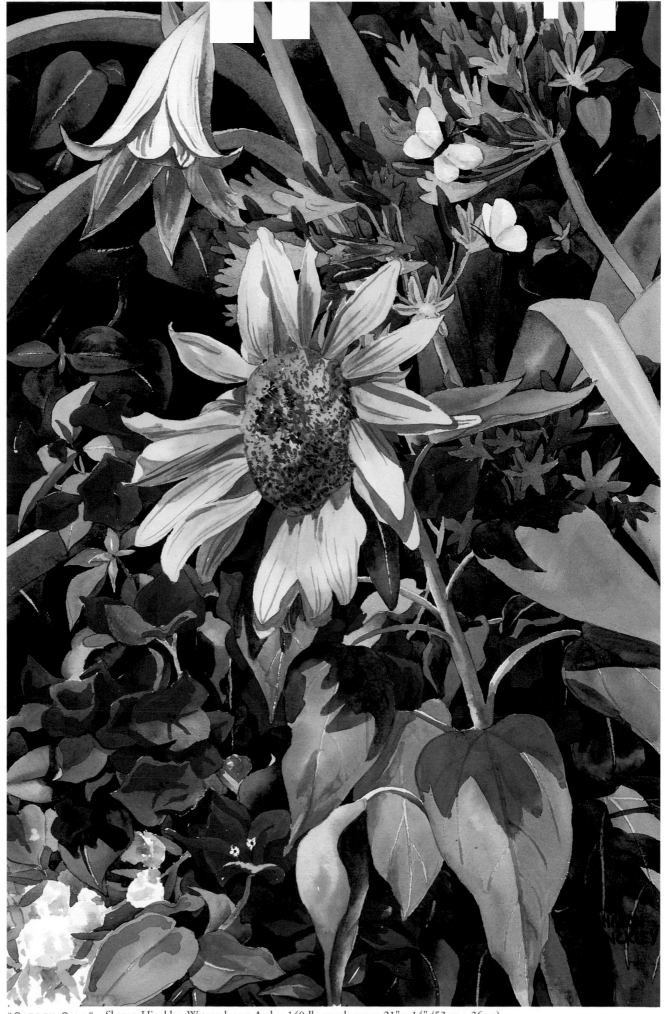

"GARDEN GALA" Sharon Hinckley, Watercolor on Arches 140-lb. rough paper, 21" x 14" (53cm x 36cm)

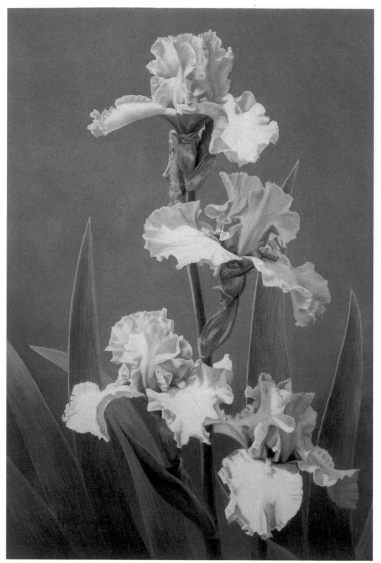

"BEVERLY SILLS" Halcyon Heath Teed
Pastel on acid-free paper, 32" x 22" (81cm x 56cm)

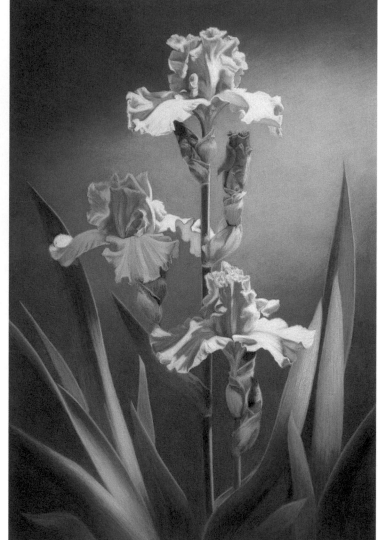

"LADY CHATTERLEY" Halcyon Heath Teed
Pastel on acid-free paper, 38" x 26" (97cm x 66cm)

Halcyon Heath Teed

This pink iris is named for my favorite opera star, Beverly Sills. The asymmetrical design of the bloom stalk and the gownlike quality of the flower give it a real "stage presence." To ensure its grandeur I painted the flower four times life size.

"Beverly Sills" is painted predominantly in a range of Permanent Reds with Light Blue Violets and Cadmium Orange. I like a smooth finish on these florals with very little paper showing. Hard pastels, tortillons and stomps are used to push softer pastels into the paper as well as to handle edges.

Every time I look at an iris, I see Louis Comfort Tiffany's stained glass. The intense color and shimmering aspect of these flowers look just great in glass.

With pastels you can keep colors clean and bright. It's easy to overlay hues in light and shadow. The preferred way to blend juxtaposed color notes is with stomps, but I admit to sometimes using my gloved finger to blend areas. (Never use an ungloved hand. The oils of your skin will interact with the pigment.) Impasto-type strokes in light areas over blended portions give sparkle to the painting.

"Lady Chatterley" contains a range of red- and blue-violets, Ultramarine, Cerulean Blue, Roses and Madder Lakes. In the foliage there are Phthalo Greens, Permanent Greens, Viridian, Cadmium Orange/Yellow and blue-violets.

Douglas Alden Peterson

"Summer's Reflection" (bottom right) is composed from four photographs, three capturing a wildflower species at its peak, and one the fledgling green-backed heron. Serious botanists would chuckle because they know these yellow marsh-marigolds bloom in May, the blue flag irises in June, and waterlilies a month later. If this were a scientific illustration, I wouldn't take such liberties. However, when the goal is to delight the eye, I'll bend reality with no apologies.

The rich colors in "Summer's Reflection" are created with glazes (up to ten layers) moving from pale to saturated color. The intensity of transparent liquid acrylics builds lively colors since the underpainting doesn't re-wet. But beware; unlike watercolor, mistakes in acrylics are essentially permanent. Achieving a full range of natural green, for example, requires extra effort, due to the vibrant pigments marketed. Adding tiny flecks of irrational, bright colors in unexpected spots energizes this composition with sunlit sparkle.

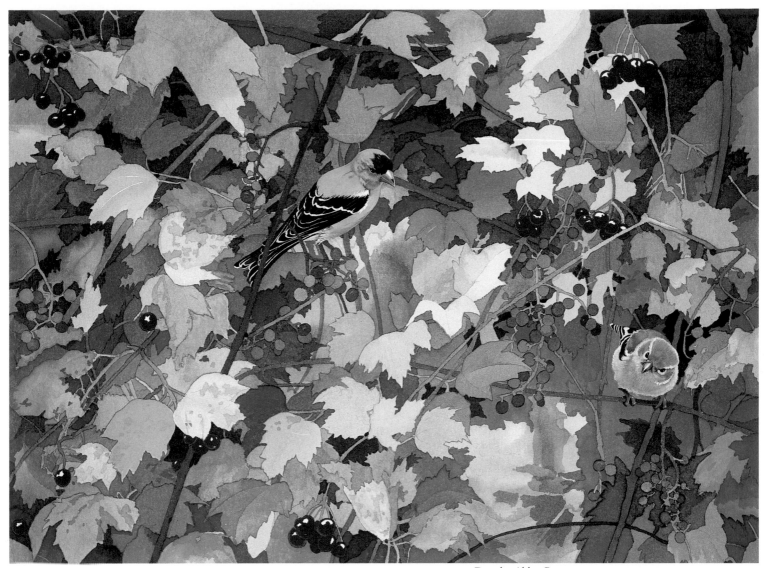

"BERRIES AND GOLDFINCHES" Douglas Alden Peterson
Liquid acrylics & gouache on 140-lb. watercolor paper, 11⅜" x 15⅜" (29cm x 39cm)

"Berries and Goldfinches" is an intentionally ambiguous composition. I avoided creating a strong focal point and allowed the foliage and birds to blend together as they do in the wild.

Crimson currants intertwined with deep blue wild grapes in golden sunlight, the three primary colors, caught my eye in a cemetery hedgerow not far from my home. While gravesites may be manicured, the edges of older cemeteries are often teeming with wildflowers and shrubs in glorious disarray, a rich source for floral paintings.

I arbitrarily selected goldfinches to enrich the primary color scheme and illustrate how easily even brightly colored birds blend with their environment.

With the exception of the initial wet-into-wet ochre background, most of this painting was created in simple, flat washes. Each was allowed to dry thoroughly before painting adjacent areas to retain crisp edges. No masking was needed. Leaves, berries and stems were defined by colors and shapes rather than by detail or three-dimensional modeling.

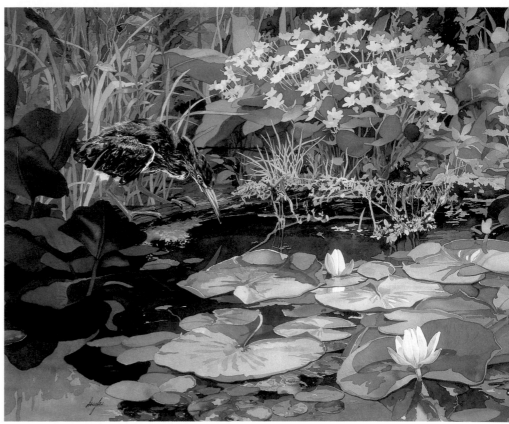

"SUMMER'S REFLECTION" Douglas Alden Peterson
Liquid acrylics & casein on 300-lb. watercolor paper, 22¼" x 30" (57cm x 76cm)

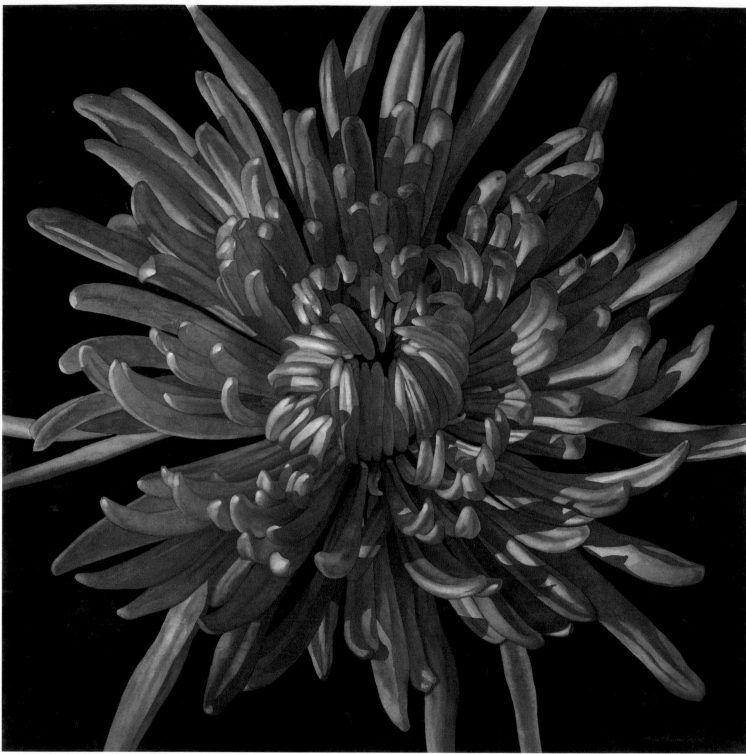

"SOLEIL" Claire Schroeven Verbiest
Watercolor on Arches 140-lb. cold-press paper
31" x 31" (79cm x 29cm)

Claire Schroeven Verbiest

My loving husband periodically surprises me with flowers for no particular reason. On one such occasion, I received a bouquet of bright yellow mums. Their spindly petals clustered around a central point reminded me of exploding fireworks or radiant stars shining high in the night sky. In order to convey my idea, I chose to feature a single bloom, to paint it on a large scale, and to surround it with a deep mysterious space. In spite of this dark background, I named the painting "Soleil" (French for sun) as the cheerful colors and the flower's distinctive silhouette reminded me of the day star.

"Soleil" was executed in a fairly traditional manner, using a combination of wet-into-wet and dry brush techniques. Each petal was painted separately. The areas in shadow were obtained by layering several glazes of complementary colors on top of each other until the desired value was reached.

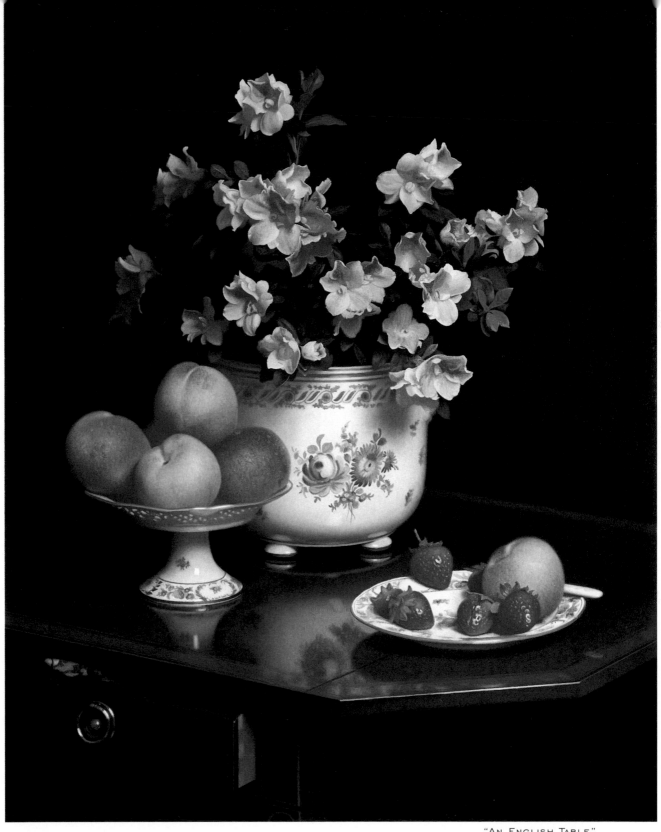

"AN ENGLISH TABLE"
Stephen Gjertson
Oil on canvas, 28" x 22"
(71cm x 56cm)

Stephen Gjertson

"An English Table" was a commissioned still life. I was invited by the clients to browse through their home and choose items to paint from their collection. I selected those that harmonized in size, shape and color. An antique English table provided an ideal base for the objects, the drawer allowing a wisp of scarf to peek out and balance the arrangement of color and values. The client wanted to include a specific kind of azalea and, when the time was right, delivered it to my studio.

I dislike painting only inanimate objects so my still lifes always include flowers and fruit. I consider them to be an extension of the French still life tradition that was brought to perfection in the best work of Henri Fantin-Latour.

Since flowers wilt and change so quickly, I paint them alla prima, designing them to harmonize with the ensemble as I go.

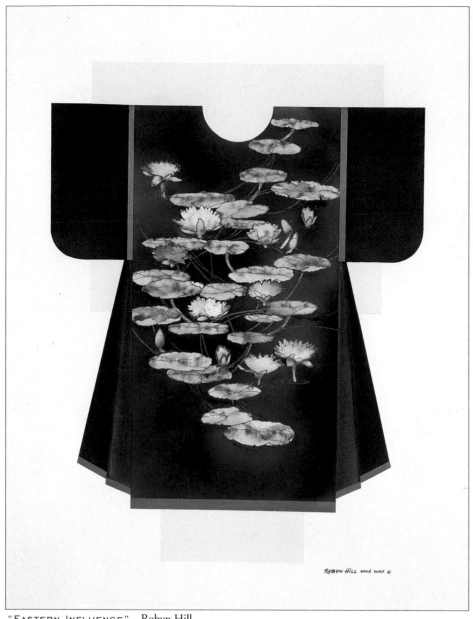

"EASTERN INFLUENCE" Robyn Hill
Watercolor, inks and gouache on watercolor board, 28" x 24" (71cm x 61cm)

Robyn Hill

The simple and classical designs of the Japanese have always intrigued me. I had recently completed a series of waterlily paintings and wished to do a series of kimonos using simple design shapes. In "Eastern Influence" I incorporated the waterlily images as a "silk" pattern area within the kimono itself.

I used a variety of mediums for many different reasons. The waterlilies were created with inks, as I desired a "transparent" lustrous look, as if they were woven out of silk. The blue background is watercolor. Some other areas are painted with gouache as I needed an opaque quality to contrast with the silk-like area. Finally, there are a few carefully chosen edges of metallic gold.

William C. Wright ✒

Still-life and flower arrangement seem almost inseparable. In this painting, I put a flower arrangement together with a fabric pattern of similar color. I wanted the arrangement to spill over into and join the fabric. Both have quite a bit of white in them along with other design elements, such as lighting and color repetition.

This is clearly a very busy painting with many confusing elements. I included the bowl because of its reflective surface and its geometric shape. The reflections inside the bowl mirror some of the colors in the flower arrangement, but its oval shape makes a nice contrast to the mostly organic nature of the painting.

"APRIL BOUQUET WITH BOWL II" William C. Wright
Watercolor on Arches 300-lb. cold-press paper, 29" x 21" (74cm x 53cm)

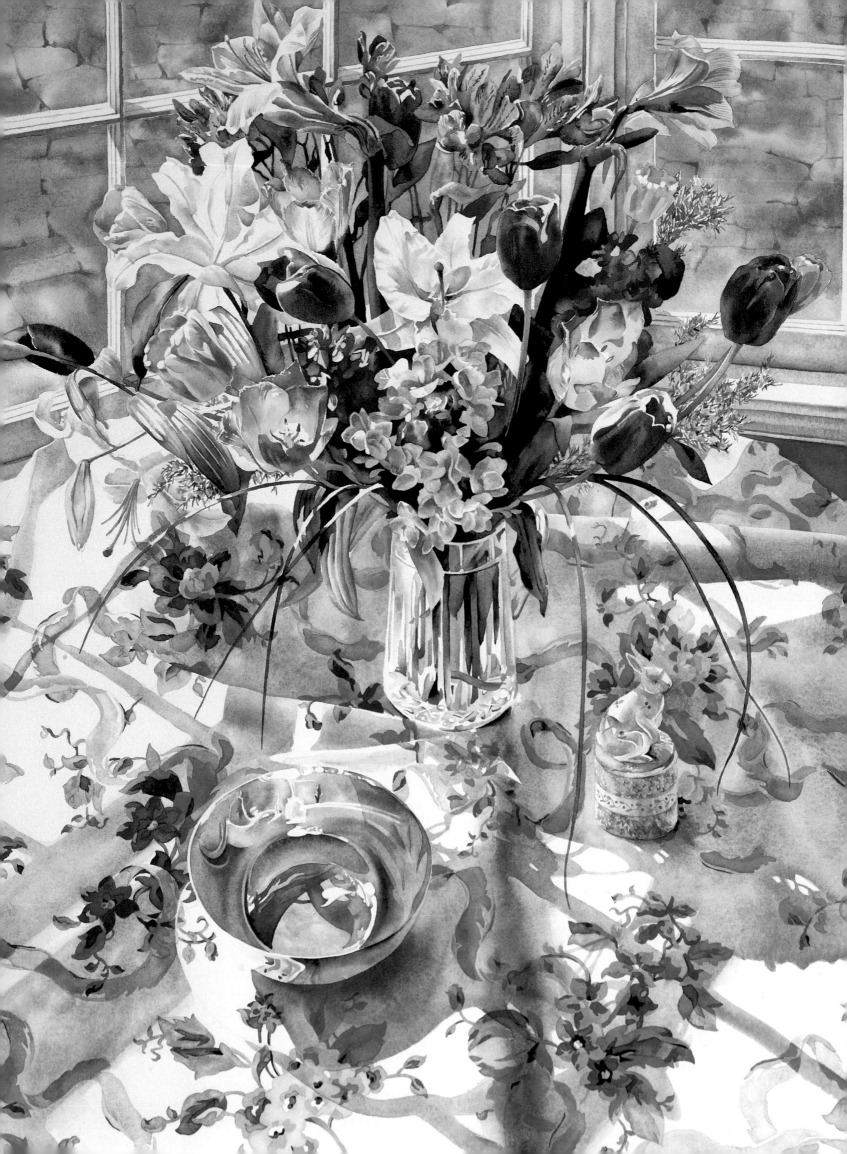

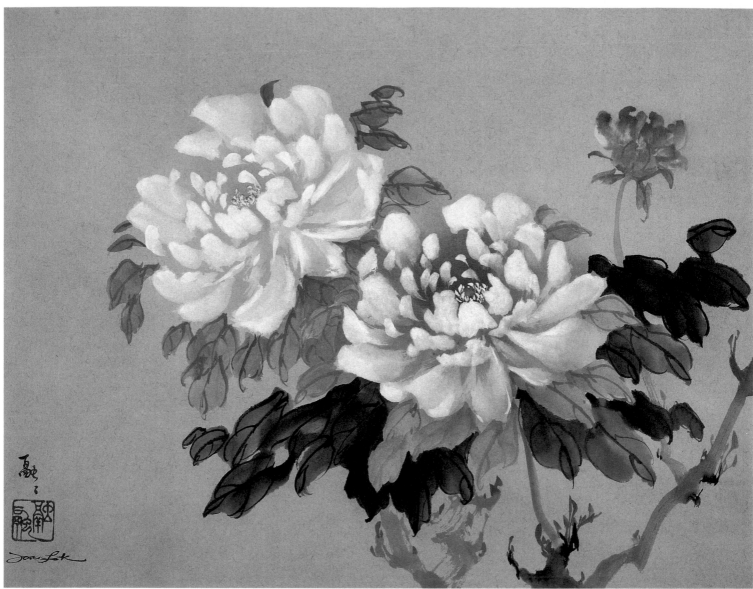

Watercolor and ink on Shuen rice paper (brown), 14" x 18" (36cm x 46cm)

Joan M. Lok

My style is a combination of sumi-e brush painting and Western watercolor technique. I strive to capture the heightened beauty of flowers with vibrant colors and calligraphic brush strokes. Shuen rice paper responds best to the spontaneity of brushwork due to its great absorbency. Since I start with only a vision rather than a sketch, I often tighten my composition by refining it. For instance, in "Full Bloom," a peony bud is added to create eye movement, and the signature and name seal are placed in the lower corner to balance the overall composition.

I begin drawing the center of the flower with an intense amount of Crimson Lake. To obtain the softness of the petals, the brush is saturated with water before tipping into Chinese White. Each petal is achieved by a single brush stroke. The brush is loaded with water, diluted ink, and undiluted ink when drawing the dark leaves. The branches are done in quick calligraphic strokes sweeping across the paper.

Jane Jones 🖋

My paintings come from my deep sense of reverence for the natural world. When I am gardening and get my face right down in the earth and plants, it's another world of color, smells, light and texture: a sacred place.

This rose, Double Delight, grows in my garden. I love the way the bright red edges gently give way to creamy white petals.

I use a fairly limited palette to keep control of the colors and to maintain harmony, most frequently Cadmium Yellow Light and Medium, Cadmium Red Light, Alizarin Crimson, Cerulean Blue, Ultramarine Blue and Titanium White. Analogous and complementary color mixing allows for many wonderful color variations.

Since flower petals are usually smooth, that is how I apply the oil paint, using soft brushes. And because of its slow drying time I can subtly blend one color into another. If it's not successful, I can wipe it off and start over. I love the forgiveness of oils.

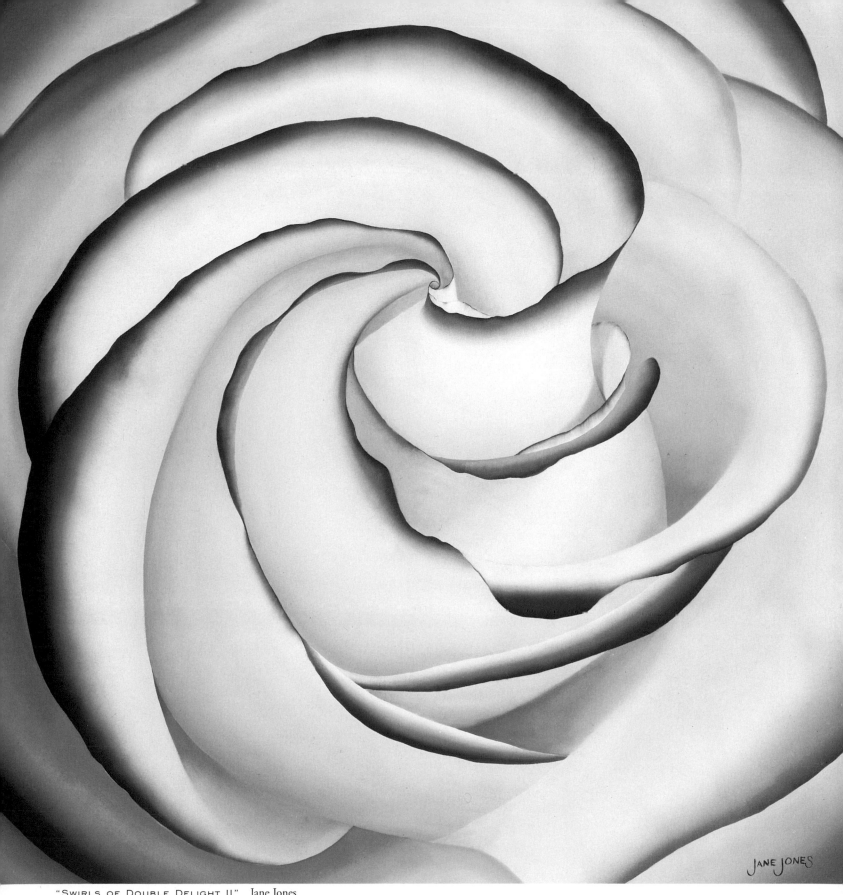

"Swirls of Double Delight II" Jane Jones
Oil paint on gessoed Masonite, 27" x 26" (69cm x 66cm)

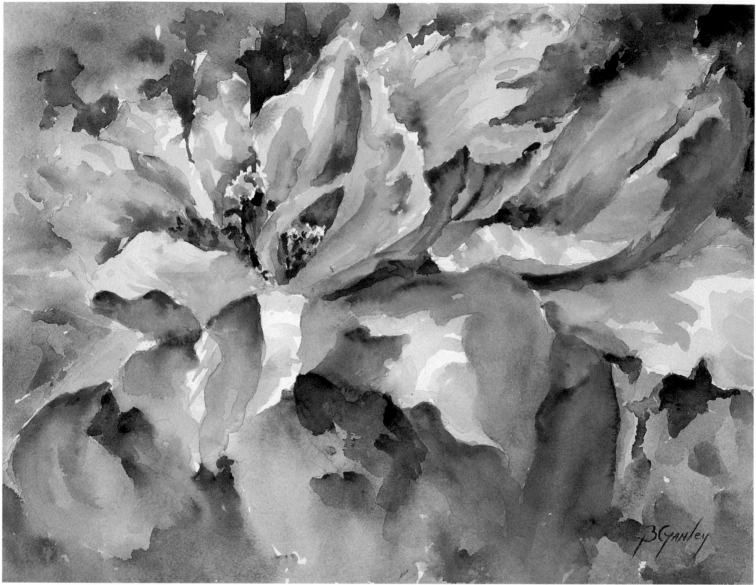

"THE JOY OF YELLOW" Betty Ganley
Watercolor on Arches 140-lb. cold-press paper
10½" x 14½" (27cm x 37cm)

Betty Ganley

An entire flower bed of yellow parrot tulips dancing in the bright sunshine, and for once I had obeyed my own rule: Always have your camera ready. For florals I prefer painting from photographs and always plan photography sessions on bright sunny days. (Without bright sun you lose values, strong shadows and reflected lights.) I take several extra photos of buds and leaves. I usually choose multilayered flowers with plenty of ruffles. The shadows produced by each ruffle add another dimension.

For floral paintings I plan for mostly soft edges, especially where the petals touch the leaves. I use the same values in the leaves as in the flower and add the main flower color to the yellows and greens of the leaves. This creates the illusion that the flowers are integrated with the background and not "pasted on."

For my palette I chose Aureolin (cool and transparent), New Gamboge (warm and semi-transparent), and a small amount of Cadmium Yellow (very warm, but powerful). To extend these values a warm red (Scarlet Lake) was added. In those areas where the petals met the leaves, I encouraged some of the greens to bleed back onto the dried yellow petal by rewetting the petal and leaf area and then lightly brushing the green only on the leaf.

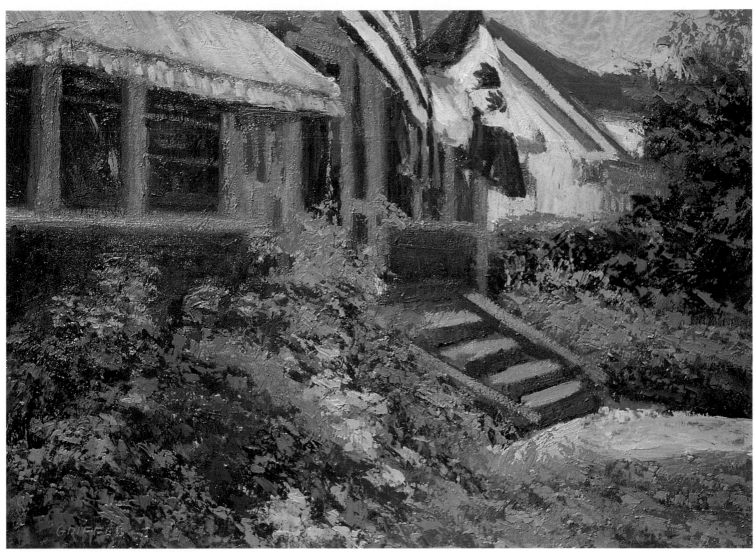

"FLAGS AND FLOWERS" Lois Griffel
Oil on Masonite, 12" x 16" (30cm x 41cm)

Lois Griffel

I love oil paints when they are first squeezed out onto my palette. The colors are so lush and shiny! I choose subjects that provide the opportunity to use my pigments at their greatest saturation and richness. In "Flags and Flowers," the sun was glowing through the flowers, intensifying their hues.

To capture their brilliance, the lilies, coreopsis and geraniums were painted with pure Cadmium Orange, Yellow and Red Scarlet. I could not have created the effect of sunlight with paint that was overly diluted or grayed.

I also used a pure Lemon Yellow to exaggerate the light on the white house. However, to keep the painting from becoming too garish, I added cool notes and grays throughout. The house is tempered with bluish hues, while there are nuances of complementary colors in the flowers.

To maximize color, a palette knife has many advantages over brushes. A knife allows pure transfer of pigment onto a paint surface, and does not require a medium, which would dilute the color.

To keep colors clean and separated, as seen in the foliage of the painting, I use a scumbling technique, which is achieved by layering paint with a knife. This allows a color to peep out from under another. The knife keeps the wet layers from mixing into one another.

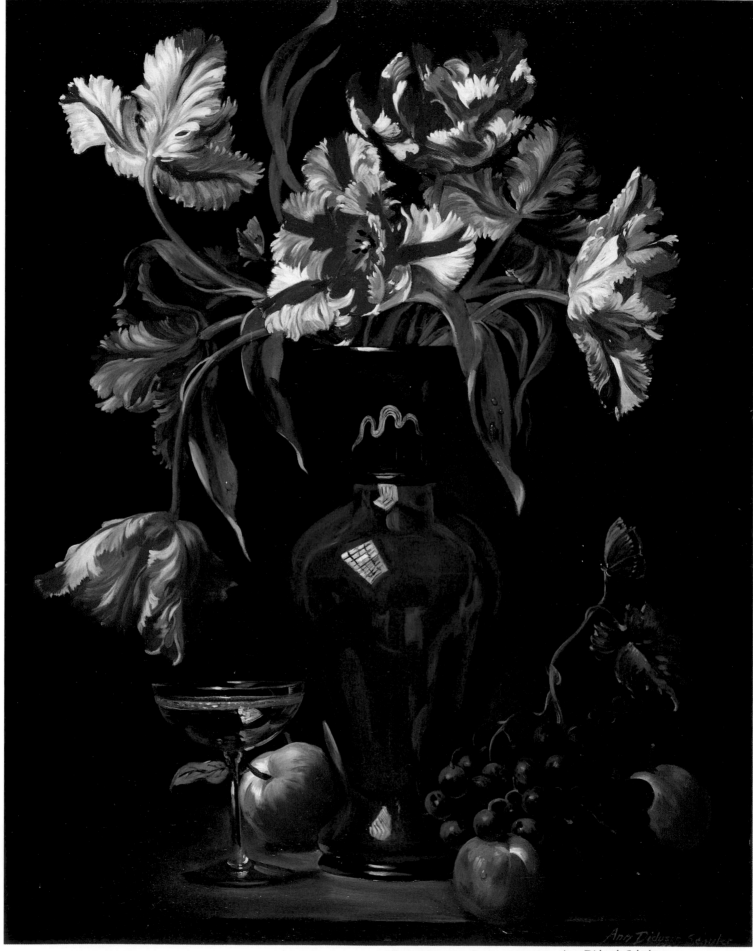

"FLOWERS IN A TIFFANY VASE" Ann Didusch Schuler
Oil on Sapelli Mahogany, 24" x 18" (61cm x 46cm)

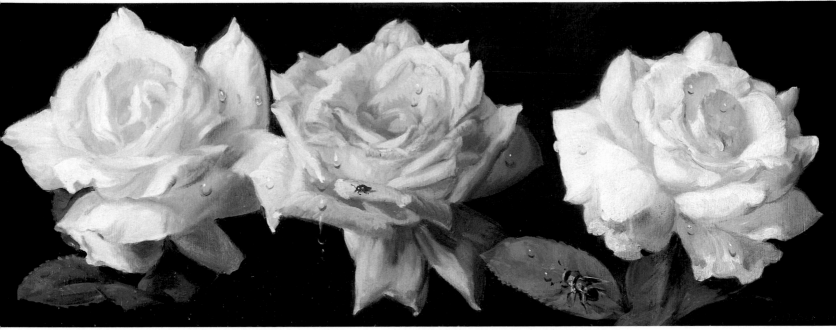

"THREE ROSES" Ann Didusch Schuler
Oil on Mahogany board, 5" x 14" (13cm x 36cm)

Ann Didusch Schuler

"Flowers in a Tiffany Vase" began as a commissioned painting featuring a cherished possession: a blue Tiffany vase. To complement its simple, elegant beauty, I selected parrot tulips for their intricately wild blooms and regal splendor.

I completed one flower at a time in concert with the black background to dramatize the brilliance of the red and white petals. The unusual color of the vase was created with a glaze of Prussian Blue over the dry background. The champagne glass symbolizes the Tiffany name.

The surface is Sapelli Mahogany prepared with three coats of rabbitskin glue and two coats of white lead, the final striated with umber. I use powdered pigments ground with Black Oil (linseed oil cooked with litharge), with the exception of two tube paints, Brilliant Yellow Light and, for this particular painting, Prussian Blue. For the brilliant whites, I use homemade white lead.

I always paint with Maroger medium, a gel made from combining Black Oil and mastic crystals dissolved in turpentine. The fresh-ground paints, combined with the medium, allows for a quick drying time, and enhances the richness and luminance of the color.

"Three Roses" began as a simple study of the peace roses that I grow in my garden. These studies become important because I do not select a group of flowers, arrange them and then paint the composition. I create the general composition that I want and then arrange the flowers, or use these references, to meet the demands of the sketch. However, I liked this composition as it developed, so I decided to complete it.

A little red bug on the center rose adds a point of interest and complements the subtle shades of red that grace the peace rose. I always add dewdrops, which are simply done by outlining the shape in the tone of the petal and adding a shadow underneath and a highlight on top. The beauty of the roses allowed them to stand on their own without further elaboration.

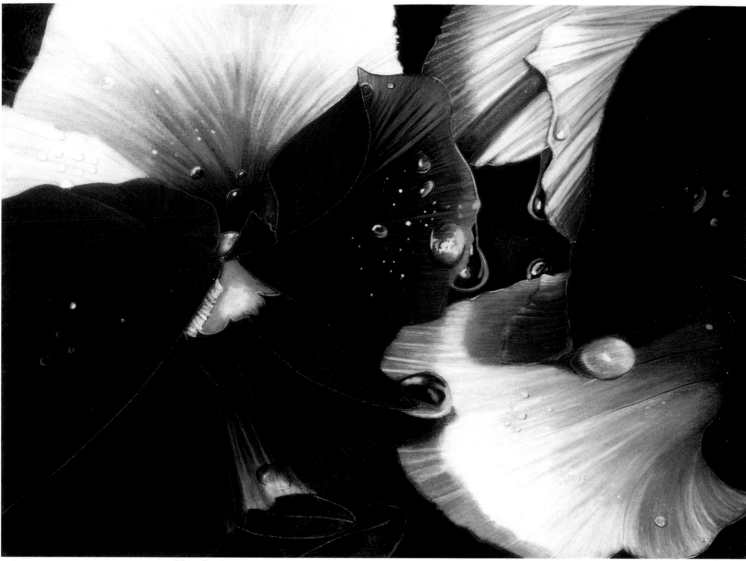

"GREENE THUMB SERIES #4" Vera Curnow
Wax-based colored pencil and solvent on cold-press
illustration board, 15" x 20" (38cm x 51cm)

Vera Curnow

The beauty of painting flowers is that you don't have to be true to
their nature—unless, of course, the painting is a botanical study.
While portraiture demands accurate proportions, florals can be
manipulated, interpreted and exaggerated. That's what appeals to me.
I use flowers to explore abstract possibilities. The easiest way to do
this is to take the subject out of context by painting a close-up view of
it. I keep the shapes simple, the colors bold (black doesn't scare me),
and juxtapose light and dark masses for contrast. The dewdrops are
added to provide some activity. If the shape, form or hue of the flow-
ers are contrary to my goal, I just make up some new ones.

Over a white surface, dense color saturation is obtained with
wax-based colored pencils, turpentine and cotton rags. The result of
this undercoating depends on the amount of pigment laid, quantity
of solvent used, degree of pressure applied and the size of the area.
After values and color patterns are balanced, form and texture are
developed with a combination of dry and wet applications. Details
come last.

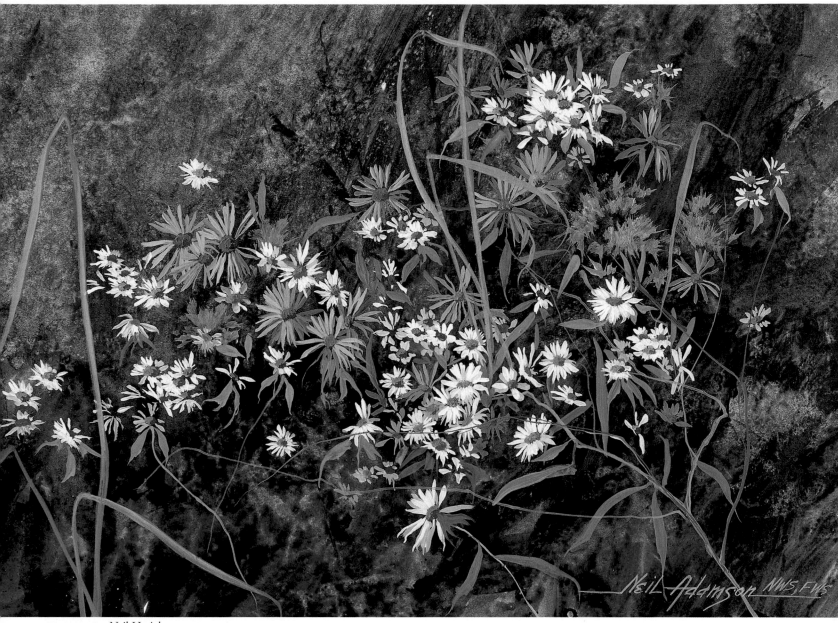

"ASTERS" Neil H. Adamson
Acrylics on Strathmore high surface illustration board
11" x 16" (28cm x 41cm)

Neil H. Adamson

The idea for "Asters" came about while I was exploring the Brandywine River and the wooded areas and flower gardens beside the old mill at Chadds Ford, Pennsylvania.

The fall foliage colors were wonderful, but it was the asters seemingly growing everywhere that caught my attention. I liked the way they were growing in their natural state—wild, not cut back or trimmed. Their beautiful petals of lavender and purple and rich yellow-orange centers stood out against the greens in the stems and leaves. In this setting, there was a small wild daisy growing among them that added variations of color, texture and design, and enhanced the composition.

I used Thalo Blue and Raw Umber to mix up various grayed acrylic washes. I applied several washes, flowing them on, drying each with a hair dryer, keeping them darker behind the flowers for contrast. Then loosely mixed, semi-transparent acrylics were mixed in white and Acra Violet for the asters, Thalo Blue, Raw Sienna, Yellow Oxide and Hansa Yellow Light for the leaves and stems. The colors were applied thicker and heavier until I got the desired results. After these dried, I used thin washes of Ultramarine Blue for the shadows.

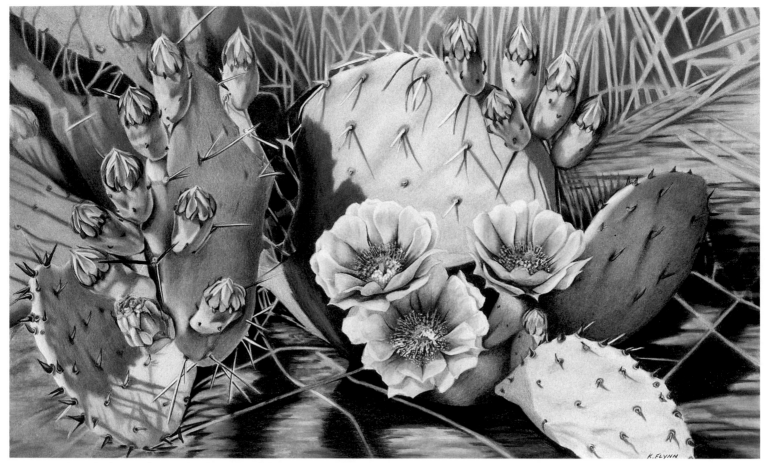

"Sunburst" Katharine Flynn, Colored pencil on hot-press watercolor paper, 16" x 19" (41cm x 48cm)

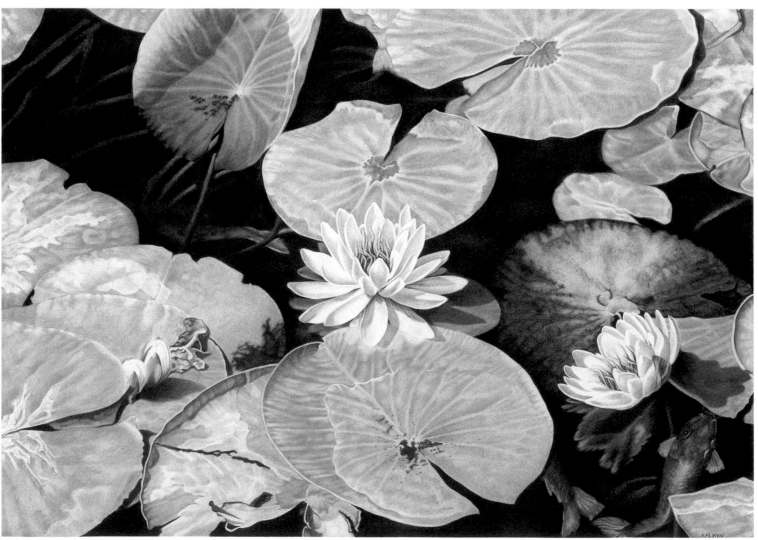

"Ordinary Magic" Katharine Flynn, Colored pencil on hot-press bristol board, 20" x 30" (51cm x 76cm)

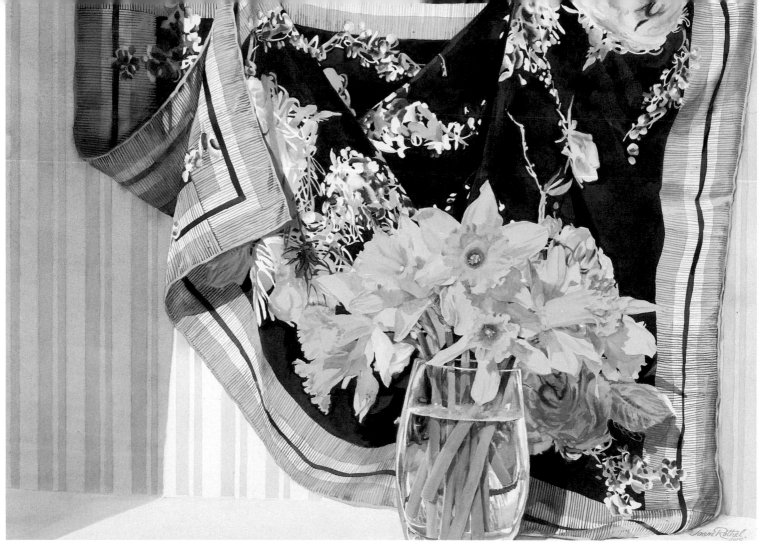

"FLOWER STILL LIFE" Joan Rothel
Transparent watercolor on Arches 140-lb. cold-press paper, 22" x 30" (56cm x 76cm)

Joan Rothel

This casual arrangement combines a favorite scarf and a simple bouquet of daffodils from my garden. I chose extreme darks to keep the flower painting from appearing sweet or sentimental. Placement of the darks high in the composition is unexpected, yet the pink and yellow pattern on the scarf break the large area and keep it from appearing top heavy.

I painted the daffodils in a total mass and shape rather than individual flowers because I wanted the background and foreground to interlock much like a puzzle, with three-dimensional "real" flowers merging with the silken image.

The black line on the edge of the scarf varies in width and value as it leads the viewer through the composition. I repeated the yellow stripe on the scarf in a much larger scale as wallpaper for the background.

Clear, rich, transparent darks are achieved with a base of Winsor & Newton Neutral Tint warmed with a hint of Alizarin Crimson or touch of Ultramarine Blue. Neutral Tint bleeds when re-wet. I capitalized on this in the upper left scarf shadow, blurring and occasionally losing the hard edges and lines.

The luminosity of the daffodils develops through several glazes of both warm and cool yellows in overlapping areas. Shadows take shape with delicate washes of Cobalt Blue or pale Dioxazine Purple. Winsor & Newton Olive Green applied thickly and then scraped with the end of a brush handle accent the flower center.

Katharine Flynn 🐦

My artwork intends to honor the sacred and primal elements found in the natural world. These themes are reflected in the contrasting environments of "Ordinary Magic" and "Sunburst."

"Ordinary Magic" is an exploration into a swamp environment—rich with uncounted organisms in every stage of life, death, decomposition and regeneration. The purity of the white waterlilies above the surface contrasts with the murky water and dark mysteries hidden below.

"Sunburst" focuses on the meaning of survival and subsistence in a desert environment. To survive the hot and dry conditions, the body of the prickly pear is angled to create rotating shade and coolness for the surfaces of the plant.

In both drawings, three complementary colors (Indigo Blue, Tuscan Red and Peacock Green) are layered to establish a monochromatic underpainting. Then local colors are added until the image has life-like color. Next, alternating layers of light and dark values are blended and burnished over the image. These final layers give the rich paint-like results.

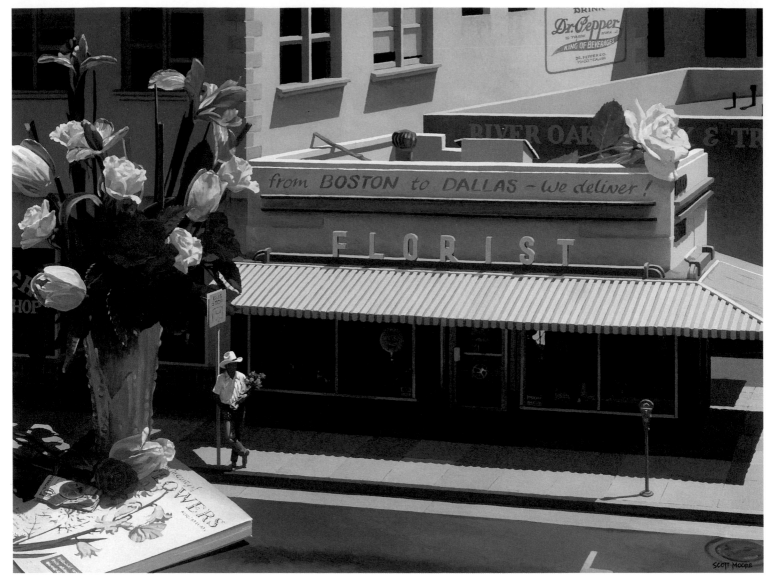

"BLOOMS WITH A VIEW" Scott Moore
Oil on linen, 33½" x 45" (85cm x 114cm)

Scott Moore

I had clients in Dallas, Texas, who commissioned me for an oil painting that would reflect some aspects of their personal lives. I began by driving around the Southern California area looking for an interesting background. The quaint architecture of this flower shop in Pasadena got me started.

I immediately envisioned the large vase of flowers on the sidewalk and the yellow rose of Texas on the roof of the building. By bringing in the male figure at the bus stop, holding the same bouquet of flowers, I now had a story to help explain the bigger-than-life objects.

When my clients told me their favorite flowers were the pink tulip and the blue iris, I had the makings of my floral arrangement. The signage on the buildings related to the birthplace of their children and their work. After I had designed the tall building with its corner room and windows, the title "Blooms With a View" came to life.

Waltraud Fuchs von Schwarzbek ☙

The preparation of this oil painting took more than six months of meticulous detail work. I created it after researching the style of the Dutch masters of floral still life painting of the sixteenth and seventeenth centuries in museums here and in Europe.

About 110 flowers of approximately 30 species are pictured, the majority of which I cultivated in my garden. "Nature's Wonders" includes butterflies, fruits and various critters and even an abandoned robin's nest.

The casually arranged flowers were placed in an Italian vase on an antique Persian rug, both of which are family heirlooms.

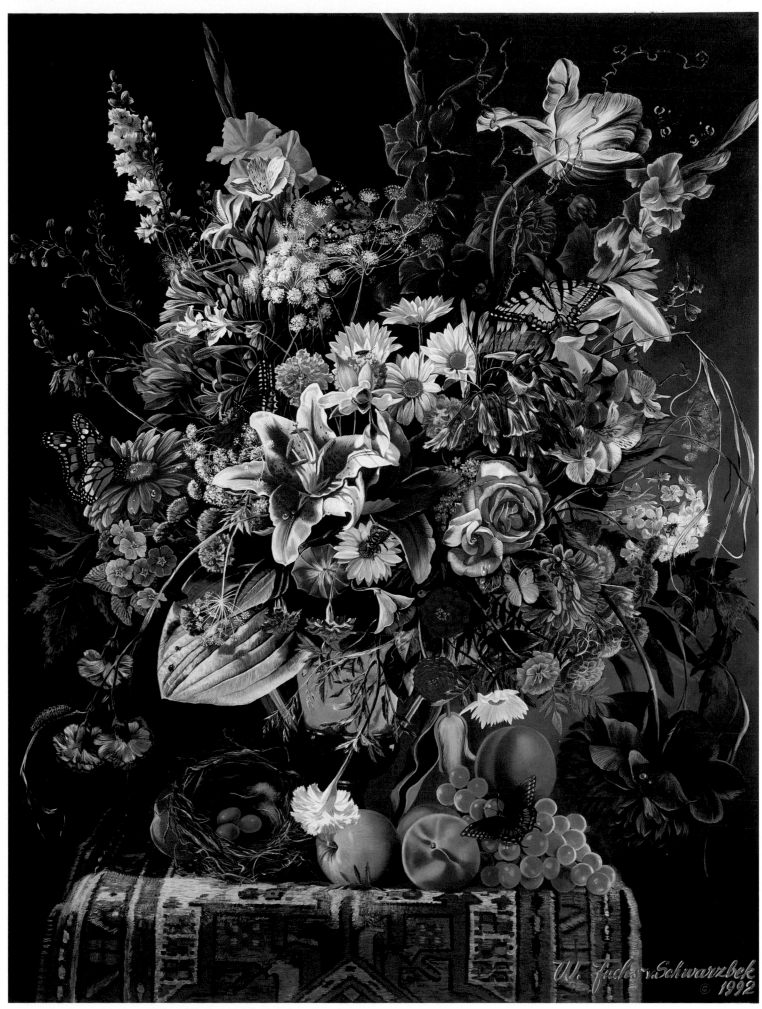

"NATURE'S WONDERS" Waltraud Fuchs von Schwarzbek
Oil on Masonite panel, 30" x 24" (76cm x 61cm)

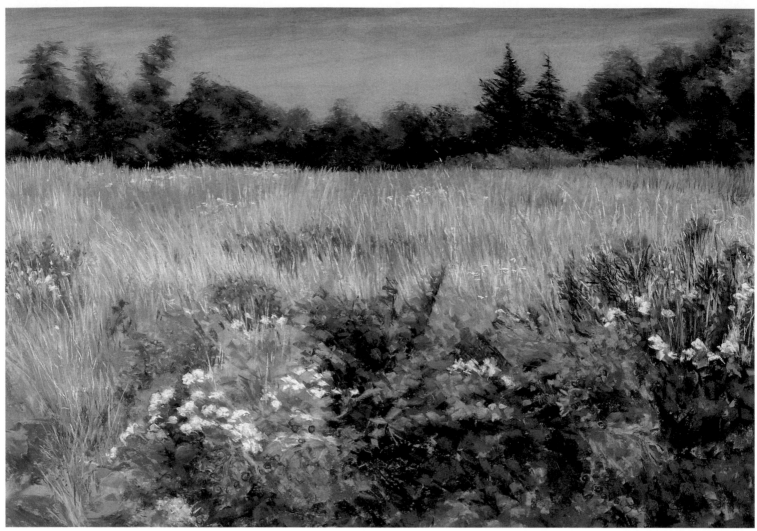

"MAINE FIELD" Lee Heinen
Pastel on sanded paper, 24" x 36" (61cm x 91cm)

Lee Heinen

This scene is a field on Deer Island, Maine. I am not as concerned with the literal representation of a place as in the emotional quality of the subject. To me a scene like this represents the long summers of childhood—sunny, warm and free. It's the untamed quality of the field flowers that appeals. They allow for an abstract expressive interpretation that a more formal garden does not.

I find it surprising how realistic my pictures appear when I step back from them, since I strive to keep them loose and spontaneous. Looking at this field makes me yearn to return to a Deer Island summertime to sit in a field, smell the salt air and paint the flora and fauna.

I use a variety of soft pastels, some of which are handmade, on Ersta Starcke 500 sanded paper. I layer the colors, often dissolving parts of the first layer by painting into it with alcohol on a brush. (Don't try this on ordinary pastel paper.) This is particularly effective in achieving rich dark colors, as in the foreground shadows of "Maine Field."

Mari M. Conneen &

The soft but bright whites of these calla lilies, along with the sculptural lines and whites of the porcelain vase, seemed to fit like a hand in a glove. The gentle curves of the long stems and the lines of the vase were a natural composition. While working in transparent watercolor washes, and using the natural whites of the board, I thought it would be both a challenge and fun to create a totally white painting. The results were elegance and simplicity.

"Calla Lilies" was painted by letting paper whites shine through, and carefully layering light washes around those whites. An experiment of color mixing—Ivory Black with Winsor Blue and Olive Green—surprisingly gave the soft whites I wanted to achieve. Light pencil lines were drawn on areas of the vase, petals and stems. Those areas were avoided, but later blended into painted areas with water.

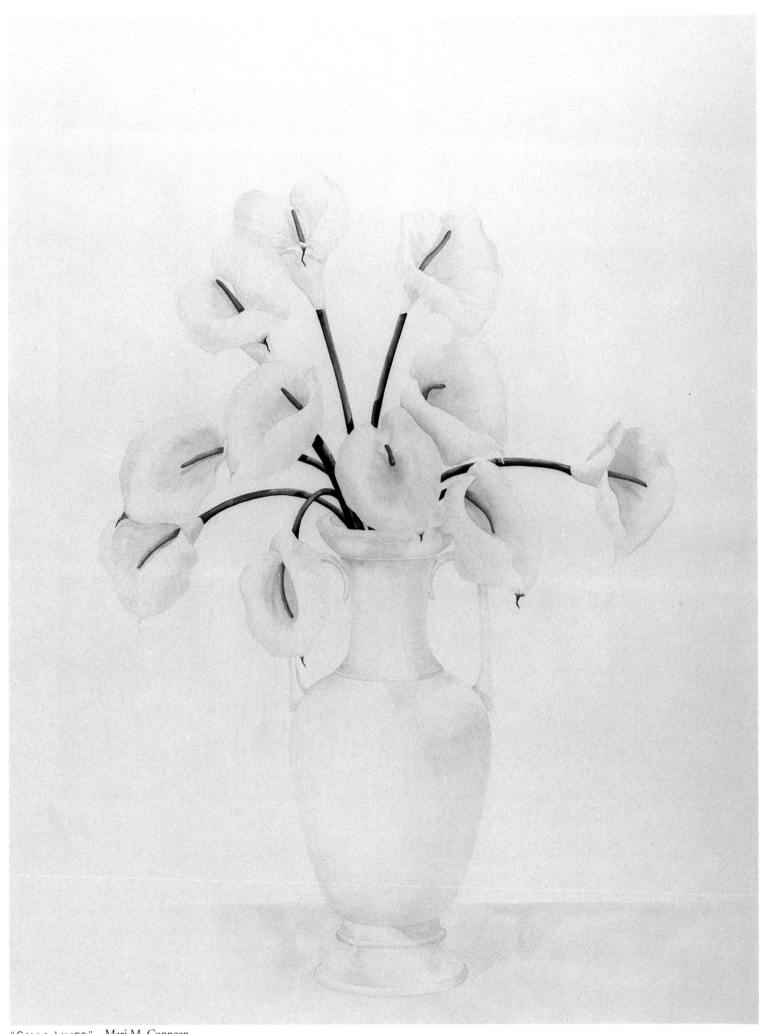

"CALLA LILIES" Mari M. Conneen
Watercolor on cold-press rag board, 35" x 25" (89cm x 64cm)

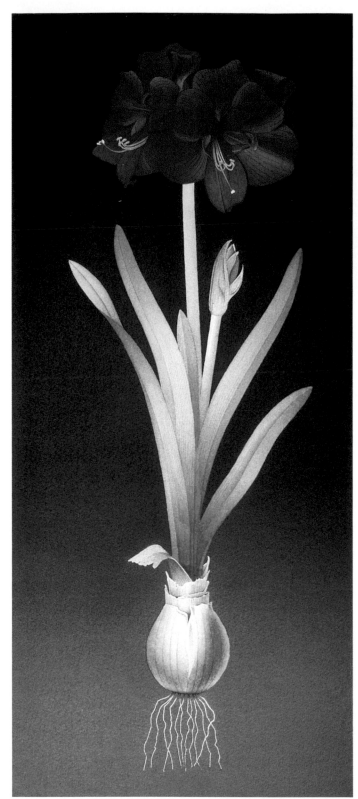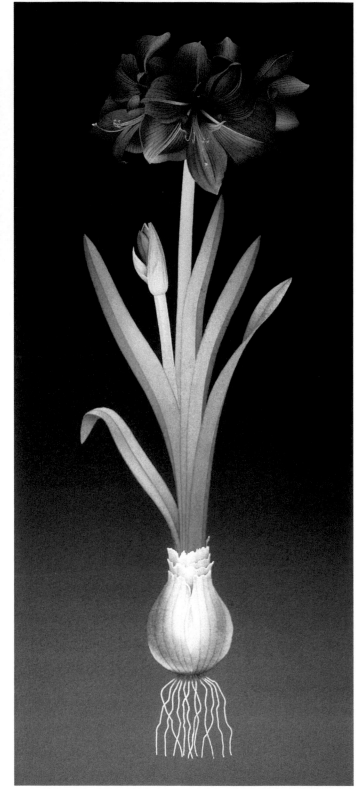

"RED AMARYLLIS/VIOLET AMARYLLIS" Wayne Waldron
Watercolor on Arches 300-lb. rough paper, 25" x 10½" (64cm x 27cm)

Wayne Waldron

The flowers I prefer to paint are bulbous plants with vibrant color such as irises, lilies and amaryllis. Having studied old eighteenth- and nineteenth-century bookplates and, in particular, the works of P. J. Redouté and Albrecht Dürer, I take a more technical approach to my flower painting. Thus, the watercolor botanicals, "Red Amaryllis" and "Violet Amaryllis."

So as not to damage my paper's surface in any way, I make a preliminary drawing on extra heavy tracing paper. I then position the image on my paper and make a graphite transfer to its surface. Next I mask out the flower, stem, bulb and roots. With a 2-inch Winsor & Newton wash brush, I begin laying in the Burnt Umber background, working top to bottom, dark to light, wet into wet. My palette consists of Raw Umber, Burnt Umber, Sap Green, Hooker's Green, Naphthol Red Light, Grumbacher Red, Acra Violet, Cadmium Yellow Medium, and Yellow Ochre. I reserve the paper for my white.

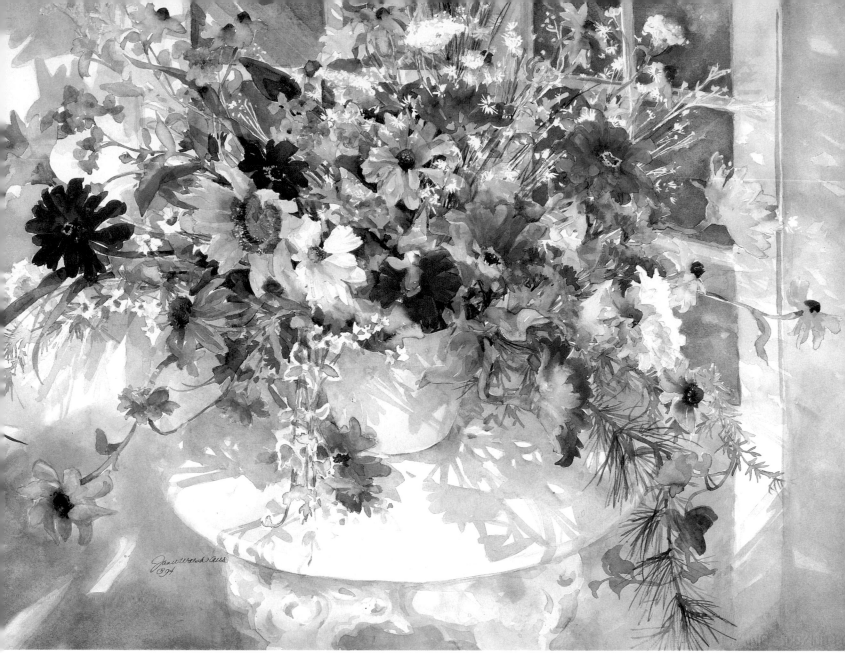

"SUNLIT PATTERNS" Janet Walsh
Watercolor on Fabriano 140-lb. unstretched cold-press paper
22" x 30" (56cm x 76cm)

Janet Walsh

Morning walks through my garden in late summer inspired this setup. The flowers, table and container are used as echoing round shapes of varied colors and sizes. The foliage and windows add a sense of movement and counter-movement to the composition.

At first, large white flowers and an approximation of the container are loosely sketched as oval and rectangular shapes. These give the basic framework of the bouquet. White mask is used only for Queen Anne's Lace and the darting white shapes. My greens are usually mixed with Phthalo Blue and Indian Yellow, with some Cobalt Turquoise and Permanent Green Light. I treat the foliage of the bouquet with as much importance as the flowers, rarely finding it necessary to paint every leaf; rather, I create a variation of shapes, value and color to complement and continue the movement in the bouquet.

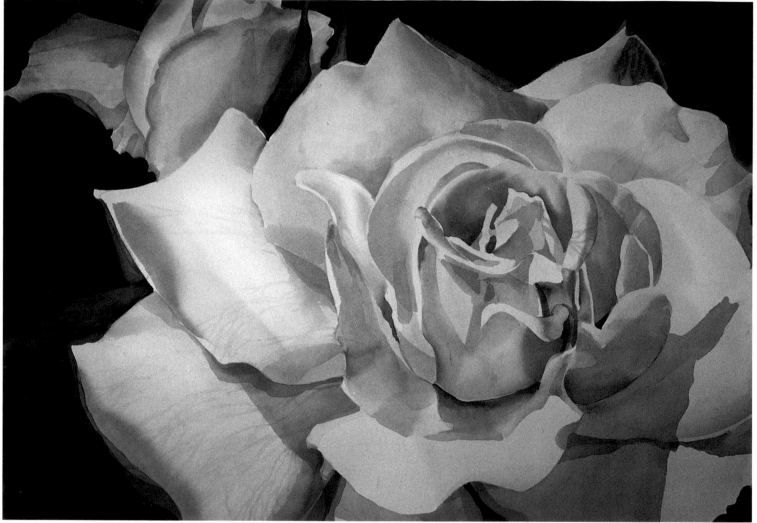

"I Never Promised You..." S. Webb Tregay
Transparent watercolor on Arches 140-lb. rag paper
22" x 30" (56cm x 76cm)

S. Webb Tregay

For me, floral painting is a visual adventure. I submerge myself in the lush contours and colors. I challenge myself with evaluating the nuances of color temperature and value. Then I force myself to take the painting past the bounds of my reference material. These are both exercises and escapades for my mind, eyes and hand. The particular joy of floral painting is combining these difficult lessons with lush, fragrant flowers—while escaping the reality of a Buffalo winter.

"I Never Promised You…" was done from a photo to freeze the light and shadow patterns that are crucial to this particular painting. But I found that when I had gleaned as much information as possible from the photo, the painting was still only 70 percent finished. Many more layers of rich darks and delicate washes were needed to create the depth and roundness that one remembers about roses, but that the flat photo forgot. Multiple edges, "saved" as the background value gradually intensified layer after layer, turned the lips of the petals over and made them flutter in the breeze.

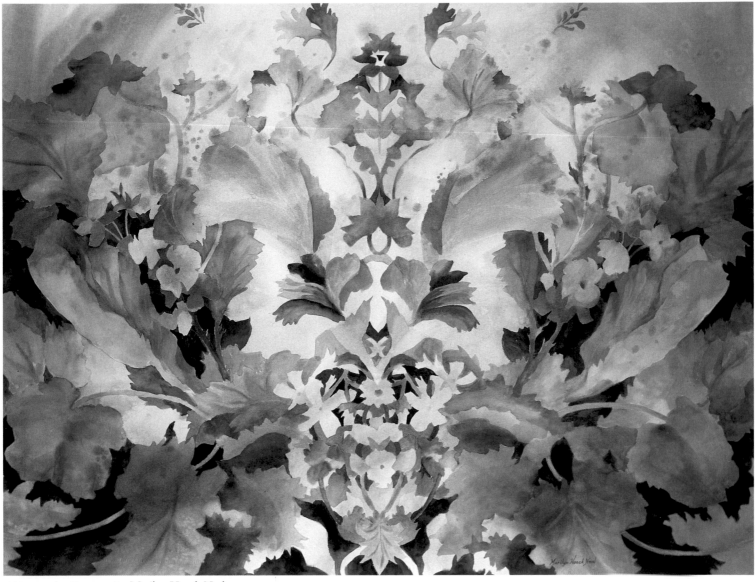

"NATURE'S THRONE" Marilyn Hoeck Neal
Transparent watercolor on Arches 140-lb. cold-press paper
32" x 43" (81cm x 109cm)

Marilyn Hoeck Neal

Compositions of formal balance have always fascinated me. My inspiration for "Nature's Throne" came from a small bouquet of fresh flowers and large leaves; my challenge was in how to avoid the mundane and the expected. I decided to draw shapes in symmetrical formality, then paint informally with sweeping and free-flowing rhythmic washes. Rich darks would be added for mystery and contrast.

First I made a full-size drawing on tracing paper. The tracing paper was divided into halves. The drawing was only on one half.

Then I flipped the tracing paper, repeating on the other half in reverse. New shapes formed on the center fold. The drawing was then transferred to watercolor paper.

I worked wet-into-wet, underpainting soft-edged washes. My goal was to work sensitively and yet present a bold, strong statement. I painted both positively and negatively, hard and soft edges, lost and found areas.

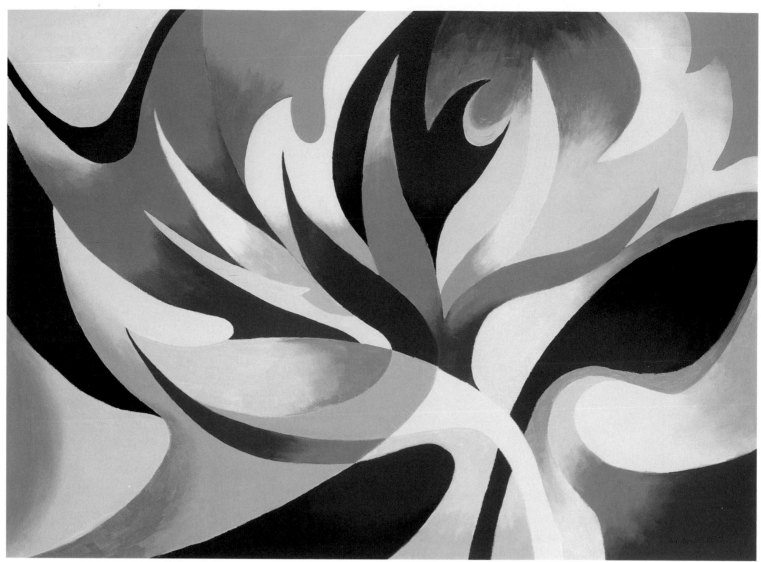

"BIRD OF PARADISE LOST" Barbara J. Betts
Acrylics on Lana 140-lb. cold-press watercolor paper, 21" x 29" (53cm x 74cm)

Barbara J. Betts

The Bird of Paradise is such an unusual, exotic flower that it has inspired me to paint it several times. I love its soaring, spear-like petals. My aim here was not to portray realism but to use the flower as a basis for a well-designed composition. I echoed the shapes of the flower and used other compatible shapes to integrate figure and ground. Repeating the same colors in subject and ground also helped achieve unity. I flattened the picture plane but modulated the color for greater interest.

Using Liquitex tube acrylics, I thinned down the paint with water and a little acrylic flow improver. Indo Orange-Red mixed with yellow, white and/or brown was the basis for the oranges in this painting.

Frances Cohen Gillespie ✍

In the last twenty years I have been painting mostly plants and flowers. Often I set them in front of mirrors, poised on draperies or on bare wood.

I start by trying to paint what I see, but the longer I look, the more there is to be aware of, especially since nothing that lives is ever exactly the same from day to day. By the time I am done, I have come to love the thing I have painted.

While artist-in-residence at Duke University I began the painting, inspired by one of John Hope Franklin's orchids. The flowers appear to be animate, like birds in flight. I sewed an obi to arrange its birds to be in circular flight, reflecting the elliptical journey of the orchids through their mirror image.

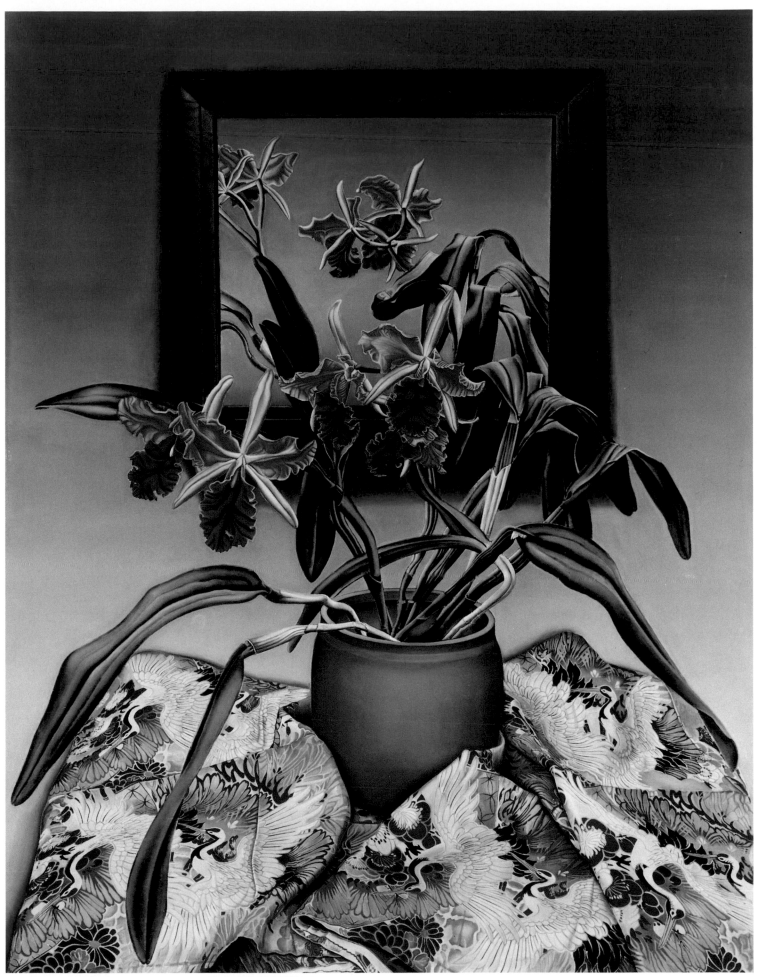

"John Hope's Cattleya Orchid" Frances Cohen Gillespie
Oil on canvas, 72" x 60" (183cm x 152cm)

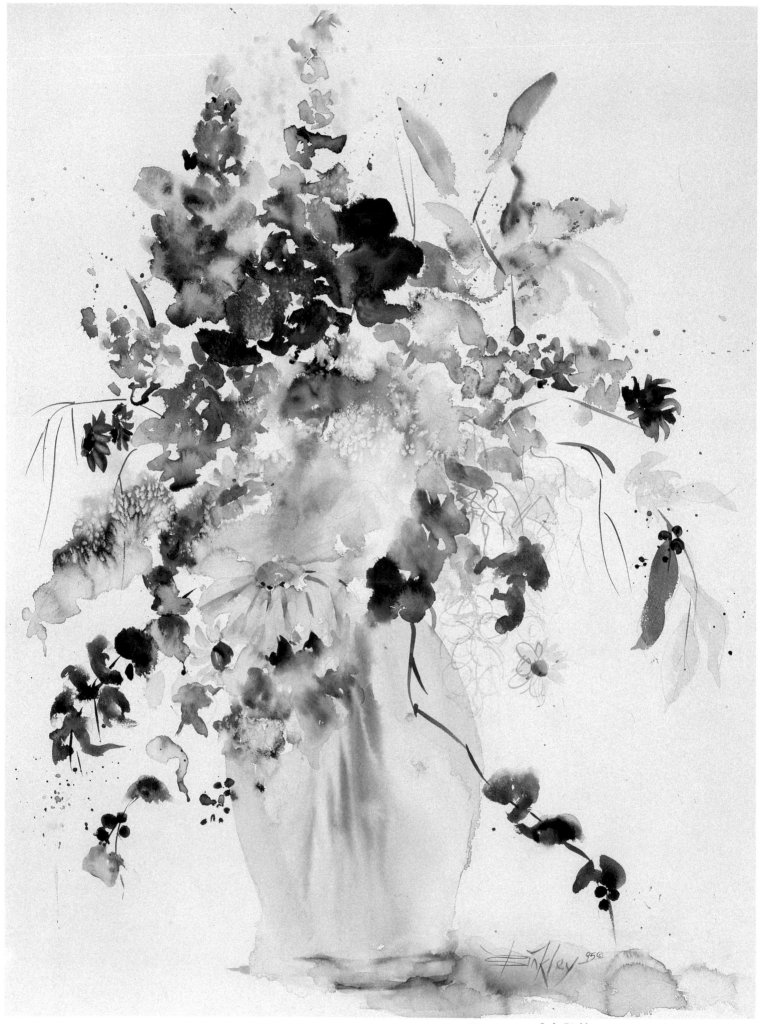

"JUBILANT" Jody Binkley
Watercolor on Arches 140-lb. paper, 30" x 22" (76cm x 56cm)

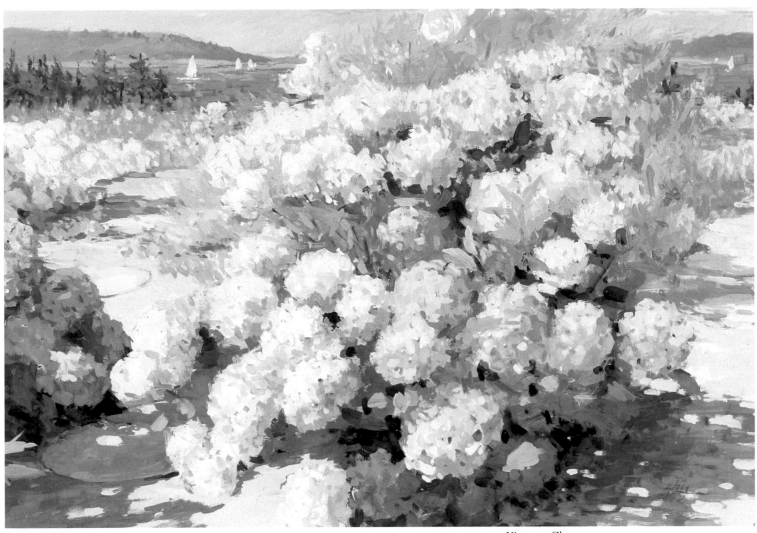

"GARDEN AND SEA" Xiaogang Zhu
Gouache on 140-lb. hot-press watercolor paper, 18" x 27" (46cm x 69cm)

Xiaogang Zhu

Years ago I came across one of the old Impressionist masters' paintings of beautiful rose bushes with the sea as the background. This made me think of so many similar scenes in the San Juan Island area of Washington State. I thought it would be unique to do a flower painting with a seascape background.

I chose the hydrangea shrub mainly because of its colors: cool blue and purple pastel shades. This cool tone of the shrub looks so harmonious with the sea color in the background.

I used my preferred medium, gouache, and instead of painting thinly as with watercolor, I painted very thickly, almost like oil. This allowed me to take advantage of gouache white and mix it with other colors to get a variety of subtle pastel shades representing the petals of the hydrangea.

Jody Binkley

Spontaneity is the key to my work. And what could be more spontaneous than being surprised by my student, a florist, who brought me a tall, dramatic bouquet of fresh flowers on a cold, Colorado winter day?

The loose, flowing nature of watercolor lends itself well to the look I'm after in my florals: elegance with an Oriental flavor. The loose edges where neighboring colors mingle give a light and airy feel, and at the same time create a sense of mystery as the flowers take on a more dimensional quality.

After lightly penciling the composition on a dry paper surface, I used clear water and a flat brush to wet each shape. Then the color was dropped in using a wet-into-wet process. Working quickly, I kept the board tilted at about a 70-degree angle. To achieve a variety of edges, I occasionally misted some shapes with water using a spray bottle. My colors were Cadmium Red, Alizarin Crimson, Raw Sienna, Sap Green and Thalo Blue.

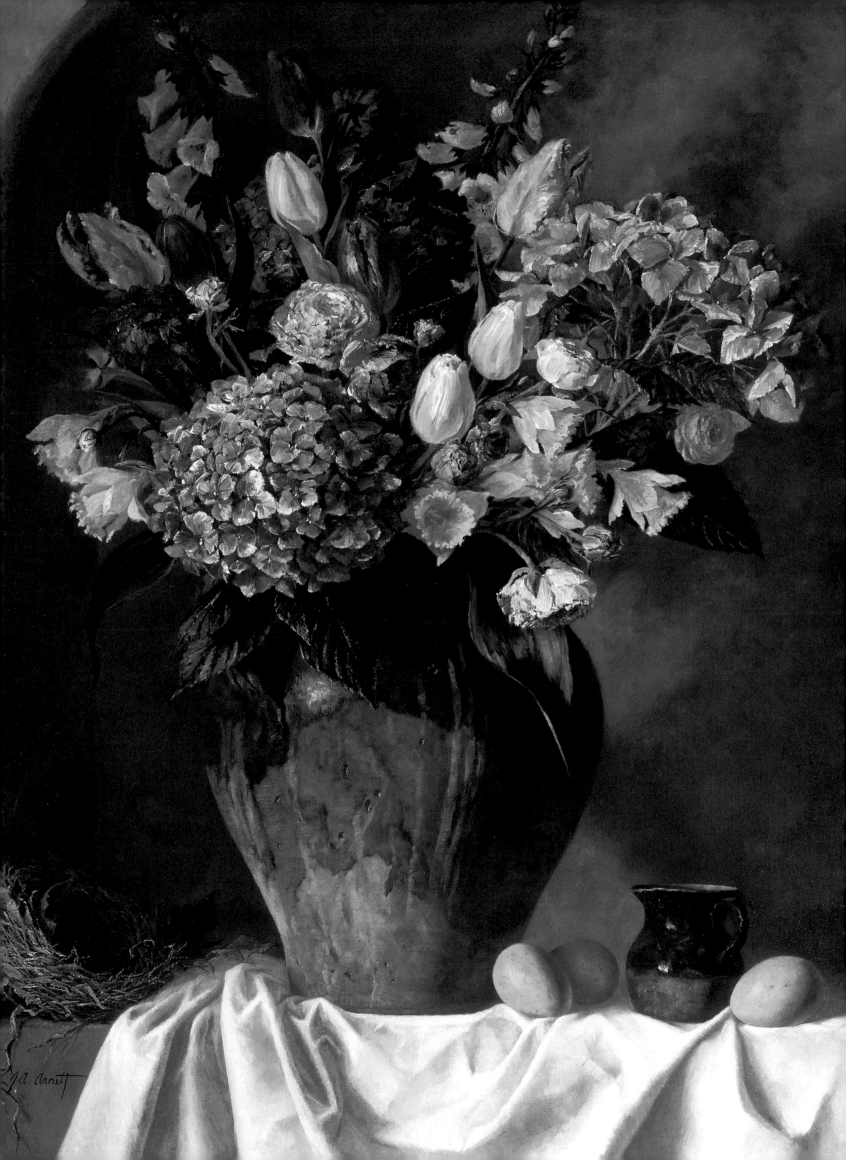

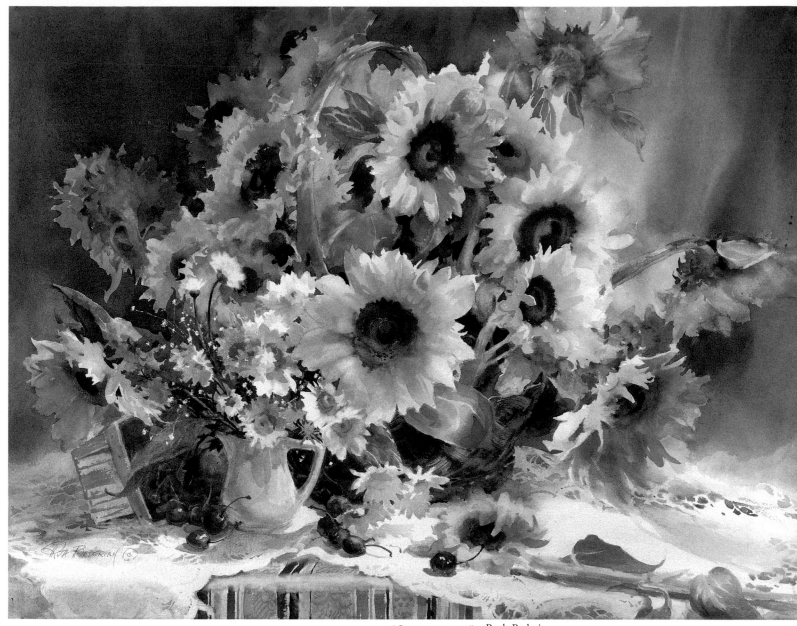

"SUNFLOWERS" Ruth Baderian
Watercolor on Arches 140-lb. cold-press paper, 22" x 30" (56cm x 76cm)

Ruth Baderian

One summer the sunflowers in my garden were in blazing glory, but I was too ill to paint them. Sadly, I had to watch them fade. Then on a cold, cloudy day in late October, I found sunflowers in my local supermarket staring up at me with their bright golden faces, daring me to take up the challenge to paint their dramatic personality. Would my spirit wither or win? I melted under their spell. My warm and bright summer sunflower season had finally come.

I use the wet-into-wet technique, floating pigment, saving large whites, masking only small ones before wetting the paper. Aureolin, Permanent Rose and Cobalt create transparent light yellows, without the opaque look of Yellow Ochre, which I never use. Indian Yellow, Cadmium Scarlet and Winsor Blue create darker yellows (or browns). Edge orchestration works wonders to express various moods.

Joe Anna Arnett

Tulips, daffodils and ranuculus are among the first flowers we think of in the spring. These are, however, all of similar scale. Varying the scale of objects in a painting is one of the key things that makes a painting interesting. The large hydrangeas became my solution to the scale problem and consequently became one of my favorite flowers to paint.

The flowers here were all painted alla prima, with more impasto for the flowers in the foreground than the flowers further back. The flowers that fall in the shadow of the niche were painted with very thin paint and far less contrast to make them recede.

"SPRING/HYDRANGEA" Joe Anna Arnett
Oil on linen, 29" x 24" (74cm x 61cm)

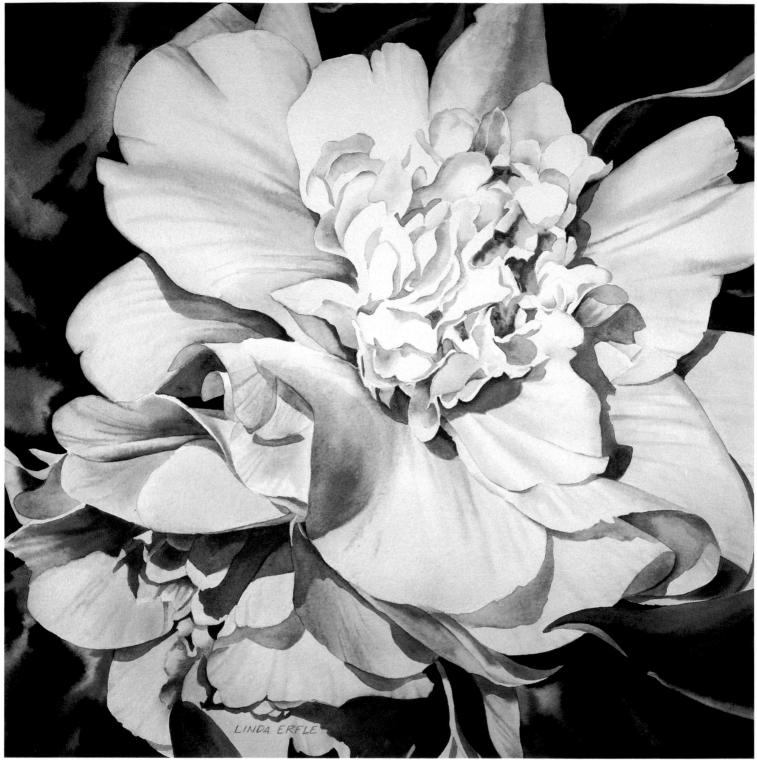

"BETTY'S CAMELLIA"
Linda Erfle
Transparent watercolor on
Arches 300-lb. cold-press paper
14" x 14" (36cm x 36cm)

Linda Erfle

Nothing describes the elegance of a flower more effectively than flowing water and pigment. It takes only the slightest coaxing for the dimensional form of a camellia to seemingly emerge from the paper's white plane.

For a bold, dramatic composition I balance middle-value ranges with the white of the paper and a dark just this side of black. To achieve this high contrast I place my subject in strong sunlight. My shadows and darks are a lively combination of several pigments blending on the wet paper to create depth, variety and a feeling of spontaneity. Carefully, I work around those areas of the painting where I want the white of the paper to show through.

Sharp, hard edges indicate shapes in the forefront while varying degrees of soft edges push petals back and denote curved surfaces. Damp-into-damp best describes the method by which I impart the characteristic veins and shadows on the petals of this camellia.

"WINDOWS INTO SPRING"
Dani Tupper
Transparent watercolor on
Arches 140-lb. cold-press paper
30" x 22" (76cm x 56cm)

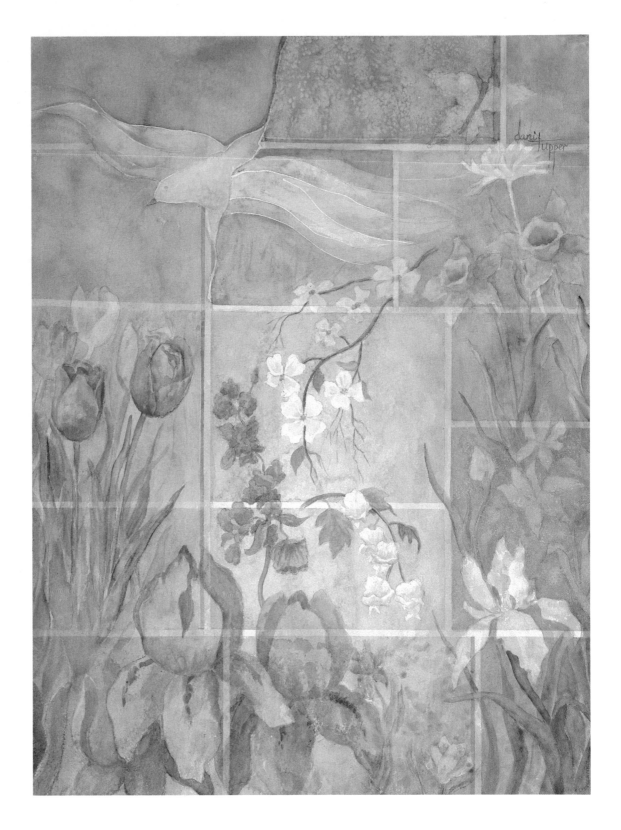

Dani Tupper

I started this painting to demonstrate how to achieve different textures to a watercolor class. I sketched in the large iris and the bird, then let the textured underpainting suggest other flowers and shapes, such as the stems and leaves of the tulips and daffodils. These were derived from vertical lines made by plastic wrap.

After sectioning my paper into a pleasing design with quarter-inch masking tape, I created textures by sprinkling salt, spritzing with alcohol or water, splattering paint, and laying on plastic wrap while the paint was still wet. I also painted through a napkin in two sections. Many of the flowers were developed by negative painting when I reglazed the background. After removing the tape, the stripes were toned to tie in with the overall painting.

I like to work with a limited palette so the painting holds together as one entity. For this painting, my palette consisted of Carmine, New Gamboge, Ultramarine Blue, Thalo Blue and Thalo Green.

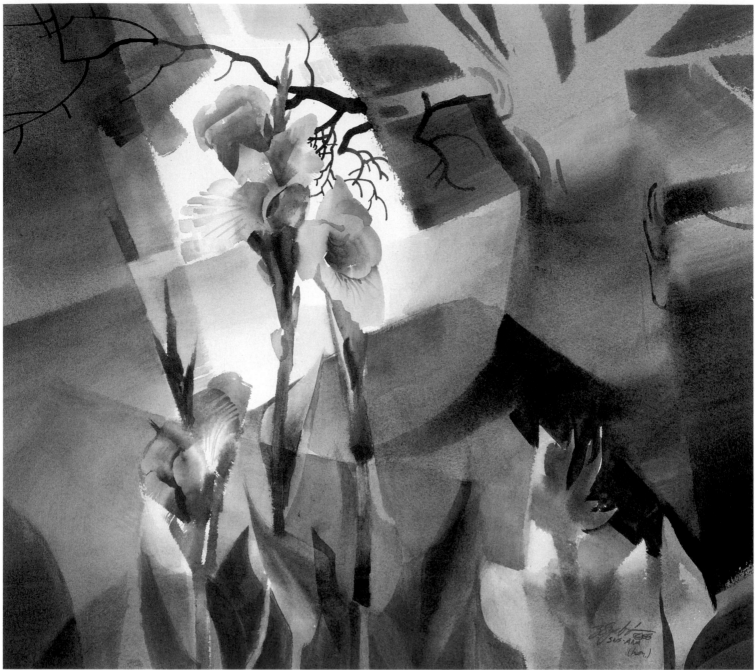

"MISSION TORCHES" Zoltan Szabo
Watercolor on paper, 19" x 22" (48cm x 56cm)

Zoltan Szabo

Nature is exceptionally generous in giving us pure brilliant colors when she presents us with flowers. My love of flowers is based on their delicacy and almost miraculous beauty. I enjoy interpreting these incredible little charmers by composing them with strong personalized design.

These canna lilies were born in a California mission, and I painted them on location. The sun lit them like little flaming torches. Behind them were the deeply shaded trees under which monks were probably meditating as they quietly walked the paths. This little painting still reminds me of the quiet solitude, the cool shade and the wonderful scent of the flowers around me. It seemed like a solemn hour frozen in time that I will never experience quite the same way again.

I enjoy the spontaneous application of watercolor without pencil drawing, and I painted "Mission Torches" that way. My emotional excitement is best communicated by working directly on the virgin surface. I use slanted brushes that I designed to paint and blend the edges. I save the beauty of the white paper but make equally sure that my darks stay luminous and clean.

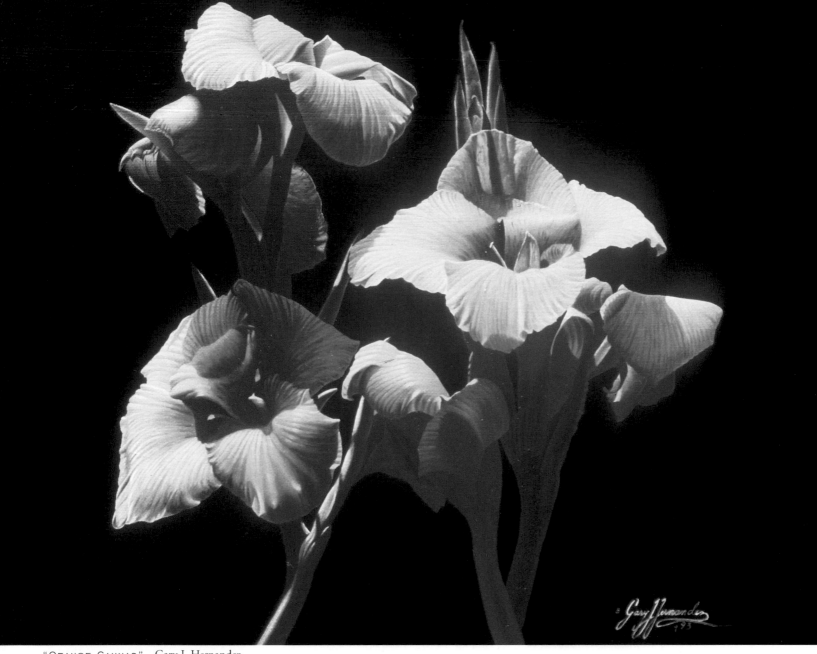

"ORANGE CANNAS" Gary J. Hernandez
Oil on linen canvas, 16" x 20" (41cm x 51cm)

Gary J. Hernandez

When I first saw an orange canna it seduced me with its form and color, its sensuous curved lines and translucent orange petals against deep green leaves.

I studied the orange cannas I grew in my garden at different times of the day, paying particular attention to the effects light had on the flowers. I did some preliminary work of touching the flowers, taking slides, sketching, drawing, and finally a color study in watercolor.

"Orange Cannas" was painted in oils on an oil-primed linen canvas. I prepared a smooth surface to facilitate great detail work. Next, I transferred the finished drawing onto the canvas and painted a monochromatic underpainting in oil color thinned with turpentine. Over the underpainting I glazed the canvas in thin layers of paint. I used translucent colors for darks and opaques for lights. The finished painting dried for thirty days before I applied a coat of retouch varnish.

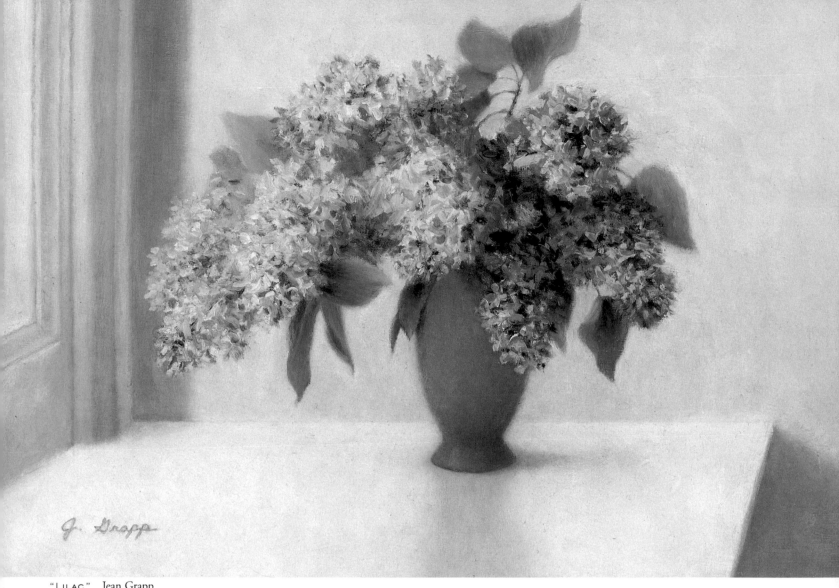

"LILAC" Jean Grapp
Oil paint on gessoed panel, 12½" x 18" (32cm x 46cm)

Jean Grapp

After a long, dark, cold Minnesota winter, spring is always a welcome delight and lilacs are truly one of spring's treasures. I love to flood my studio with lilacs. They are such an opulent mass of petals and with their conical shape, are very sculptural. Each stalk is a composite of flowers, each flower is like a facet of a cut gemstone catching the light. Laden with flowers, the lilac often bows its head.

After sketching in the placement and proportions with charcoal directly on the gessoed panel, I began the painting using large bristle brushes, blocking in the major value and color relationships. The crucial colors were Alizarin Crimson, Dioxazine Purple, Cobalt Blue, Cobalt Violet Light, Permanent Rose, Cadmium Orange and Sap Green. For the most part, I worked wet-into-wet using poppy oil very sparingly as a medium. To create the individual petals, I used no. 3 flat sables and no. 2/0 round sables.

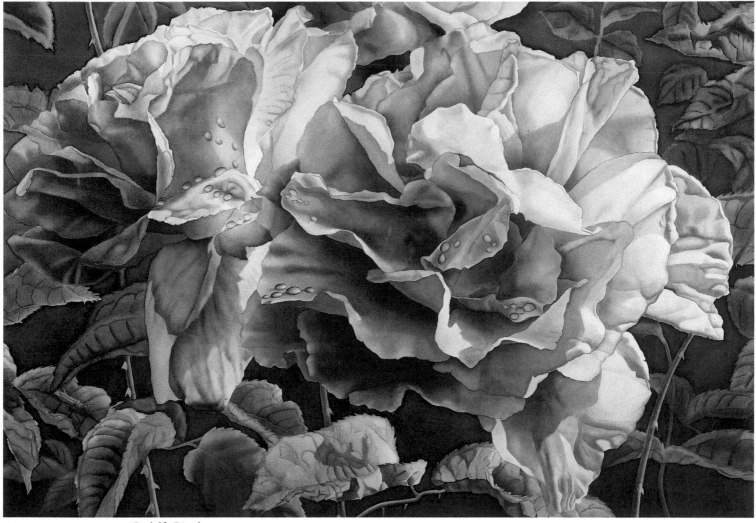

"FLORAL LANDSCAPE" Rodolfo Rivademar
Transparent watercolor on Arches 140-lb. cold-press paper
30" x 42" (76cm x 107cm)

Rodolfo Rivademar

When I paint I seek the universal. Flowers are universal because they speak to everyone. I also paint flowers because they reunite us with nature. I believe we have lost contact with nature, and that brings us trouble.

Flowers are like jewels, jewels that are alive. That's why I paint them in their habitat rather than dead in a vase. Light permeates these flowers with life. The overall feeling of this light is warm, relaxing, nurturing. Here I added a touch of mystery and punch by sinking them into a chiaroscuro atmosphere.

This floral landscape is the result of extensive research, observation, sketching, and tonal and color studies. My color palette is restricted to a warm and cool of each primary color plus Yellow Ochre, Burnt Sienna and Burnt Umber.

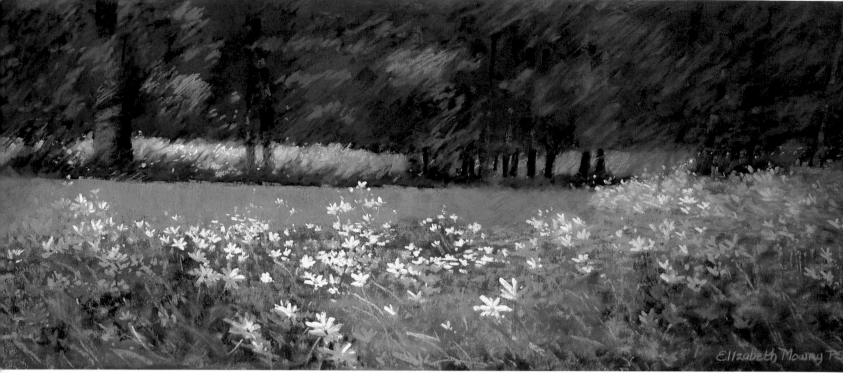

"DAISY MEDLEY" Elizabeth Mowry
Pastel on sanded paper, 11" x 25" (28cm x 64cm)

Elizabeth Mowry

Coming upon this scene, I was impressed by the obvious sensitivity
of the person who had mowed part of the field and spared the thick
and graceful mass of common ox-eye daisies. I felt an immediate con-
nection to the subject matter, which is always important to my work.
I designed a simple composition in which the darker areas of the
painting form the contrasting backdrop for the focal point, which is
the small, off-centered area of light on the daisies.

Viewers often comment on a quiet spirituality in my paintings,
but I do not consciously work toward that end. My work is not
meant to convey powerful messages, but rather to evoke feelings that
lie within the viewer who has made a similar connection with the
same subject matter.

"Daisy Medley" was painted on sanded pastel paper with soft
pastels. A limited palette of primarily blues, purples, warm and cool
greens, and small amounts of ochre and white keep color in reserve,
and the focus directed to the higher-key center of interest. Shadowed
areas do not have to be uninteresting or dull. Just put different-hue,
but same-value color into them. Here I used dark purples and blues
in the trees and lighter value blues and purples in the shaded areas of
the flowers.

Rose Ann Day ✒

Searching for subject matter to paint has never been a concern for
me—the possibilities are endless! Sometimes I am frantic because I
have so many ideas. At these times I need to become introspective, to
focus on a single idea and find peace in a simple setting.

The simplicity of this composition was strengthened by its rich-
ness of color and its deep darks of Alizarin Crimson and Ultramarine
Blue. Vibrant red highlights of Cadmium Scarlet and Cadmium
Orange add the finishing details.

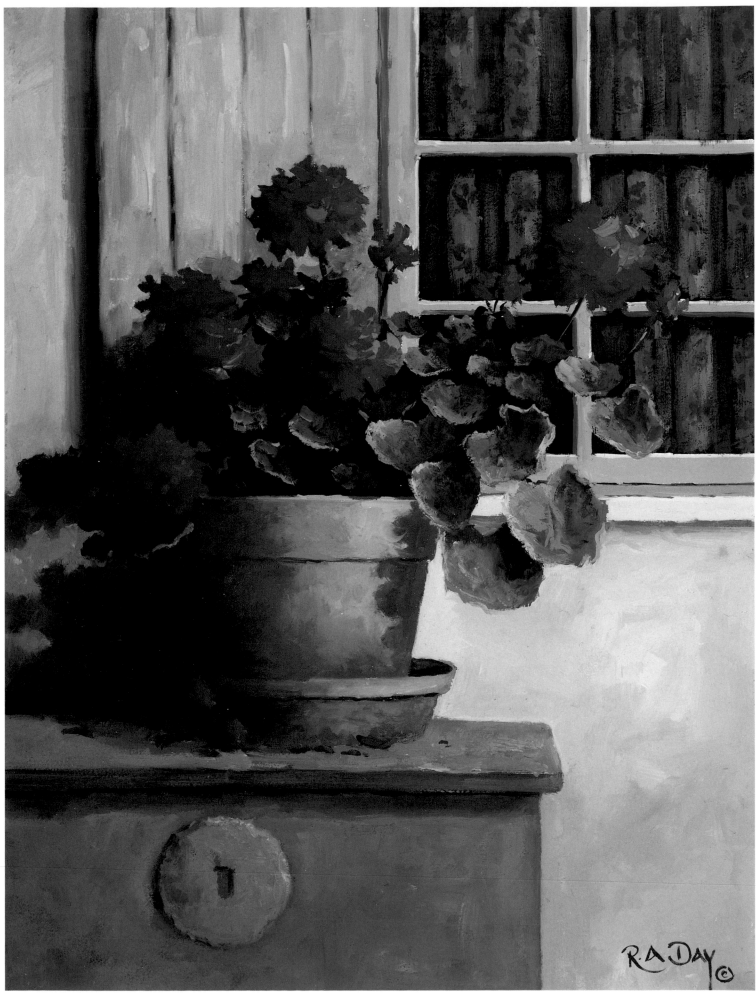

"QUIET PLACE" Rose Ann Day
Oil on Masonite panel, 12" x 9" (30cm x 23cm)

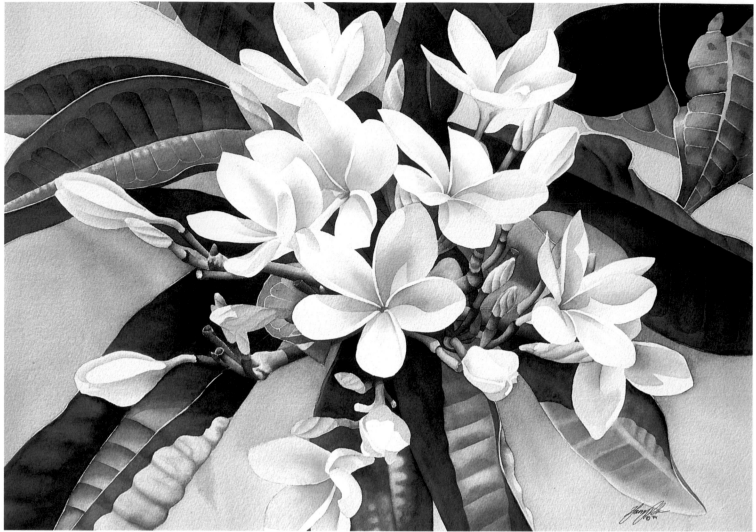

"PLUMERIAS #5" Garry Palm
Watercolor on Arches 300-lb. paper, 18" x 24" (46cm x 61cm)

Garry Palm

Living in Hawaii, I find it impossible not to be inspired by all the tropical flowers that constantly surround me. I love to seek out flowers in their natural settings. Any tropical flower can be a subject for me, but before I paint my mind has to say, "Wow, this flower is better than the rest."

One very bright, sunny day (like most days in Hawaii) I was walking through a large group of plumeria trees. When I saw this grouping of flowers I knew immediately it was special. Dark green leaves flared out from the middle of a perfect bunch of white and yellow plumeria blossoms, all casting shadows across each other.

To get the detail I like, I have to start with a very detailed pencil drawing. Putting down the lightest yellows first, I work layer by layer, building darks slowly. I do not usually use masking fluid: I find it easier to control the edges without it. One of my favorite colors is Indigo. With it I can achieve many of my extreme darks and shadows that make the flowers jump off the page.

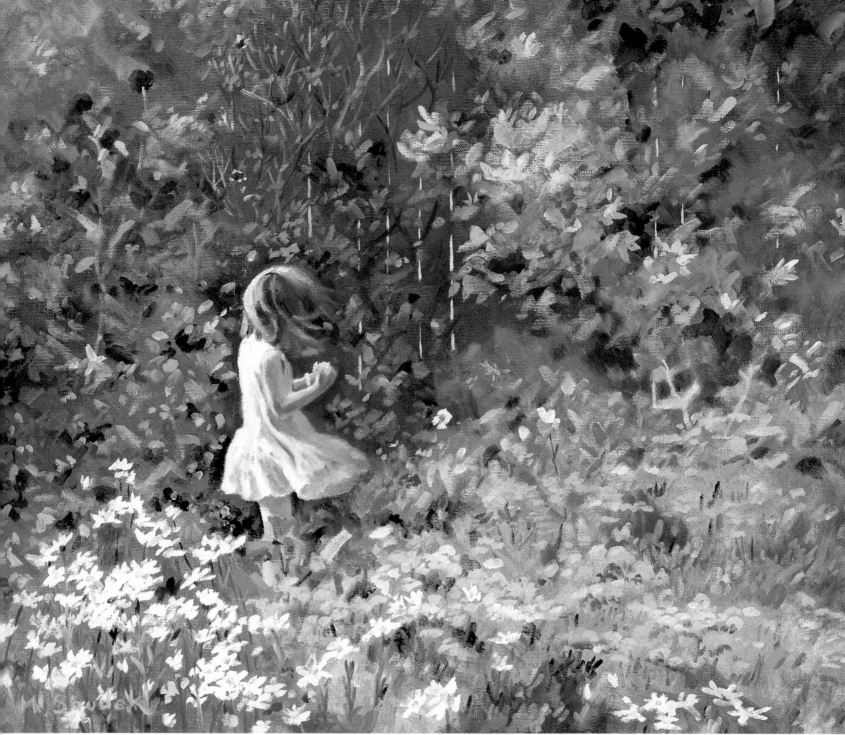

"In Grandmother's Garden" Martha Saudek
Oil on canvas, 18" x 24" (46cm x 61cm)

Martha Saudek

This is a scene in a friend's garden. She had photographed her grand-daughter in a quiet moment, contemplating a daisy she had picked. A gentle breeze has blown her hair and skirt and the child seems rapt in thought at the intricacies of a simple daisy.

I wanted the painting to speak of spring, youth and the wonder of life, so I planned the composition with fairly light values to convey sunlight, warmth and happiness. I kept the flower and foliage shapes simple, so that the contrast of action and stillness in the figure of the child becomes the focal point of the painting.

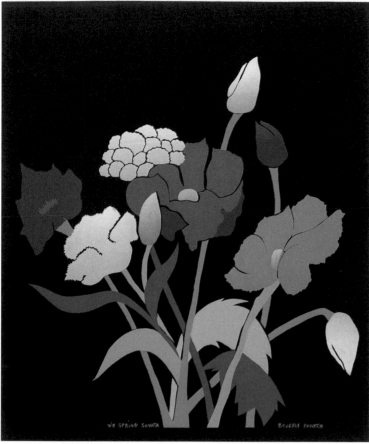

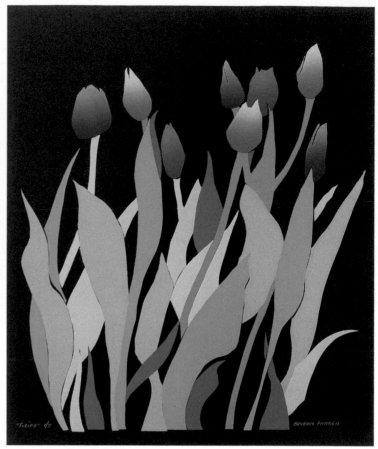

"SPRING SONATA" Beverly Panken
Silkscreen on Arches black, 100 percent rag, acid-free paper
22" x 15" (56cm x 38cm)

"TULIPS" Beverly Panken
Silkscreen on Arches black, 100 percent rag, acid-free paper
22" x 15" (56cm x 38cm)

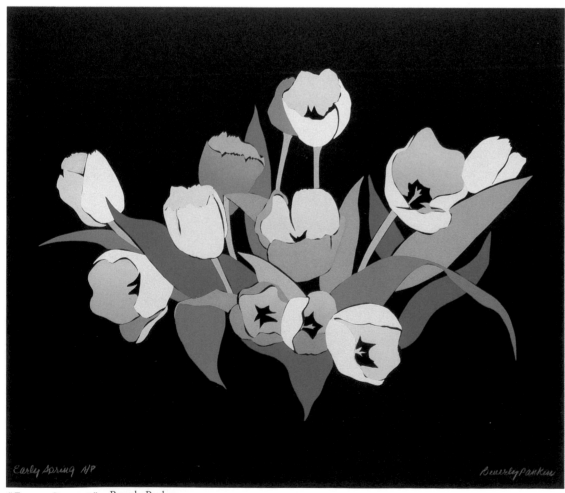

"EARLY SPRING" Beverly Panken
Silkscreen on Arches black, 100 percent rag, acid-free paper
20" x 26" (51cm x 66cm)

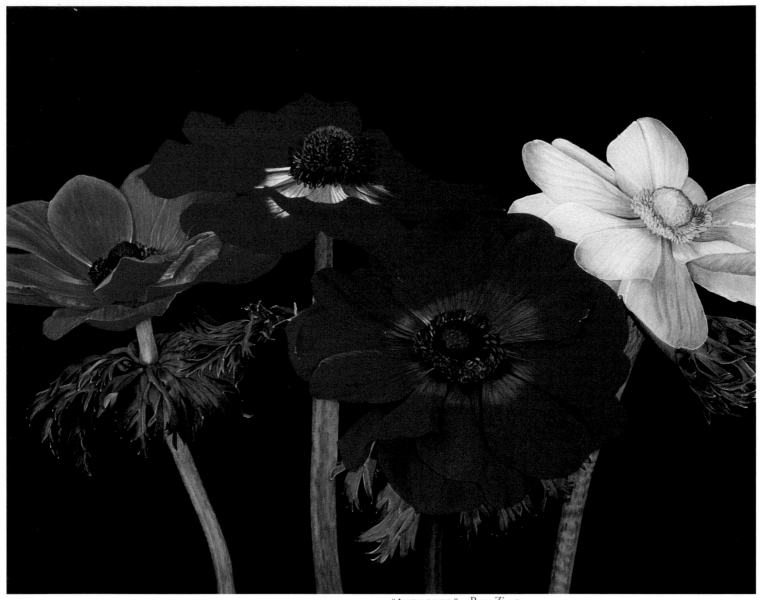

"ANEMONES" Rose Zivot
Pastel on Ersta Starcke sanded paper, 21" x 26" (53cm x 66cm)

Beverly Panken

I remember seeing these tulips set against a white wall, almost as in silhouette. It was a transcendent moment because from then on I began to see flowers differently. I looked only for purity of line, simplicity of form and intensity of color. This was the breakthrough that inspired my first silkscreen flower print. The black background creates an air of mystery around the flowers, as if they had just popped up out of the soil.

The silkscreen process works perfectly to communicate my vision because it is essentially a stencil technique. Its limitations enable me to stay focused on the most important elements: shape, line and color. Printing on black intensifies every color that's put down. Careful stencil design and cutting allows the black paper to be exposed, giving the appearance of a drawn line, accenting and separating shapes.

The silkscreen inks used were Naz-Dar Medium Yellow, Chrome Yellow, Carmine Red, Cerise, Emerald Green, Dark Green and white. To achieve opacity and matte finish, I add white to most colors along with a medium for proper consistency.

Rose Zivot

This work is about brilliant color against bold color, light, texture and larger than life flowers. I chose anemones because of their distinct flower shapes, vivid colors and fine details.

Flowers are an ideal subject for pastels. The luscious colors of pastels identify very well with the rich colors of the flowers. Pastels are a powerful medium, open to a diversity of technique.

To capture fine details with precision and control, I use Brunzeel, Conté and Carb-Othello pastel pencils. I began this painting by covering the background with a layer of green and then a heavier layer of black. By blending the two together, I achieved a warm and dramatic setting for the brilliant anemones. I worked each flower petal by petal, building layers of color, blending and feathering until I created a velvety, lustrous look. In the final stages, I added sparkle to the painting with highlights of white, pale blue and pale yellow.

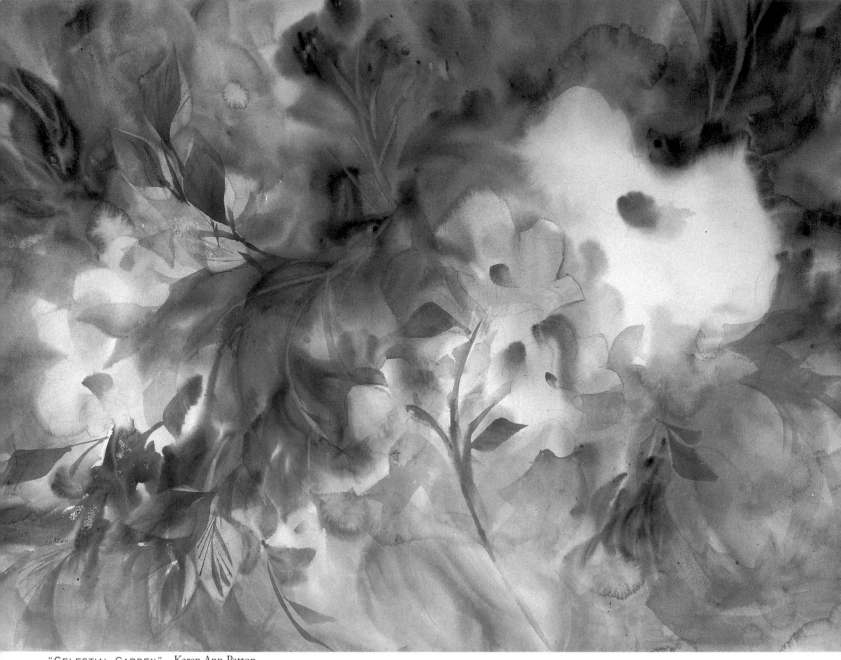

"CELESTIAL GARDEN" Karen Ann Patton
Watercolor on Arches 155-lb. cold-press paper
30" x 40" (76cm x 102cm)

Karen Ann Patton

A visit to Old Westbury Gardens on Long Island always inspires me to begin a floral painting. I enjoy wet-in-wet watercolor because it lends itself to soft shapes and interesting edges, especially for flowers. Accidents frequently happen and it is up to the artist to take advantage of them. Although "Celestial Garden" began abstractly, floral shapes soon emerged. This painting was one of those spontaneous, wet-in-wet watercolors that seemed to paint itself.

I began by thoroughly wetting the paper and applying Winsor & Newton watercolors directly from the tube, allowing them to blend and flow in a rhythmic pattern while leaving some areas of untouched white paper. Once I was pleased with the interaction of the colors and shapes, I allowed the painting to dry. Petals, leaves and stems were then penciled in the white area and the background was painted around them.

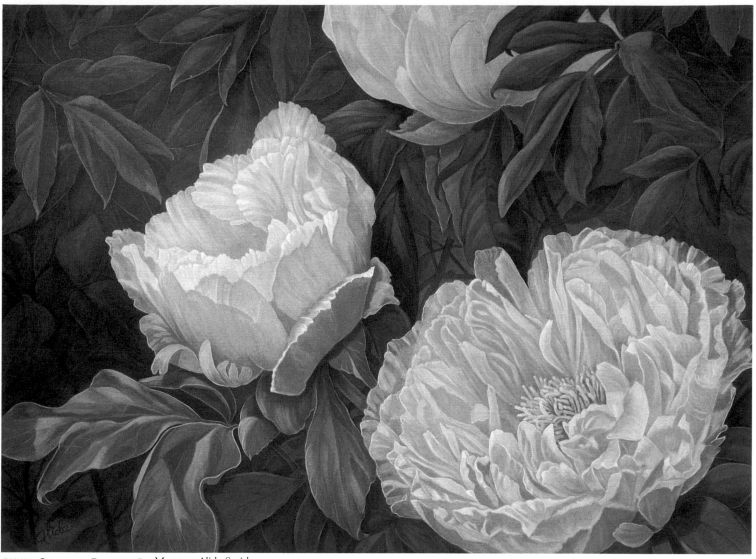

"PINK CHIFFON PEONIES" Margaret Alida Smith
Oil on Belgian portrait linen, 30" x 40" (76cm x 102cm)

Margaret Alida Smith

I grew up in Montana where the winters are cold; it was a glorious sight in the spring to see the peonies come into bloom. I loved the challenge of duplicating their tissuey petals on canvas.

My technique, gleaned from the Old Masters, is a process of first laying a good foundation. I did a detailed drawing, then went over the whole canvas with Alizarin Crimson and wiped it down, leaving only a tint (my undercoat). The next step was to paint the flowers and foliage in various tones of gray, a tonal painting. I mixed Burnt Sienna and Cobalt Blue together for a base, which, when added to white, becomes the beautiful "optical grays" that shine through all the subsequent colored glazes, providing softness, depth and unity.

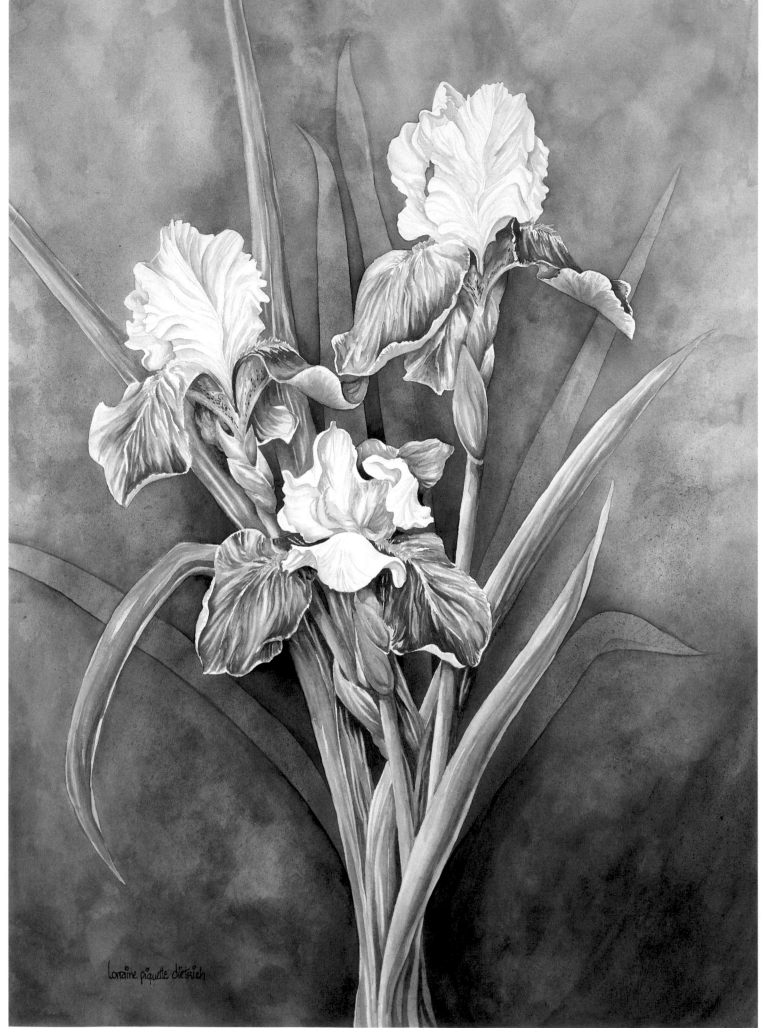

"ST. JOSEPH'S IRISES" Lorraine Piquette Dietrich
Transparent watercolor on Winsor & Newton 260-lb. cold-press paper, 30" x 22" (76cm x 56cm)

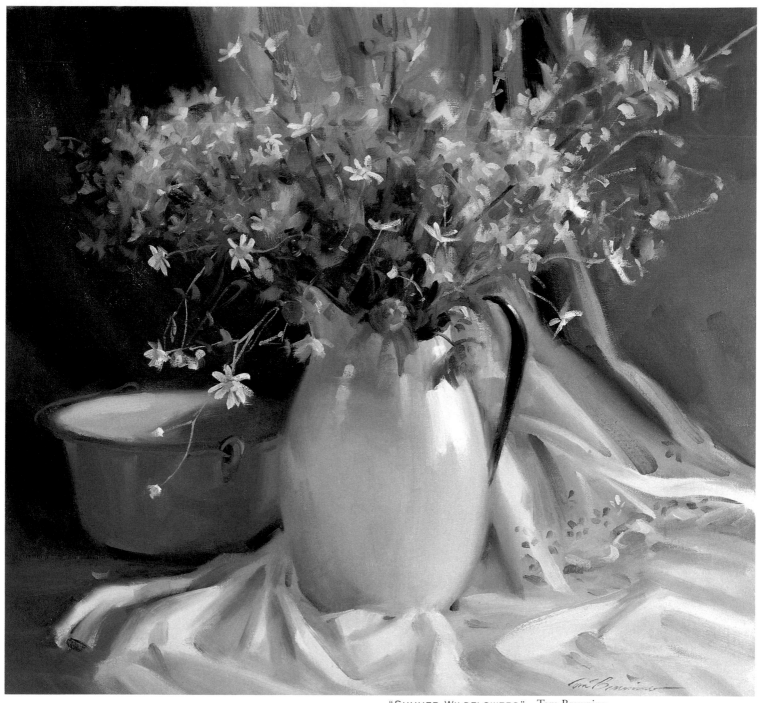

"SUMMER WILDFLOWERS" Tom Browning
Oil on canvas, 22" x 24" (56cm x 61cm)

Lorraine Piquette Dietrich 🍂

For weeks, I looked in vain for Germanica Irises. One day I passed by a statue of St. Joseph standing among hundreds of sun-drenched irises. Impressed by such a living celebration, I couldn't resist taking a few of the irises home to paint. Complementary contrasts and harmonies of colors were chosen to add glowing energy and a serene mood. Afterwards, I felt guilty about having taken those flowers from under the statue, so I titled the work, "St. Joseph's Irises."

If carefully planned, the painting process itself becomes rewarding. For this painting I used wet-on-wet, loose painting and spattering over the frisket-protected foreground; negative painting for the middleground. Creases of the petals were done on dry paper, working with two brushes, one with color, the other one with clear water to melt edges. My colors were many hues of permanent blue, yellow, violet and green.

Tom Browning

Every day on the way to my studio I'd pass these wildflowers growing along the roadside. The beautiful combination of colors kept grabbing my attention until I finally had to put all current projects aside to paint them. I set them by the window next to my easel, where the light that fell on them seemed cool and soft, a nice complement to their bright colors.

After toning the canvas with a warm mixture of Burnt Sienna and Yellow Ochre, I started with the general mass of flowers. With those petals that were catching the light, a nice contrast of hard edges on a soft background appeared. By concentrating more on the overall softness and edges rather than details, I found this picture practically painting itself.

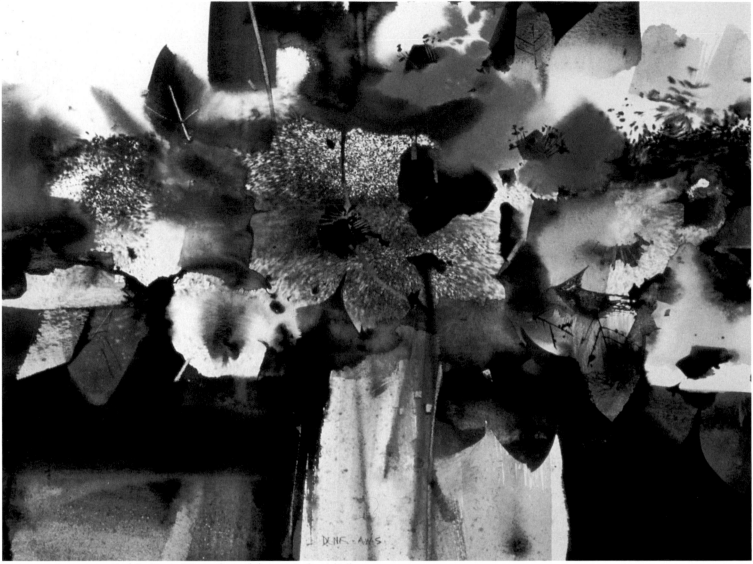

"WHITE POPPIES" Paul St. Denis, Watercolor and dyes on Arches 140-lb. cold-press paper, 22" x 30" (56cm x 76cm)

Paul St. Denis

The oriental ideal of simplicity of design and economy of technique appeals to my watercolor sensibility. The white poppy, elegant and delicate, is my subject.

My approach to painting flowers is one of a "negative outlook": I usually form the flower and leaf shapes by painting the negative areas around these elements. The master Zen painter, Ike-no-Taiga, said, "The unpainted area is the most difficult part."

Although I am not trained in sumi-e painting, I can appreciate the decisive strokes used by the masters of this style. I used medium- and fine-line sumi-e brushes made by Yasutomo. They are comparable to fine quality Kolinsky sables in body and pointing properties but much less expensive.

I began by sprinkling brown powdered watercolor dye onto the surface of the paper, which had been wet with water. A watercolor mixture of Yellow Ochre, Burnt Sienna and Burnt Umber was applied wet-in-wet. Next, a wash of Indigo and Sepia was painted with backhand strokes using the medium sumi-e brush, which quickly revealed the flower and leaf shapes. The fine-line brush added detail in the poppy centers, bringing the flower arrangement into sharp focus. A flat paint scraper reestablished some of the leaf shapes and veins and stems in sgraffito.

Kevin Brunner ✍

Along a roadside I came across hundreds of lilies against a backdrop of magnificent evergreens. Perhaps the person planting the lilies years ago never expected the evergreens to one day overshadow them. Yet they had survived, straining to capture the light. They were like soldiers at attention, all turned in one direction. I decided my subject should be the beauty and strength of one such soldier. I empathized with the flower's struggle to live beneath the outstretched arms of the evergreens: The challenge was to portray the struggle.

A splattering approach best conveyed this fight for survival and gave energy to the painting. The flower wears the scars of evergreen hues while the background is flecked with orange and gold, portraying the struggle of lily against evergreen.

I usually use the floor as my easel. This gives me maneuverability, and the level surface prevents unwanted runs. I begin with a pencil sketch, then paint very thickly, avoiding areas I want to remain light or lifting out unwanted paint with a wet brush and dry paper towel. Here, I've incorporated a splattering technique to add energy. Colors include Cadmium Red, Yellow and Orange Pale Hues, Yellow Ochre, Prussian Blue and Viridian Hue.

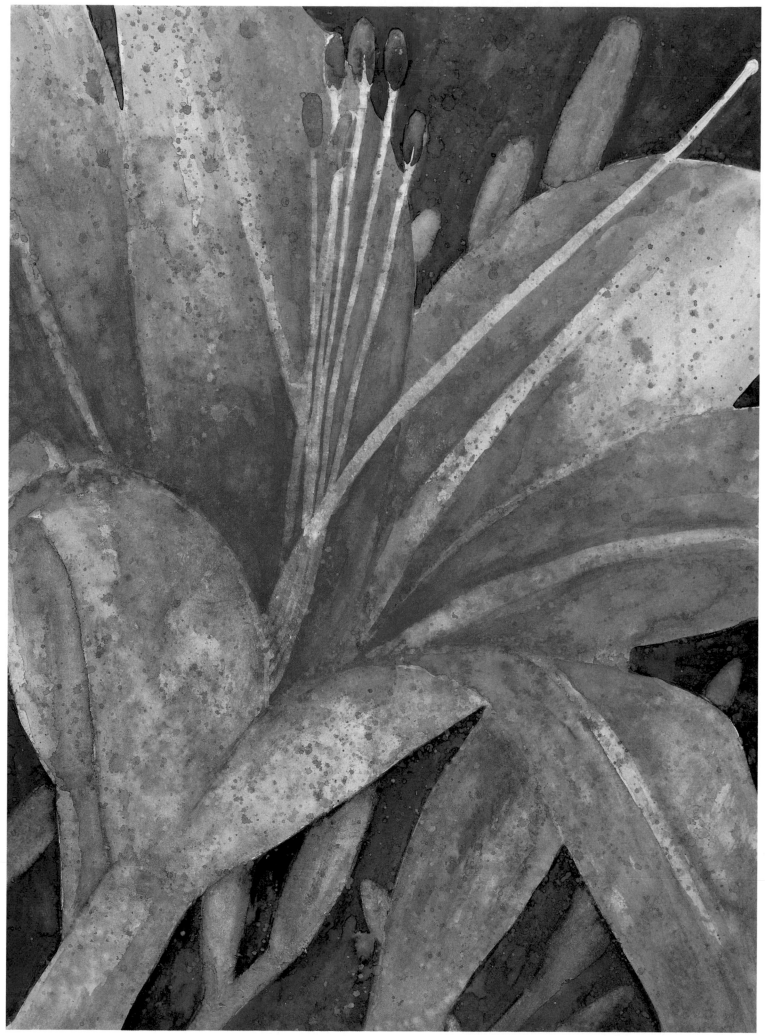

"LILY" Kevin Brunner, Watercolor on paper, 22" x 30" (56cm x 76cm)

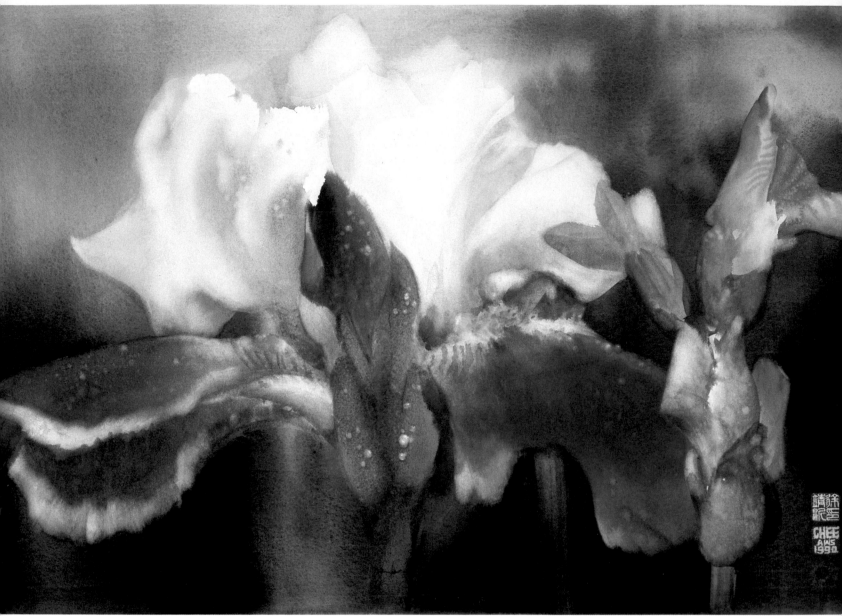

"IRIS 90 NO. I" Cheng-Khee Chee
Transparent watercolor on Arches 260-lb. cold-press paper
25" x 41" (64cm x 104cm)

Cheng-Khee Chee

When my wife and I purchased our first home, the previous owner
had left us a beautiful garden with a great variety of irises. With daily
observation and study during each blooming season, I developed a
strong sense of awe, wonder and attachment.

Although there are many different kinds of irises, my favorite one
is presented in this painting. I like its distinct form, shape and white-
and-purple bicolor contrast.

For this painting I soaked the paper until it was thoroughly satu-
rated, then placed it on the painting board to let it settle until the
shine disappeared. I premixed tube watercolors in dishes for easy
application to the paper. I roughly outlined the shapes of flowers right
on the wet surface, and started painting the background with rich
darks around shapes.

The saturated wet paper allows easy lifting and gives a great range
of edges (diffused, soft, hard, broken) depending on the wetness of
the paper.

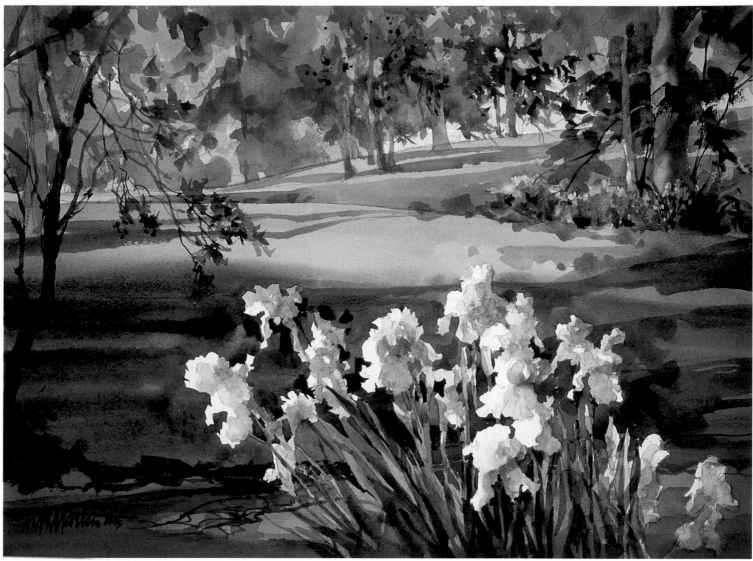

"ECSTASY" Margaret M. Martin
Transparent watercolor on Arches 140-lb. cold-press paper
22" x 30" (56cm x 76cm)

Margaret M. Martin

This natural terrain is a place for reflection and contemplation. I feel the peaceful mood, smell the aromas of freshly mowed grass and flowers, and listen to the sounds of birds.

This beautiful terrain created a rich background stage for a sparkling crowd of white iris blooms and their sword-like foliage. I was attracted to the mass of blooms as opposed to the individual. I liked their stately character and unique forms.

I made many sketchbook value compositions on location and focused on big areas before small areas, value before color. I attacked my paper with a well-described pencil drawing. The grass area was painted first with my lightest green, painting around the white iris shapes. Darker green values were layered next. Winsor Green was mixed with earth colors for warmth, blue colors for coolness. Flower shadows were painted last.

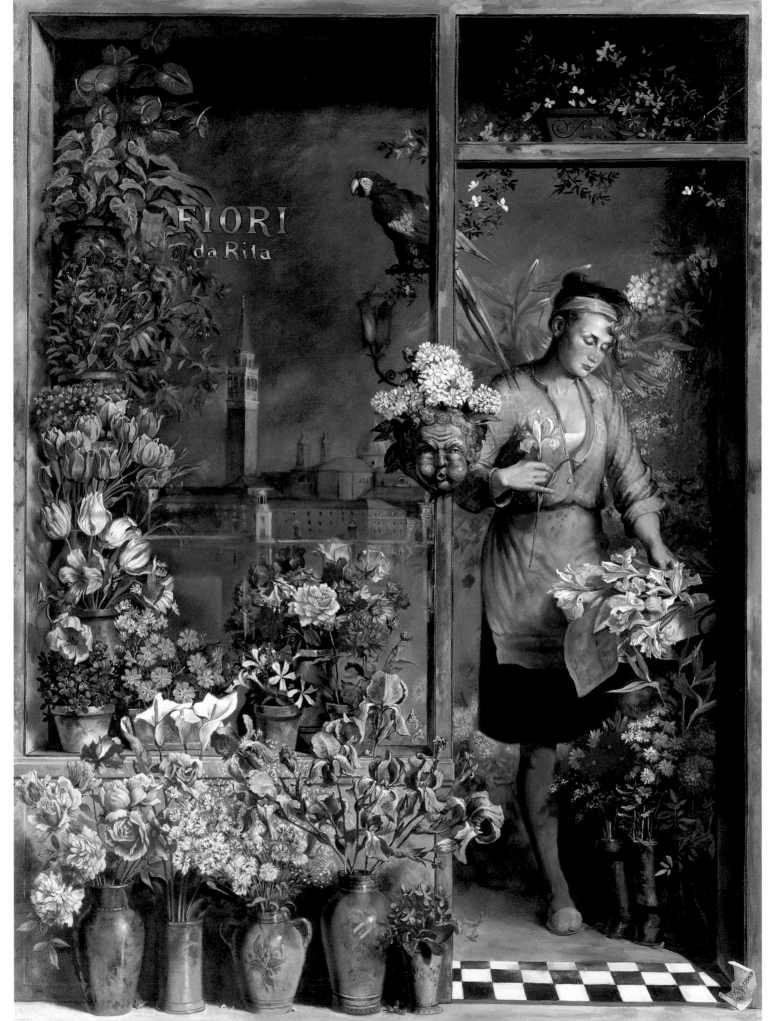

"FIORI DA RITA" Joseph Sheppard, Oil on canvas, 84" x 60" (213cm x 152cm)

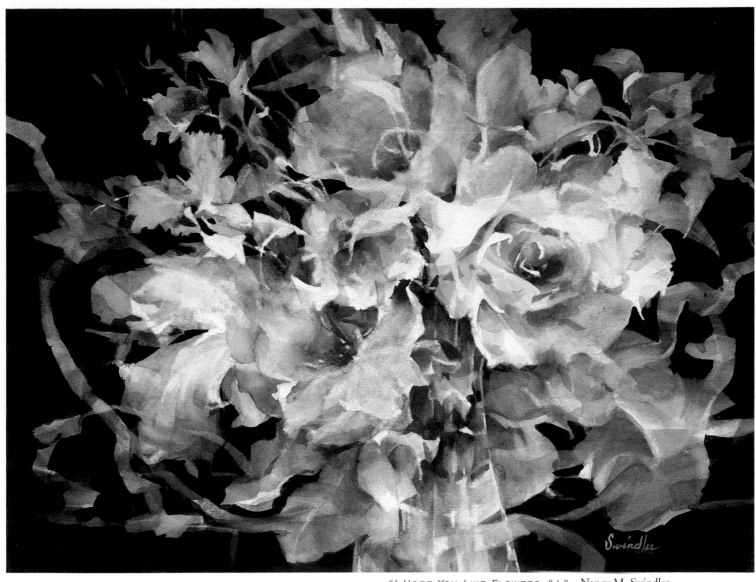

"I HOPE YOU LIKE FLOWERS #1" Nancy M. Swindler
Transparent watercolor and gouache on Arches 140-lb. paper
22" x 30" (56cm x 76cm)

Nancy M. Swindler

I have the most wonderful source for floral painting inspiration in my own back yard, since my husband is an accomplished gardener and we always have an abundance and variety of colorful blooms. I used to draw and paint my flowers in great detail, and I find that experience has served me well, since my compositions come from my memory and imagination.

The magnificent shapes and glorious colors of flowers are irresistible. Used with a very dark opaque background, the painting has the emotional impact I feel when I see them blooming.

Starting with a loose drawing, I wet all areas but the shapes I want to remain white. I lay in free-flowing color delineating blossoms and foliage. I then build with colors and values, saving my whites. I use Permanent Rose, Permanent Magenta, Cobalt Blue, Winsor Blue, Alizarin Crimson and Cadmium Orange for the flowers; and I mix my greens. For the background I mix Indigo Blue and black gouache, then paint around my floral shapes.

Joseph Sheppard ⁓

For years I had an idea to do a life size painting of the facade of a flower shop. All throughout Italy, whenever I saw a flower shop, I would take photos.

Finally, when I started this painting, I made up my own shop and composition. I arranged the architectural shapes first and then filled in the spaces.

To put the interior flowers "behind" the glass window, I glazed the entire window area over the flowers with a transparent mixture of green and black. The reflection of Venice was painted on afterwards when the glaze was dry.

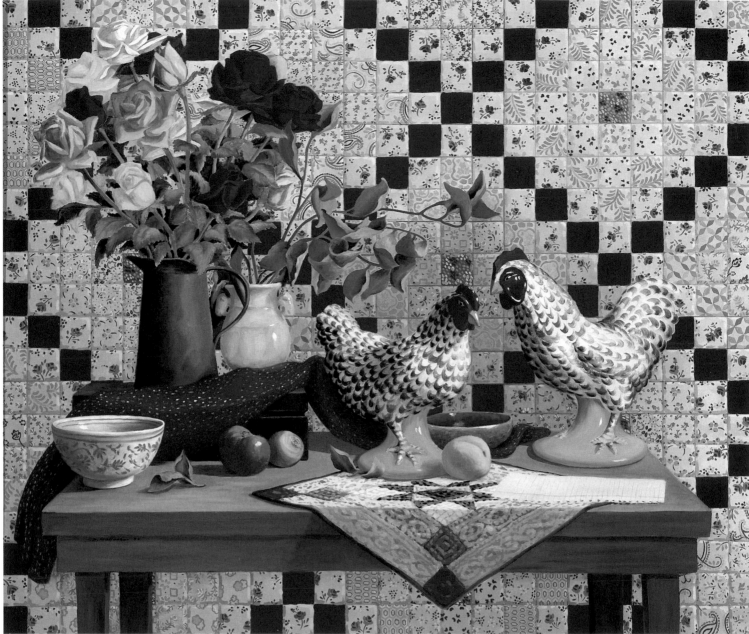

"THE UNWRITTEN LETTER" Susan Gallacher
Oil on oil-primed linen canvas, 40" x 48" (102cm x 122cm)

Susan Gallacher

Art for me is a powerful means of expressing an emotion held deep within. In this painting, "The Unwritten Letter," the blank paper on the table symbolizes the unspoken and unwritten words of love and respect I never expressed to my Grandma and Grandpa Parkin and my brain-damaged Aunt Leone during their lifetimes.

My grandmother is represented by flowers she had in her yard and by the quilt in the background. The quilt blocks are from old dresses of my Aunt Leone's, and the produce and the chickens are suggestive of my grandfather who was a farmer. My chagrin for not verbally disclosing myself to them while they lived led me to paint this memorial expression.

The painting took four months to complete. I prefer working wet-into-wet with oils, but since large paintings take so much time, I painted the entire piece in two values first. With this method, the drawing, shapes, hues and values are established early and can easily be changed if needed. I then worked back over all areas, adding more detail and concentrating on the centers of interest.

Vicki McMurry ✒

When I saw this red geranium on a windowsill at a bed-and-breakfast in Maine, I was entranced. I was surrounded by my family at the table. The smells of breakfast were enticing. All was well with the world, and I wanted to freeze this moment for posterity.

I feel oil paints enhance the richness of colors found in flowers. Although the color red is often controversial, the warmth generated by red makes me feel secure.

On a red-tinted canvas, I establish my dark patterns first, alternating warm and cool colors to add vibrancy. I concentrate on shapes and negative spaces instead of details, using random and energetic brushstrokes to represent my zeal for life.

The final stage is devoted to adding "sparkle." I dab vibrating colors at random, especially in the green leaves.

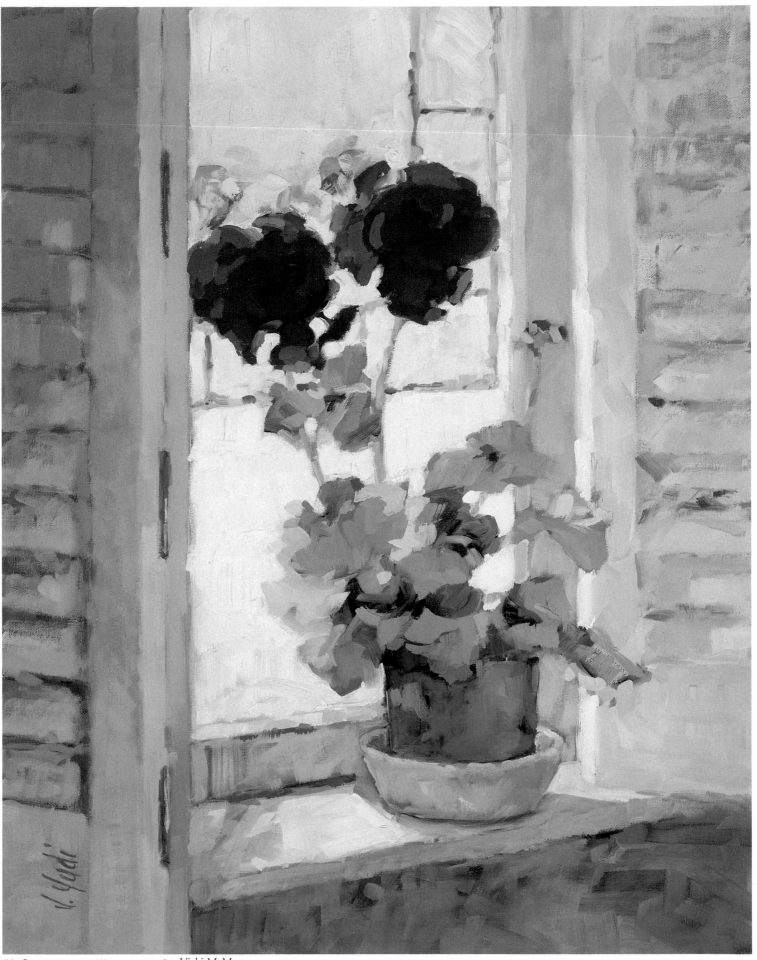

"A SENTIMENTAL WINDOWSILL" Vicki McMurry
Oil on stretched canvas, 20" x 16" (51cm x 41cm)

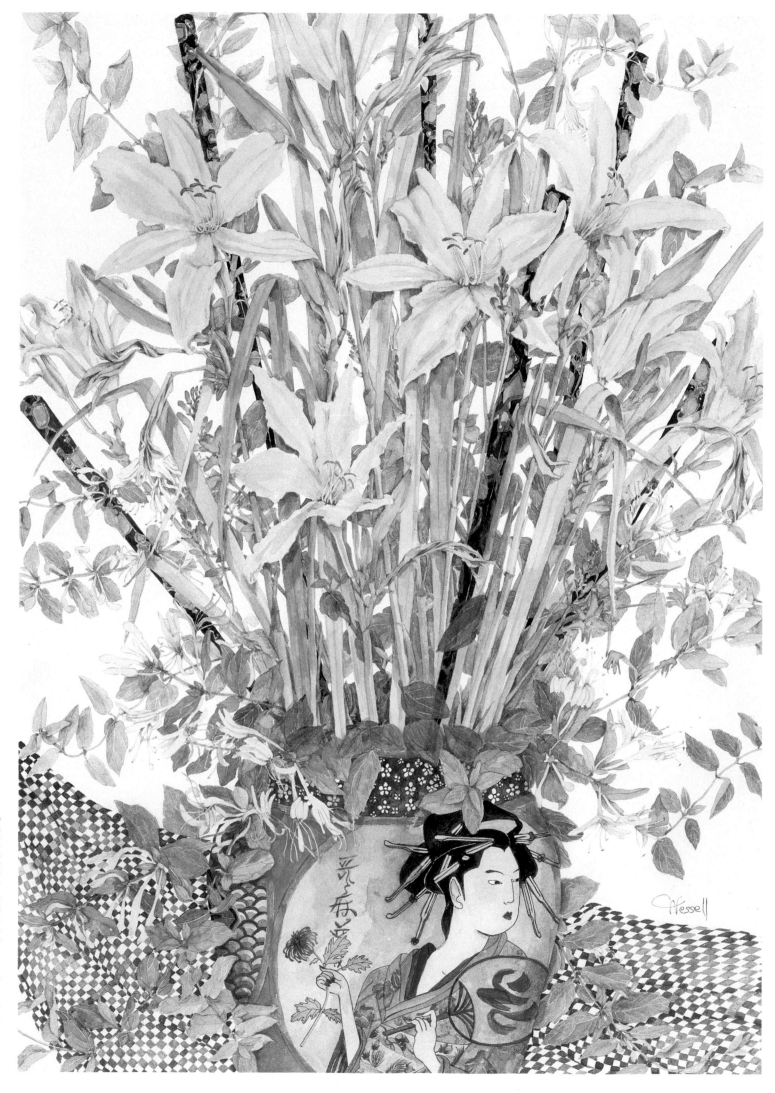

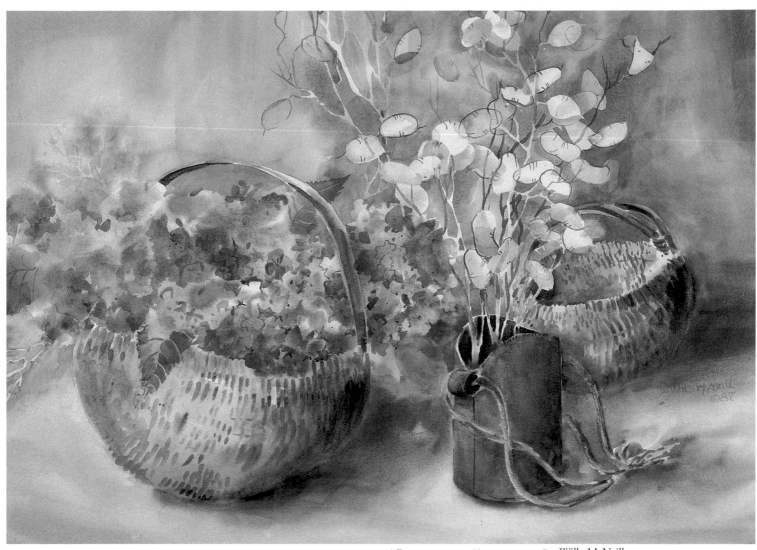

"BASKETS AND HYDRANGEAS" Willa McNeill
Watercolor on paper, 22" x 30" (56cm x 76cm)

Willa McNeill

In general I choose not to paint prearranged still lifes but often opt for "found stills." A chance gathering of favorite items begs to be captured on paper. In this particular collection, the hydrangeas bring back childhood memories of summer days at Grandmother's. The larger basket is a treasure made for me by my sister. Assembled together, these items were irresistible.

The challenges of this painting were twofold. The first was in the choice of reflective blues and earth colors which, in combination, are well known mud-makers. Careful and quick application of washes ensured luminosity even in the darkest values. The second challenge was in presenting the illusion of great detail without overworking the painting. While the hydrangeas, lunaria, and baskets may appear carefully embellished with details, closer inspection reveals only the suggestion of detail created with a combination of positive and negative brushstrokes.

June Wessell 🌿

I am primarily interested in shapes, and in fitting them together in harmonious patterns of line and light. The luminosity and clarity of watercolor paint sparkling against white paper reproduces the grace and tranquillity of flowers. The oriental objects that accompany them in my paintings are a reminder of the past, namely the oriental art in my childhood home that influenced my perception of beauty.

I use many small washes and layers of paint to give interest to leaf areas and to add form and depth to flowers. I love greens played one against the other, my favorite being Cobalt Green. I find that floating the paint on the stems gives an interesting three-dimensional look.

"CHOPSTICKS" June Wessell
Watercolor on paper, 24" x 17" (61cm x 43cm)

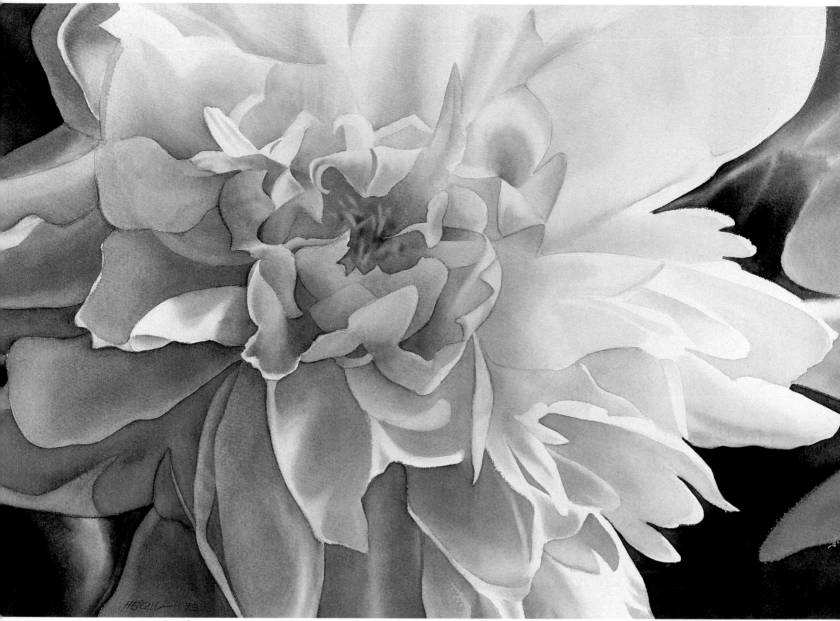

"PEONY TRANCE II" David Herzig
Transparent watercolor on Arches 140-lb. paper, 22" x 30" (56cm x 76cm)

David Herzig

Who can resist the entrancing allure of a single blossom? An object ever so small and intricate is a subject of vast exploration for me. "Peony Trance II" is part of a series of paintings in which I attempt to draw the viewer through the gateway of the picture plane and into my own fascination and wonder of these created beauties. After all, this is not "just another flower painting." This is a world we enter, a landscape if you will, a place to be.

I chose a close-up, frontal viewpoint for "Peony Trance II" to entice the viewer to walk into the painting. The sense of attraction is heightened by the use of warm colors. Multiple layers of transparent colors such as Cadmium Yellow, Alizarin Crimson and Ultramarine Blue are applied only after the preceding wash has dried. By pushing and pulling values I sculpt the forms of the petals as though they were a foreshortened hand reaching out to the viewer.

Steven J. Levin ✑

I think the challenge of flower painting lies in capturing the playfulness of nature and its variety of form and arrangement. Peonies are one of the most beautiful flowers to paint because they have this quality of fullness and exuberance. They are strikingly beautiful and endlessly subtle. That's what floral painting is all about—this contrast of vibrancy and exuberance with delicacy and subtlety.

I painted this entirely with round bristle brushes on Claessens fine canvas, an excellent surface for receiving the initial layer of paint. I was able to get a very good lay-in of the subject. As the painting came nearer to finish I used repeated glazes of color to subdue the contrasts of tone, which were always more subtle in reality than I had painted them.

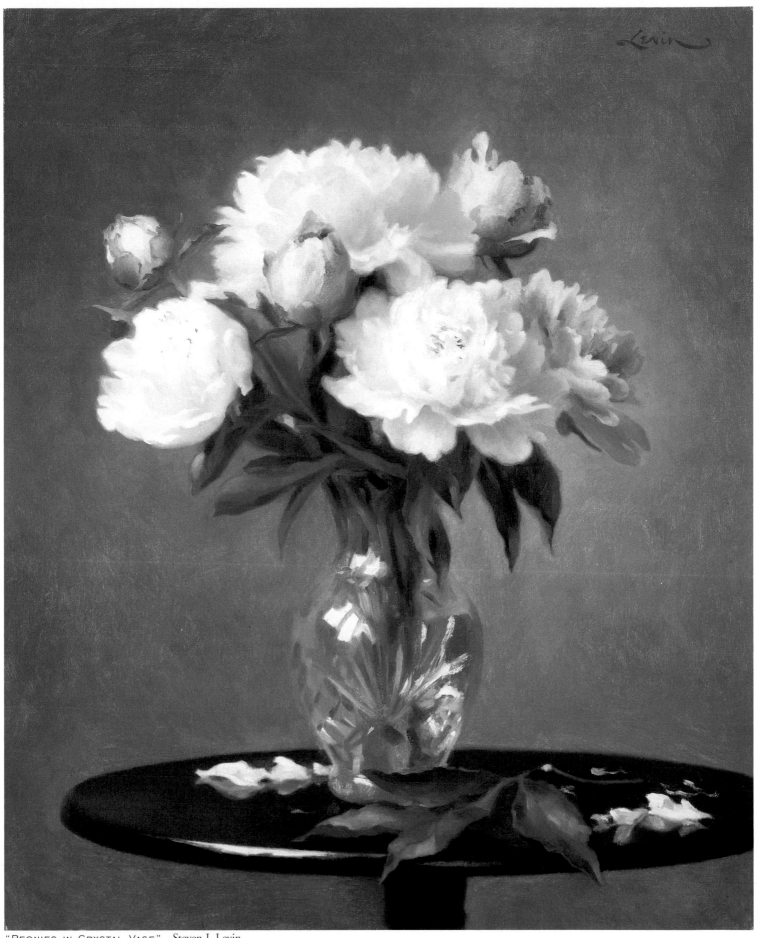

"PEONIES IN CRYSTAL VASE" Steven J. Levin
Oil on canvas, 23" x 19" (58cm x 48cm)

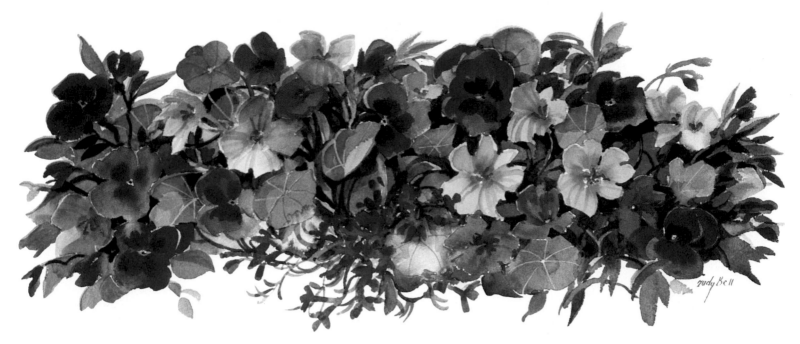

"BUDDIES" Judy Bell
Watercolor on Arches 300-lb. cold-press paper, 15" x 22" (38cm x 56cm)

Judy Bell

Buddies, just kinda hanging out together. I paint quickly on water-saturated paper lying flat. No time for details. If it dries before I've finished, the effect is lost. Equally intense color mixtures butting up to one another create a beautiful fuzzy edge with a minimum of bleed. After it's completely dry, I'll go back in to carve out a focal point with my brush, giving it a hard edge to prevent the viewer from thinking he needs eyeglasses.

I can use up a great amount of pigment in this dramatic style. I premix large puddles of color and little water for the background to be deep enough initially. I seldom presketch on the watercolor paper itself: I like the freedom of the flow. Sometimes it creates problems I love to solve.

I began in the upper left corner with a thick mixture of Winsor & Newton Ultramarine Blue, Burnt Umber and Alizarin Crimson for a luscious dark background. Moving down and across, I switched to greens of Antwerp Blue, Burnt Sienna, Aureolin. Then on to blossoms of Permanent Rose, Alizarin, Magenta. Back to greens and background colors to finish. *Stop*, catch my breath and resist going back until it's dry.

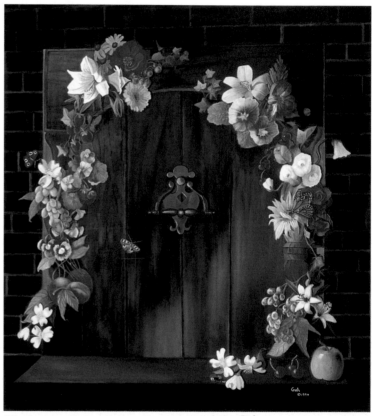

"GARLAND OF FRUIT AND FLOWERS" Anita Gish
Oil on Knickerbocker canvas, 32" x 29" (81cm x 74cm)

Anita Gish

I was inspired to paint this work after studying the Dutch floral painters. The flowers and the doorway are symbols that represent beginning an adventure in life, and the beautiful surprises that appear when you have the courage to explore the unknown.

Oils are a great medium to express the beauty of flowers. Underpainting can be done to give more depth to the petal. Glazing can easily tone a color. Highlights can be scumbled on last to give the flowers vibrancy. One of my students recommended this Knickerbocker canvas, which needs no gesso, only light sanding. I used Liquitex oils and sable brushes.

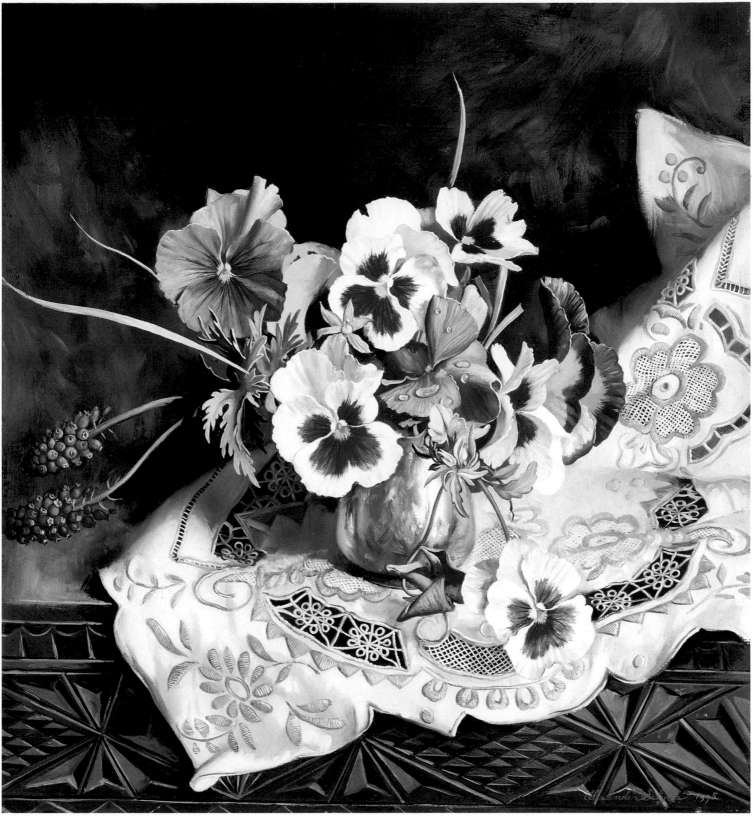

"SECRETS TO SHARE" Alexander Selytin
Oil on canvas, 12" x 11" (30cm x 28cm)

Alexander Selytin

This bouquet of precocious pansies rests on one of Grandma's linens and an antique wooden box from Russia. Representatives of the past are combined here with a cluster of spring's colorful companions. If they could speak, what would they be saying to each other?

I was trained at the Academy of Fine Arts in the former U.S.S.R. After immigrating to the U.S., I discovered my work was becoming more detailed and the colors more clear. Sometimes it takes months to paint this tightly and often I use a brush that has no more than two hairs so that I can accurately replicate fine lines.

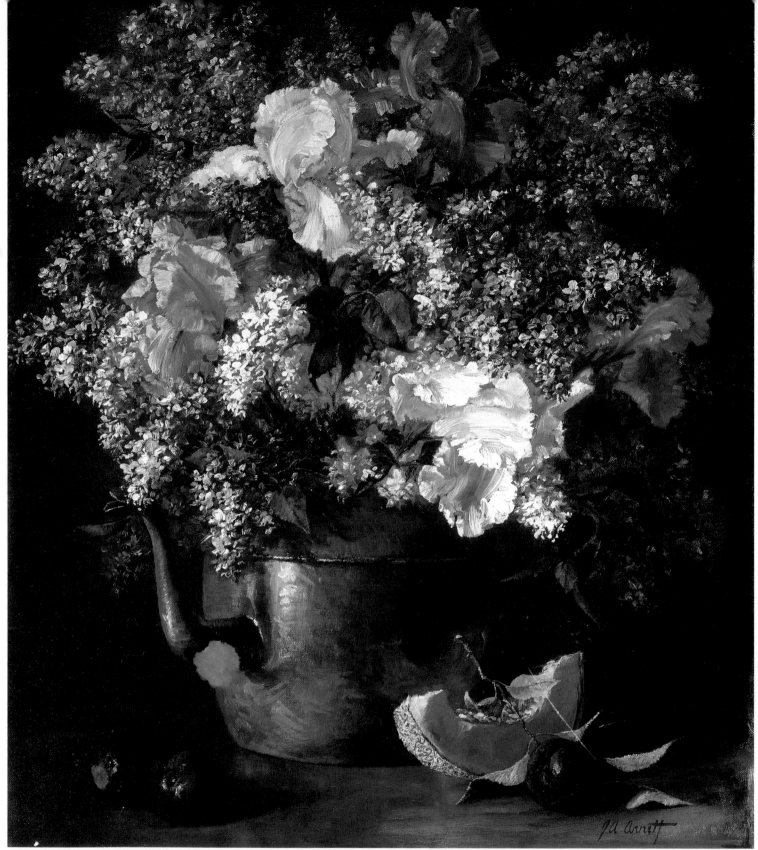

"KETTLE OF LILACS & IRISES"
Joe Anna Arnett
Oil on linen
21½" x 18½"
(55cm x 47cm)

Joe Anna Arnett

Lilacs were one of the first flowers I ever painted. My first attempts were careful and very "studied" and looked dead and uninteresting. Those canvases were scraped off. Lilacs helped me learn to paint form before detail; not to lose the form when adding the details; to use the paint in a fluid, free manner, and to let go of preconceived ideas and let the flower dictate to me. Lilacs taught me to look first for the bigger cone shapes and to float the lush impasto of the petals into those shapes.

A clerk at my art supply store loves to tease me in the spring about ordering lots of purple paint. I never use purple paint, but the joke goes on. I use combinations of blues and reds, specifically Ultramarine Blue Deep, Rose Madder Deep and sometimes even Carmine Madder Deep for the darks. For the lights, of course, I add white. The key for me is to refrain from overmixing the pigments. This adds a vibrancy I could never achieve with a flat color.

"LILAC WINE IRIS" Nancy S. Harkins
Watercolor on paper, 17" x 10" (43cm x 25cm)

"LOUISIANA IRIS" Nancy S. Harkins
Watercolor on paper, 18" x 11" (46cm x 28cm)

Nancy S. Harkins

"Lilac Wine Iris" was painted in the peaceful atmosphere of my garden. In the past, I had painted irises while sitting in the shade of a huge oak tree next to the garden. But now the tree had been cut down and I had lost my natural canopy. To my delight, thick clouds rolled in just when I needed them. The soft natural light revealed the irresistible highlights on the deep red falls of the iris. Although breezes ruffled my model and spider mites dropped onto my paper, the challenge of capturing such beauty kept me enthralled for hours.

I painted the purplish-gray highlights first, blending the value and color changes around those areas with a damp brush. These pieces were then carefully knit together with flowing strokes of Grumbacher's old formulation of Brown Madder. Darker hatching of Brown Madder and Payne's Gray brought out the satiny texture of the petals. The standards were completed with thin washes of Raw Sienna, Ultramarine Violet, and accents of New Gamboge.

In "Louisiana Iris," I sought to capture a paradox. Contrasted with the quiet simplicity of the single stalk of blossoms is the dramatic shout of velvety color and intriguing form of the blossoms themselves. The stark contrast of bright yellow signals against the violet-black petals of this iris compelled me to paint!

When I set out to paint "Louisiana Iris" I had just discovered that my favorite tube of purple was not permanent. The purples I had mixed in trying to replace it were disappointing. Finally, I discovered that Grumbacher's Payne's Gray—used first to paint the velvety highlights—made an excellent mix with Thio Violet. Variations of this mixture are used throughout each blossom. Hatching with a thicker mixture of Thio Violet and Thalo Blue finished the darkest areas.

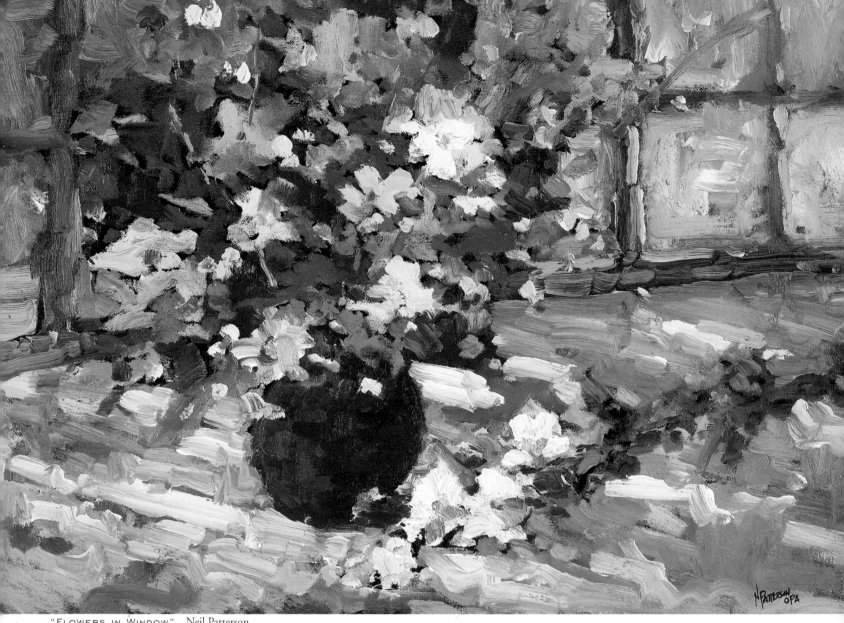

"FLOWERS IN WINDOW" Neil Patterson
Oil on canvas over board, 18" x 24" (46cm x 61cm)

Neil Patterson

Like all of my flower paintings, this one developed spontaneously. When I daubed the first splashes of Hansa Yellow Light and Titanium White on the canvas, I had no idea a window would later emerge or that I'd decide to put in a vase.

Flowers as a subject cry out for pure color. About five years ago I stopped painting tonally and started working right out of the tube. Ever since then, painting has been a far more joyful experience. I find I can achieve highlights and shadows by mixing the paint on the canvas so that certain areas sink back behind the pure colors. Oil really lends itself to being pushed around like this. Also, it has texture, so when the light hits a built-up passage it creates an impression of relief.

I begin every painting with a dark ground, then put in the lightest lights. It's like entering a room at night and turning up the dimmer switch so I can see. I always work with a bright palette: Cadmium Yellows and Reds, Manganese Violet, Cerulean Blue and Sap Green. I use flat brushes because they're springier and they hold more paint, which allows me to smudge it across the canvas in a wonderfully loose way.

Susan Adams

I like my flowers up close, alive and growing. The zinnias in my painting are not delicate hothouse blossoms, but robust beauties— hale and hardy. Their sturdy stems grow tall and bold. Their penetrating colors speak of strength, courage and power.

To capture the exuberant life force of these zinnias in my painting, I prefer rich vibrant colors to the pastels usually associated with traditional watercolors. I pay close attention to the transparent, staining and opaque characteristics of watercolor. I mix my paints carefully, and use glazes extensively.

I painted a staining undercoat on each zinnia face first and let that dry before glazing each petal separately. To glaze, I touched a no. 6 or no. 8 round sable loaded with transparent paint to the dry paper at the base of the petal. Using another brush loaded with water, I pulled the paint to the outer edges of the petal. I applied many glazes to create luminous petals. For the earthy quality of the darker flowers, I mixed two opaque colors together and allowed the suspension to dry on the paper. (Brown Madder Alizarin is one of my favorites.) To suggest shape and volume on leaves, stems and petals, I lifted color using a ½-inch angular shader. I finished with a glaze of Aureolin Yellow for a sun-kissed look.

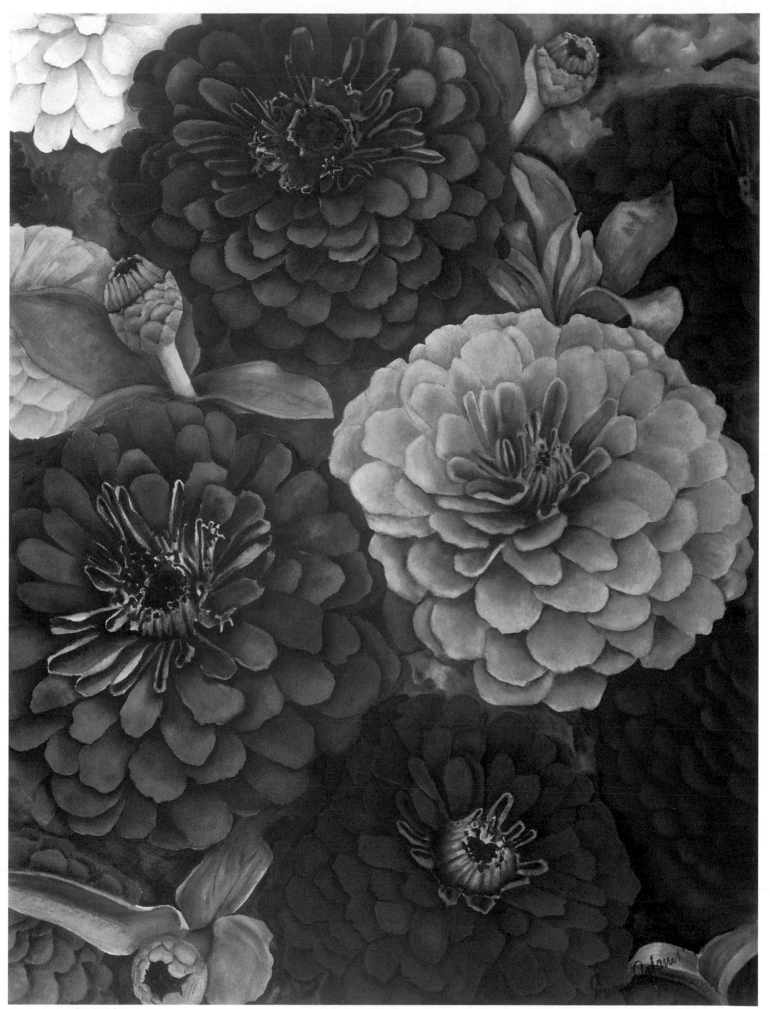

"ZINNIAS" Susan Adams
Watercolor on Arches 300-lb. cold-press paper, 30" x 22" (76cm x 56cm)

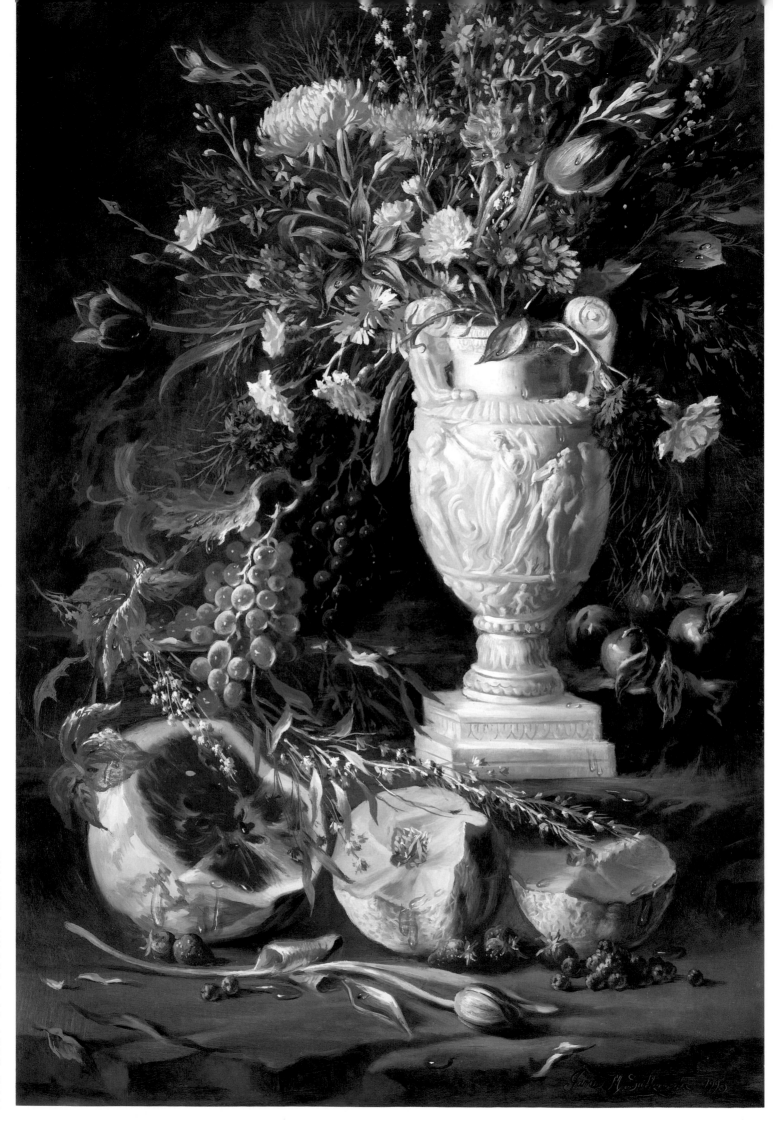

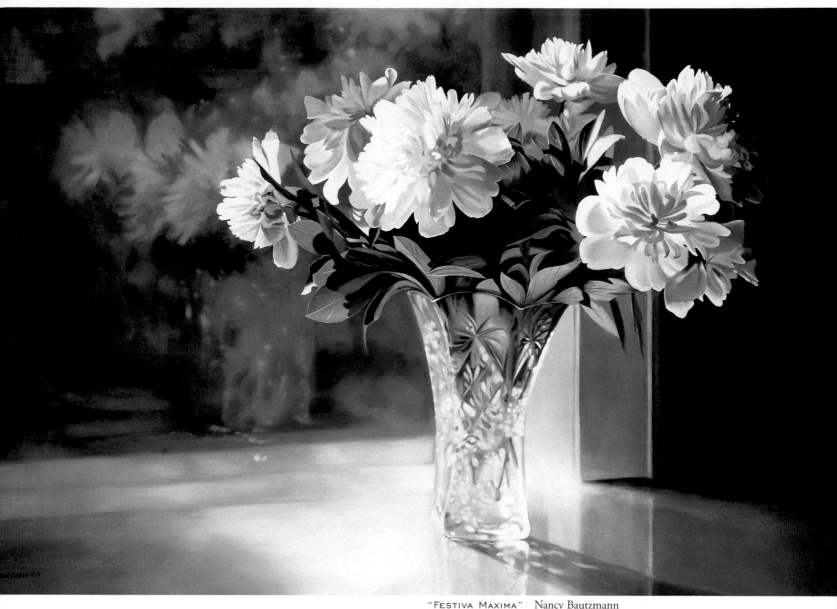

"Festiva Maxima" Nancy Bautzmann
Oil on linen, 24" x 36" (61cm x 91cm)

Nancy Bautzmann

"Festiva Maxima" was one of a series of paintings I created in pursuit of a study on white. What excites me most about this painting is the great contrasts of black and white afforded by the white of the peonies against the subdued background. The essential ingredient for floral painting is tonal value, which creates the illusion of depth and space. Oil paints provide the control I need to achieve this, through the blending of a petal or the strength of a hard line.

Reflections and contrasts are important themes in my work. My backgrounds are purposefully abstractions of the subject: a soft reminder and image of the focal point.

"Festiva Maxima" began with a transparent underpainting. The whites have only canvas under the white paint, which means they will hold their luminosity for centuries. The second layer is opaque, or colors with white paint added. The cleanest white is achieved by using Cadmium Red, Cobalt Green and Titanium White. The darks I use are a mixture of colors, never pure black.

James M. Sulkowski

I often build a floral painting around the vase or container that holds the flowers. For "Garden Delight," I came across a Grecian urn and decided to compose a floral in a garden setting. The flowers are pouring out of the urn in a waterfall of color and light. This motion follows down through the grapes to the melons and is picked up in the tulip laying on the ground.

I prepare my gessoed panel with a rabbitskin glue-Bologna chalk recipe that dates back to the Renaissance. I make my own varnish and sun-thickened linseed oil mediums, and I grind my own pigments, which gives me added depth and control of my brushstroke. I like to paint deep transparencies against strong impastos, and as I build my painting up in layers, I use thin glazes or veils of color throughout the painting to create a luminosity otherwise unattainable.

"Garden Delight" James M. Sulkowski
Oil on gessoed Masonite panel, 36" x 24" (91cm x 61cm)

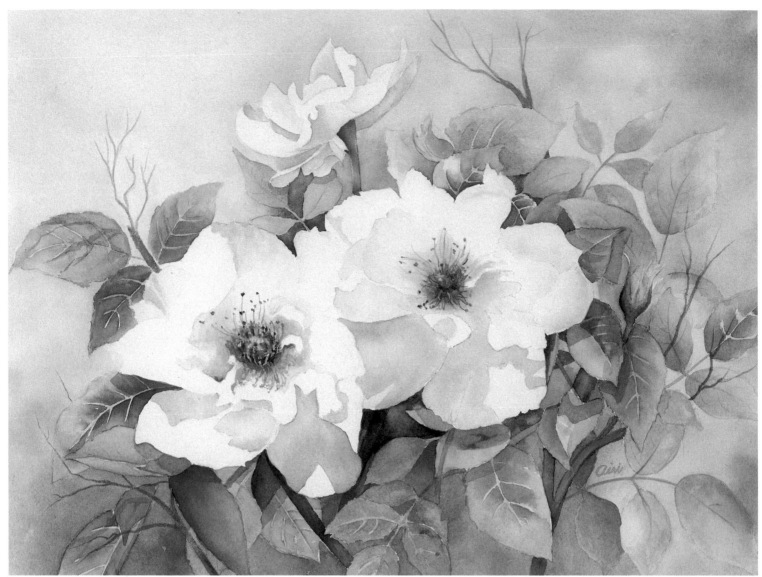

Airi Foote

Ten years ago my art teacher told me I had no talent. Discouraged, I turned to flowers for a creative outlet, and my garden became my canvas. I didn't realize it then, but I was teaching myself composition, light and shadow, color and value. Flowers became my passion: Even in winter I could close my eyes and see the subtlety of leaves and petals.

Finally, I found the courage to try painting again. Alone in my studio I painted my favorite: the white rose. Suddenly, I didn't care what anyone thought of my work. Nothing existed except the smell of the rose and the play of light on its petals.

My flowers' leaves are never just green, but have colors such as Permanent Rose and Winsor Violet with an underpainting of Aureolin Yellow for the glow. I then pull a hint of the colors from the leaves into the shadows. I hold the white petals without masking but work wet-into-wet in sections for control.

Ric Benda ✍

". . . at the river's edge" is a flashback from a trip to New Orleans several years ago. I had been wandering through one of the near suburbs and stumbled on this swampy, mystical area at sunset.

Using Arches watercolor paper in the roll form gives me more latitude to work with. Here I wanted a more textured feel so I applied a thin coat of gesso to the surface. Working in layers as wet-in-wet as possible, I built up several stages of acrylics. The final application was almost an impasto technique. Then I worked back into certain areas, defining and re-defining with more detailed brushwork, trying to stay loose.

"...at the river's edge" Ric Benda
Acrylics on Arches 140-lb. cold-press watercolor paper
60" x 43" (152cm x 109cm)

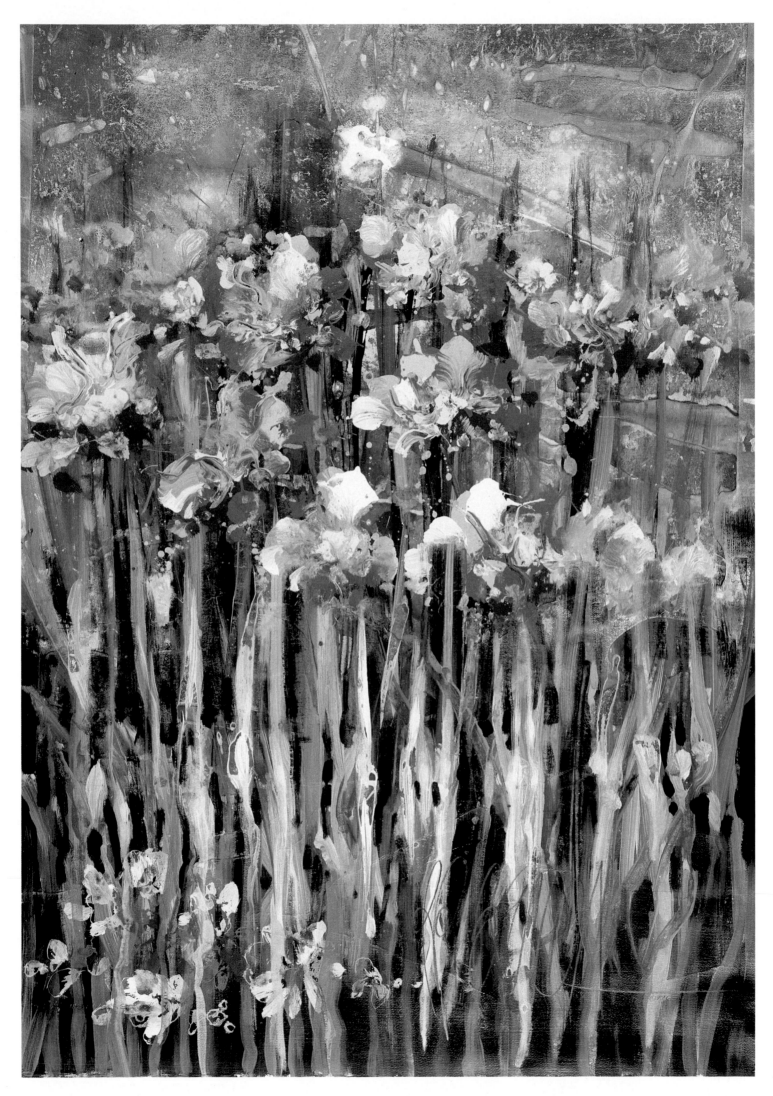

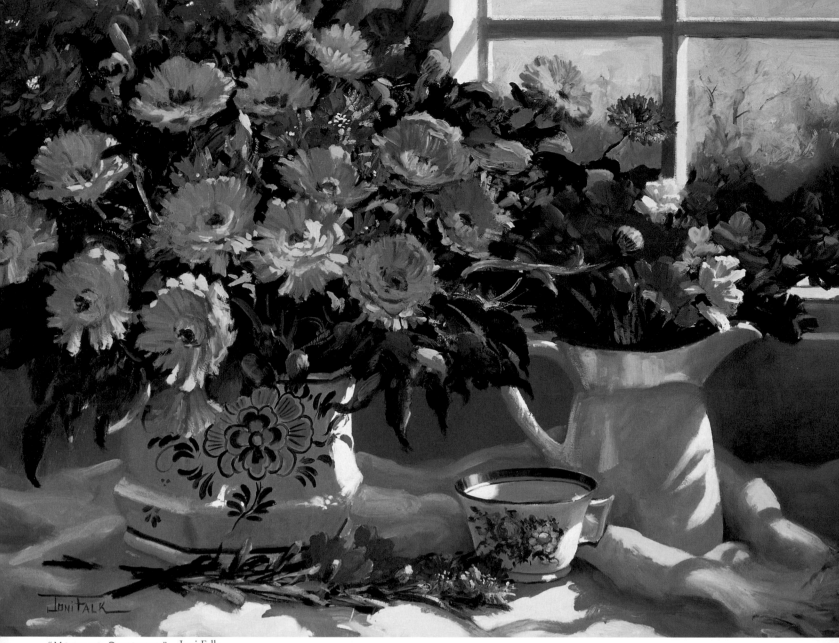

"MORNING SUNSHINE" Joni Falk
Oil on linen canvas, 18" x 24" (46cm x 61cm)

Joni Falk

Some of my favorite florals have been painted in the company of my best friends, who also happen to be accomplished artists. "Morning Sunshine" began with a phone call from Jane and a trip to the Japanese Flower Gardens. Filling our pails with a full variety of colors and flowers we headed back to Jane's sun-filled studio where two window seats provided the perfect backdrop for our creations.

This painting is a story about light, which I concentrated throughout one-third of the painting, softening the outer areas, forcing the strongest contrasts only around the focal areas. To reinforce the brightest areas I repainted them two or three times. The use of complementary colors gave the end result an exciting look.

Penny Stewart ✑

During an early summer's visit to Wichita, I was advised to "take in" the weekend Farm and Art Market. Camera in hand, I was electrified by the vivid color of potted flowers by the hundreds. Gleefully I spent hours taking photos. The colorfully dressed young woman contemplating her selection especially caught my eye.

Creating an interesting composition from static regular rows of flower pots was a challenge. First, I varied the spacing of the pots. Then I made each flower shape unique and changed the color of some flowers. By eliminating detail and treating the resulting shapes as flat silhouettes, I concentrated on color and form.

Using warm-hued Cadmium Red, Orange and Yellow, I recreated the sunlit beauty of the flowers. I enhanced the brightness of these pigments by abutting each with its dulled complement: muted blue-green foliage with orange flowers and dull purple shadows in the greenery adjacent to yellow blossoms.

"FLOWERS TO GO" Penny Stewart
Transparent watercolor on Arches 300-lb. cold-press paper
22" x 15" (56cm x 38cm)

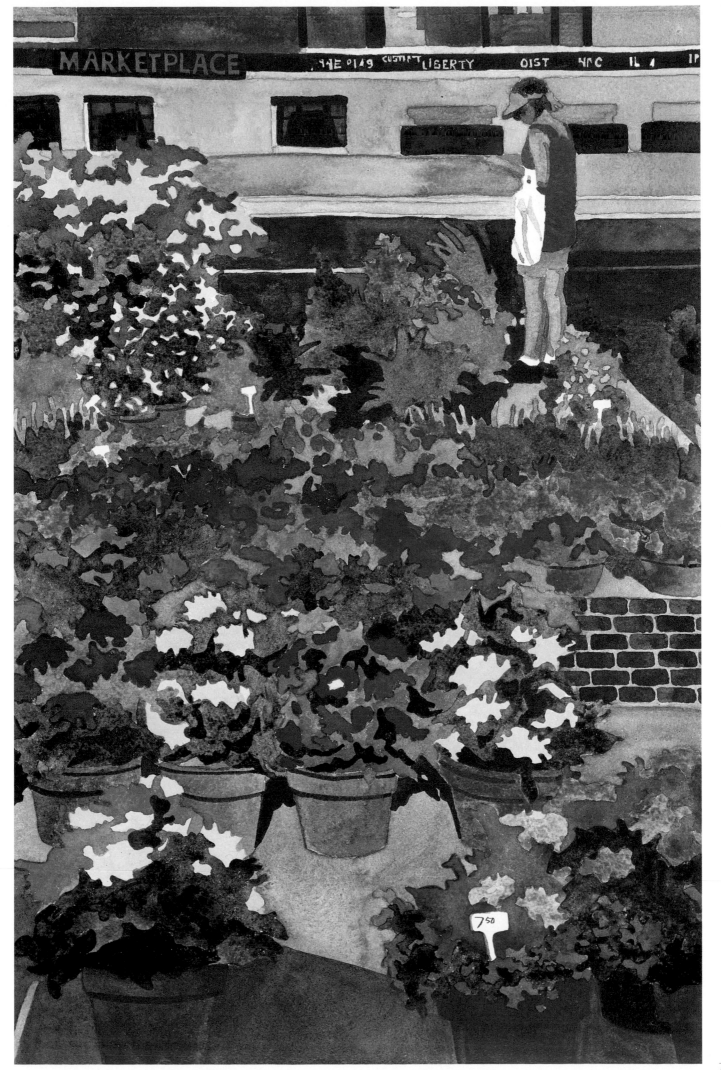

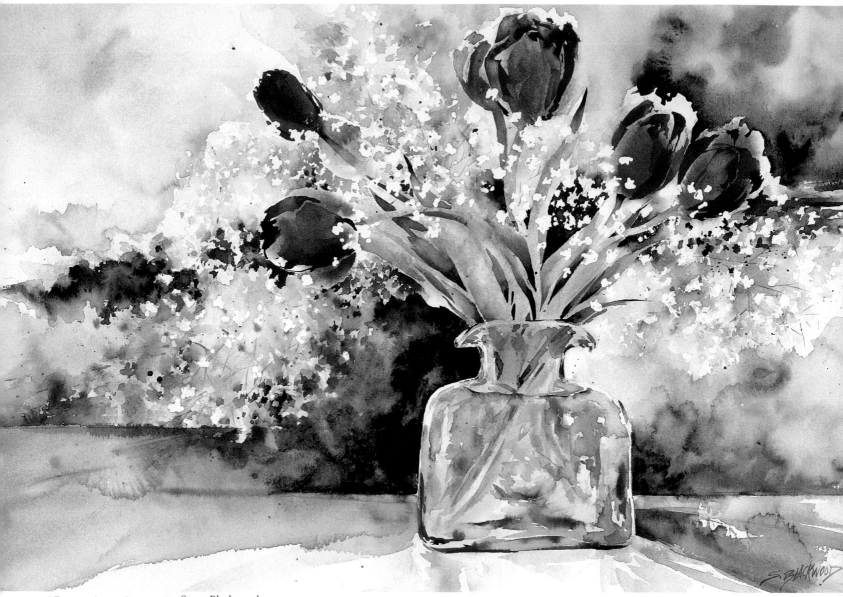

"BURST INTO SPRING" Susan Blackwood
Transparent watercolor on Arches 300-lb. cold-press paper
14" x 21" (36cm x 53cm)

Susan Blackwood

Winter is long in Montana, frozen in black and white. When spring finally arrives I'm starved for color. Tulips bravely shout their color to the world, often pushing aside blankets of snow.

I like the combination of baby's breath with tulips. Changes in texture and size bring a feeling of movement. The vibrant tulips seem to be dancing and the baby's breath becomes confetti fluttering around them.

Normally I don't use masking because it makes edges too harsh and disruptive, but this time it was perfect. I used Dr. Ph. Martin's Frisket Mask Liquid because it is thin and white. Rather than apply it with a brush, I used an "oiler boiler" from Cheap Joe's. Before I began painting, I put the masking on and it remained until the end. As I built the background darks, I repeated the shapes in my brushstrokes for repetition and continuity.

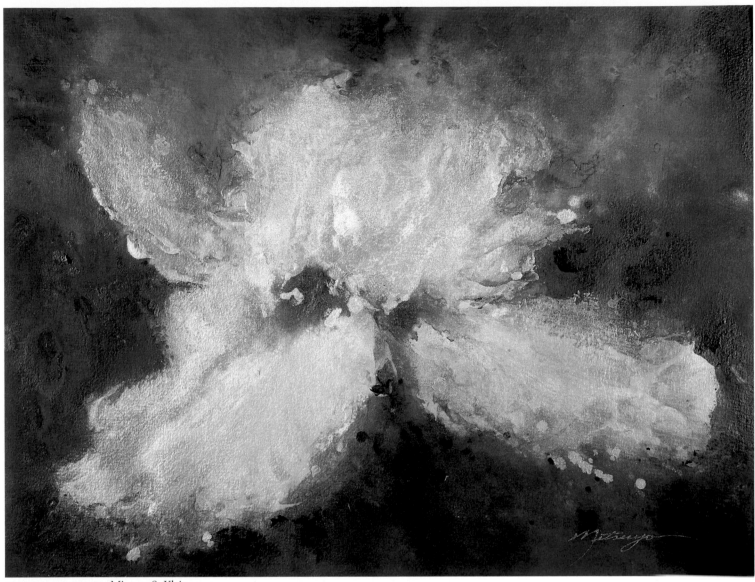

"SPIRIT OF IRIS" Mitsuyo St.Klair
Watercolor, metallic and interference acrylics on
Arches 300-lb. cold-press paper, 15" x 19" (38cm x 48cm)

Mitsuyo St.Klair

Spring is glorious in my garden on a slope of the Sierra Nevada
foothills in California. Every morning of April and May the air is full
of the slight yet distinguishable scent of irises. Everywhere is a sea of
hues and shades of color. Most of the time, after I walk through the
entire garden, I sit quietly among some irises to do daily meditation.
Once, when I came back from a deep meditation, I saw each shim-
mering particle of the translucent petals. The garden was transformed
into an orchestra of celestial lights and shadows, ethereal music, colors
and fragrance.

 When I came back into my studio, I had an urge to paint what I
had witnessed and experienced in the garden. Then I realized how I
could paint the elusive "spirit" of the iris.

 I mixed transparent Holbein artists' watercolors and metallic
gouache acrylics with Golden's interference acrylics over a very wet
surface. It was a challenge to transfer my experience with the irises
onto a two-dimensional surface, but this loose and carefree approach
seems to have captured the feeling.

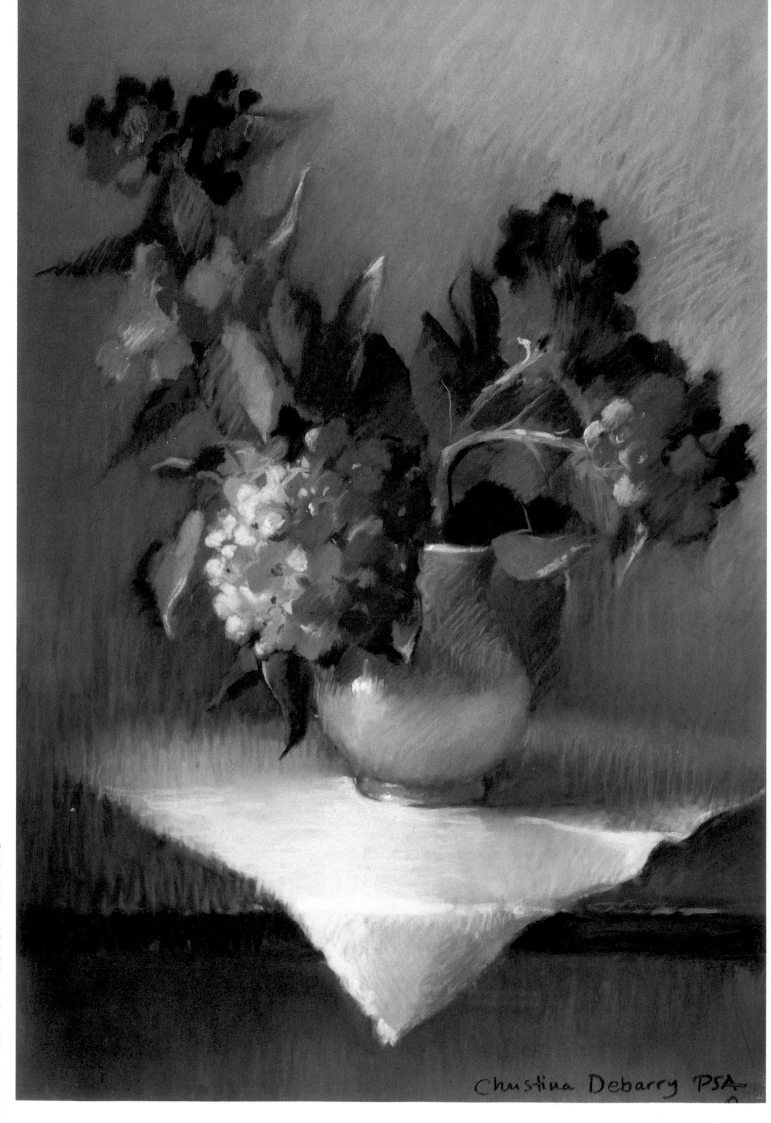

Christina Debarry PSA

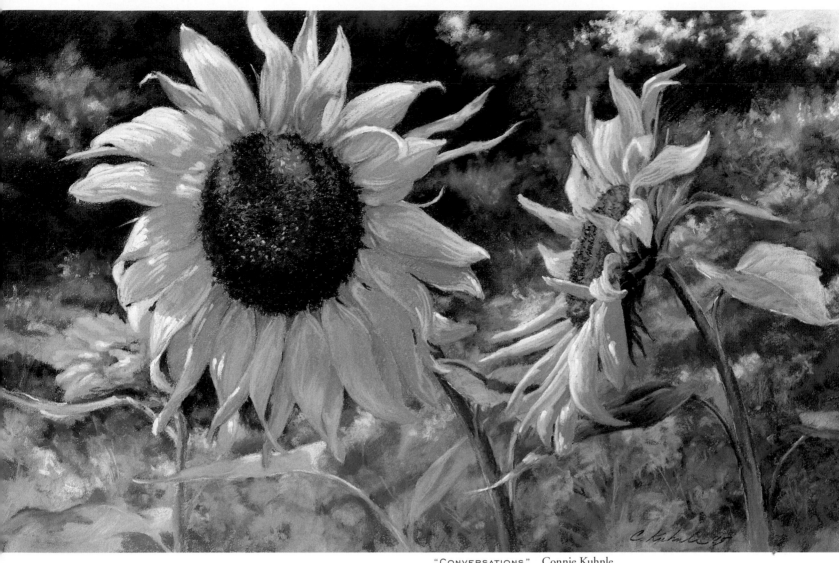

"CONVERSATIONS" Connie Kuhnle
Pastel on Canson Mi-Teintes paper, 15" x 24" (38cm x 61cm)

Connie Kuhnle

At the time of painting "Conversations" I was exploring the use of yellow as a primary color; this is one of a series of "yellow" paintings. I often drive through the country looking for subject matter and when I came upon this vast field of sunflowers I was overwhelmed by their color. I was interested in the contrast of the golden yellow against the purple-lavender of the background, and the twists and turns and edges of the petals against the softer, more amorphic shapes of the background.

Using a middle value, sand-colored paper, I sketched in the sunflowers with a Nupastel slightly darker than the paper. The challenge in this painting was to correctly paint the value of the yellow in shadow without it becoming dull and dirty looking. First I applied a light layer of cool violet to the shadow areas, and then layered on shades of gold, orange and raw umber.

Christina Debarry

In "Hydrangea" I wanted to capture the delicate, multi-toned, silky petals of this intricate flower. I loved the purples, soft blues and hot pinkish colors. The dark greens of the leaves were a strong contrast to the fragile blossoms. The purple flowers set against the warm yellows and rusts of the background also contrasted and complemented each other. Since my background was warm, I chose to paint the vase a cool silver. Into the metal surface I reflected the warm colors of the surrounding area, but kept the edges softer, cooler and bluer so that they would recede. The white cloth was used for its lightness to balance all the darker values in the composition.

"HYDRANGEA (WITH SILVER VASE)" Christina Debarry
Pastel on sanded pastel paper, 24" x 18" (61cm x 46cm)

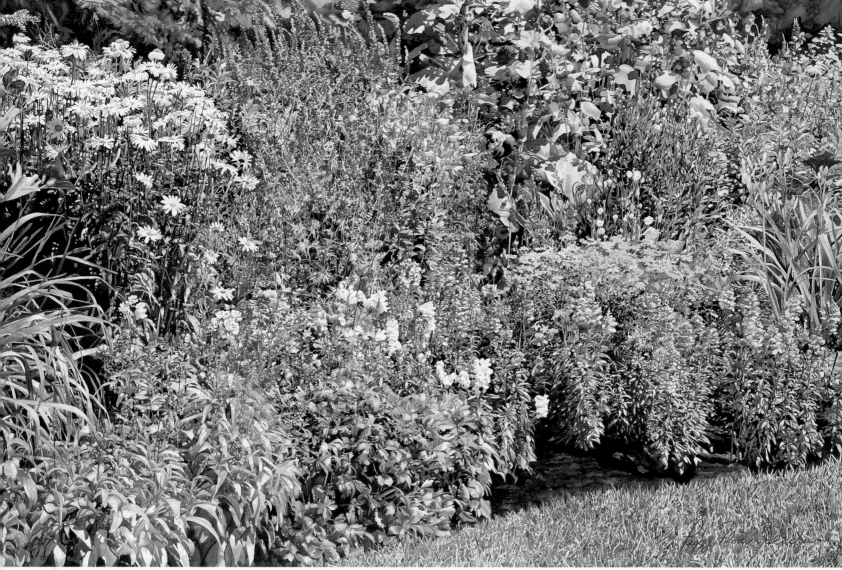

"Sprinkler Gardens" (diptych part 1) Peggy Flora Zalucha
Transparent watercolor on Arches rough 100 percent rag paper
36" x 52" (91cm x 132cm)

Peggy Flora Zalucha

When I decided to do this monumental painting, I searched for a
year to find the perfect garden for my needs. I wanted a riot of color
and a good sampling of the flora that flourishes in the Midwest.
When I found it, I photographed it for a day.

As I began to work, the painting took on a life of its own,
demanding perfection in every square inch. I painted very small areas
at a time. Even every blade of grass required attention. I worked on it
for months, making sure that the flowers and leaves were botanically
correct. It is not often an artist can commit so much time to one
work, and I found it both invigorating and trying.

This painting is the right panel of a diptych. When the two are
stretched out side by side, it feels as if the garden is in front of you.

There is very little of this painting that is done in the traditional
watercolor style of washes and blends. Rather, using an extremely
small round synthetic brush to place the marks, I laid down colors
next to each other much as one would expect in a pointillist oil
painting.

Barbara Newton ✒

One spring day a peony made an unexpected appearance in our gar-
den and a lilac bush materialized nearby. I don't have plant fairies; I
have a mother-in-law who can't resist a bare patch of earth and appar-
ently likes to work incognito. Several years ago I was pleased to find
her favorite "Peace" rose planted beside our front deck. I pondered
how I could best represent its radiance in a colored pencil painting
and finally decided upon a single perfect rose. For additional impact I
decided to make it big (each petal is the size of a salad plate).

Upon close examination, color appears to have been applied in
vertical strokes, but this effect was the result of the distinctive texture
of the paper. In the dark background, black water-soluble colored
pencil obliterates this texture and a glaze of wax-based Indigo Blue
enriches the black. Shingle texture was created by lifting color with
masking tape. Bare white paper was left for strong sunlight.

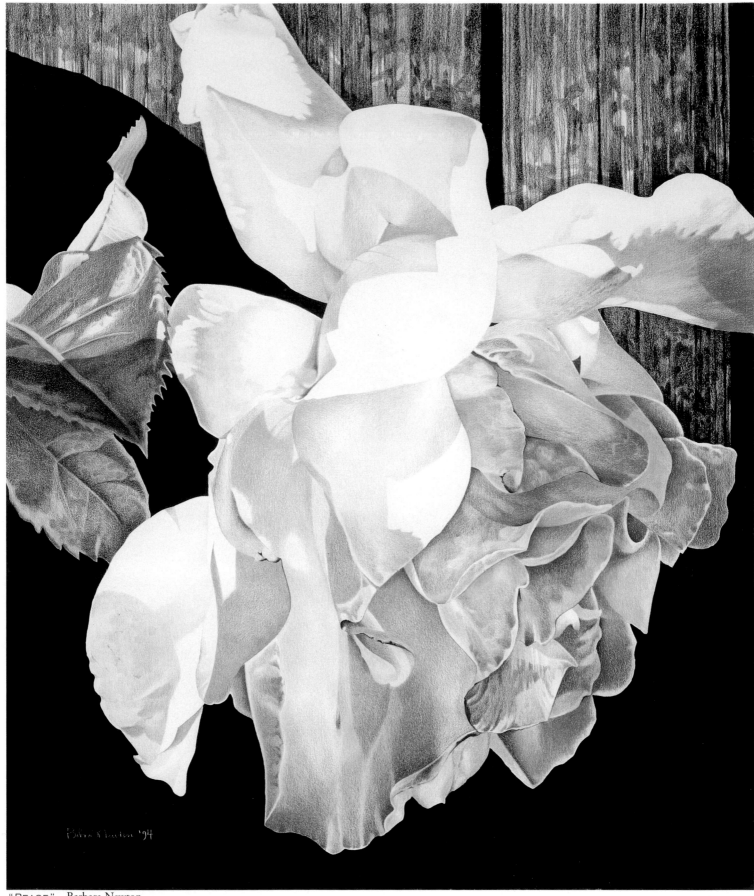

"PEACE" Barbara Newton
Colored pencil on Crescent rag mat, 27½" x 23¾" (70cm x 60cm)

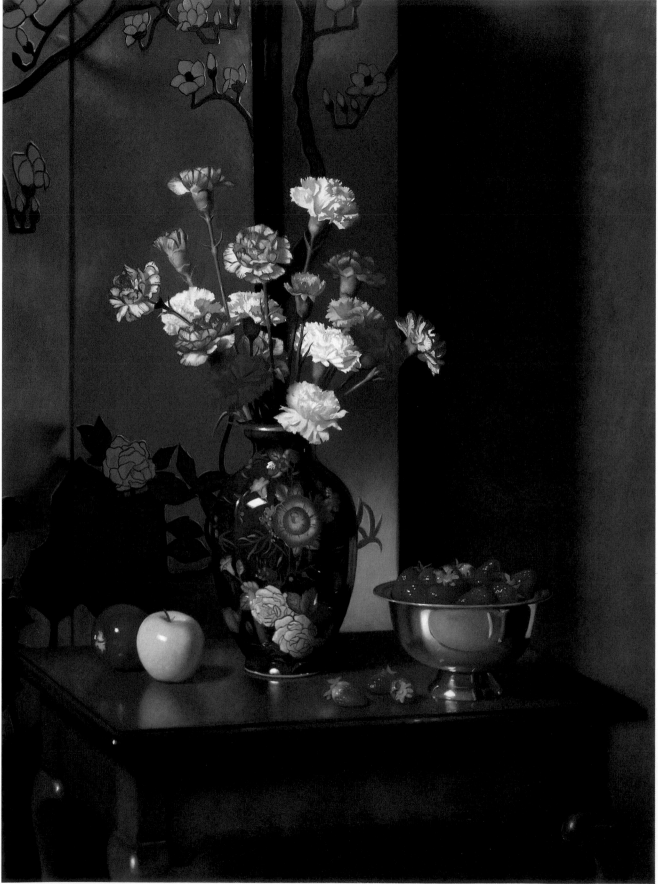

"GOLDEN CORNER"
Kirk Richards, Oil on canvas
40" x 30" (102cm x 76cm)

Kirk Richards

In "Golden Corner" the illusion of three dimensions on a two-dimensional surface is achieved through the convergence of several essential elements. Value relationships must be correct. Areas of light and dark will not assume their proper place unless all the values on and around them are correctly established. Edges must resemble their appropriate degree of hard or soft, lost or found as seen in nature. Visual perspective accurately rendered by virtue of sound drawing and careful placement of objects also adds to the successful illusion of three dimensions.

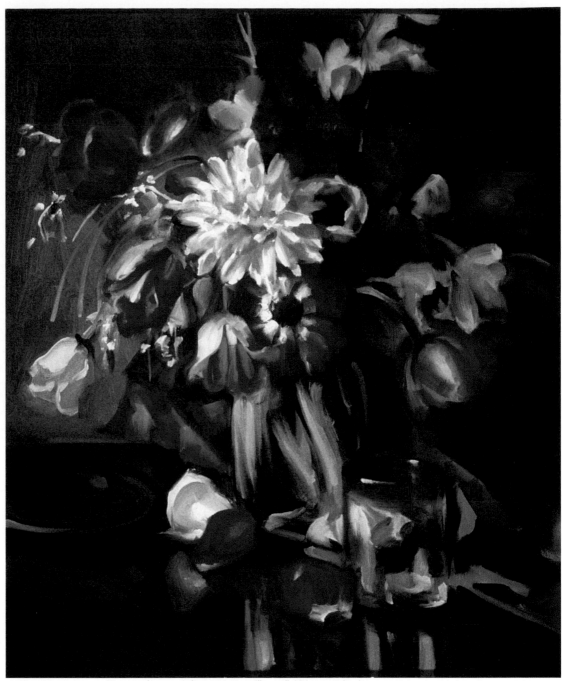

"APRIL BLOOMS" Kurt Anderson, Oil on canvas, 26" x 22" (66cm x 56cm)

Kurt Anderson

I had been an artist for many years before I first tried my hand at floral still lifes. One of the reasons I had avoided flowers was my fear of painting a subject with so much detail. In painting a flower arrangement you are faced with delineating hundreds, perhaps even thousands, of petals and leaves. In addition, over the course of a day, flowers can completely change.

To deal with both these problems I have learned to work very quickly and broadly, using an alla prima (or direct painting) technique. When I was painting "April Blooms" the tulips completely altered position, drooping and opening wider as the day progressed. I had to work very quickly, and I couldn't really come back later and re-examine what I had seen and painted. However, if I preferred the

new shape and position a tulip had taken I would wipe it out on the canvas and paint it over. Painting flowers has forced me to adopt a more fluid approach to painting, and to see and interpret nature more impressionistically.

One technique I use is to create an interplay between the lightest notes painted thickly and the darker notes painted more thinly. This contrast creates a sense of three-dimensionality, and it worked especially well with the pinkish-white chrysanthemum. The flower leaps forward because each petal has a little ridge of thick paint along its edge, which picks up the light and creates a slight shimmer.

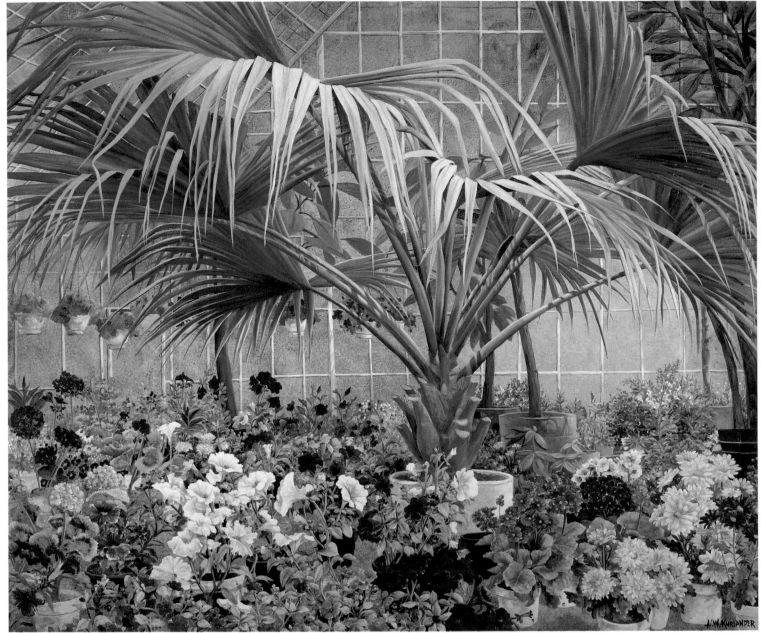

"GREENHOUSE — PALM" Honey W. Kurlander
Acrylics on linen canvas, 42" x 50" (107cm x 127cm)

Honey W. Kurlander

Flowers are a delight to me. I grow them outside in my garden and indoors throughout the year. After collecting many varieties, I study them closely, pluck the petals, examine the leaves and make many pencil drawings and watercolor sketches. I spend hours in greenhouses to absorb the sensations of warmth, aroma and chromatic vibrancy of flowering plants.

In "Palm" a mass of blooms spreads across the familiar architecture of a greenhouse. Painting the interior of a greenhouse allows me to play with light and color in infinite variations. With muted impressions in the background, and strong, realistic detail in the foreground, I try to entice the viewer into the lively, sparkling, heady atmosphere. Color and form create both the harmony and discord found in nature, and lead to a joyous feast for the eye.

Mary Kay Krell

We've lived in Texas six years now, so I knew I was putting down roots when I combined these gatherings. This is a Texas still life, found close to home.

Texas wildflowers put on their big show in April. By late summer Mother Nature has been ruthless, but these hardy sunflowers bloom well into fall—whole fields of yellow by the roadside.

The sticky green fruit of the bois d'arc tree is also plentiful in late summer in Texas. Totally useless to man or animal, it's rich in textural quality. The pecans grow abundantly in my back yard.

In this painting I gradually built up the rich yellows of the petals in layers. I used a pale wash of Naples Yellow first, to establish form. Titanium and Hansa Yellows were used in the lightest areas, where petals were most transparent. Cadmium Yellows and Oranges were layered on darker petals. Magenta and Violet were combined sparingly for the darkest shadows. The flower centers are a mix of Van Dyke Brown, Violet and Neutral Tint painted over a rich orange.

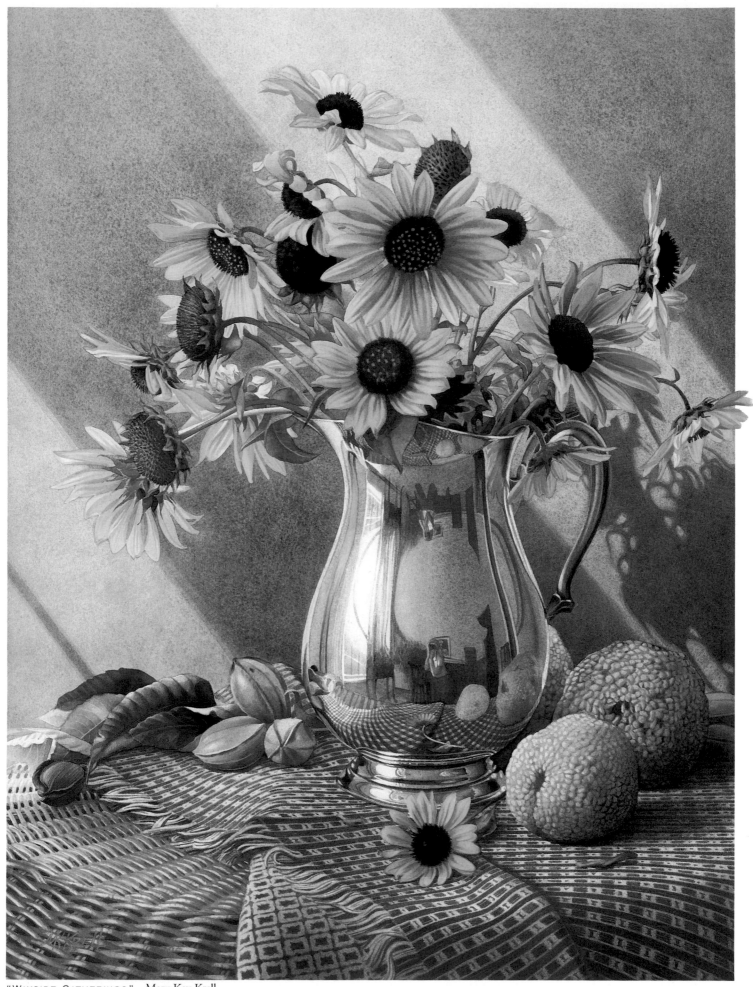

"WAYSIDE GATHERINGS" Mary Kay Krell
Watercolor on Arches 300-lb. cold-press paper, 24" x 18" (61cm x 46cm)

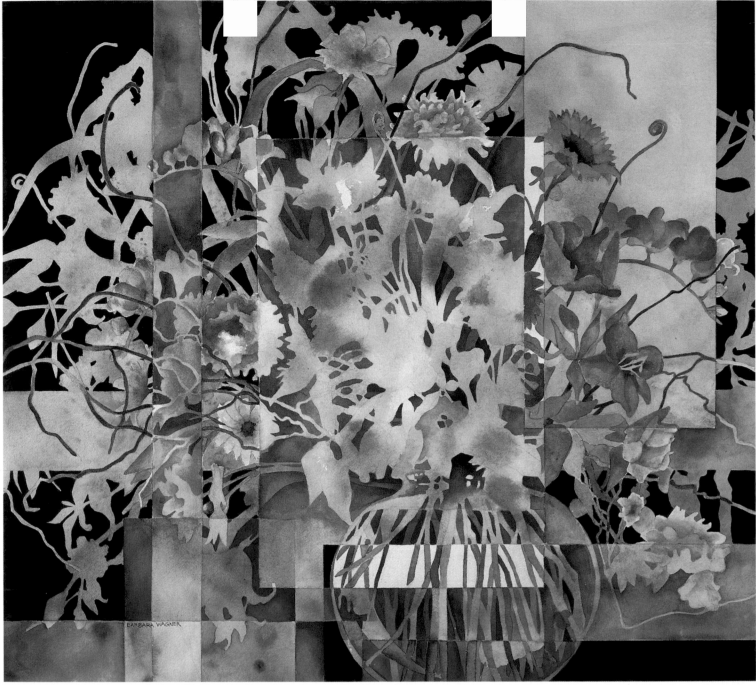

"SUMMER SILHOUETTE" Barbara Wagner
Watercolor and acrylic on Arches watercolor paper
26" x 33½" (66cm x 85cm)

Barbara Wagner

Because I work in a way that combines realism with abstraction, I feel that flowers are perfect for this special treatment. No matter how abstractly I handle them, they never lose their readability and appeal. I often block out large areas with opaque acrylic colors, yet the viewer always accepts and enjoys these quiet passages as part of a flower's essence.

"Summer Silhouette" combines two drawings, one of summer flowers in a crystal bowl, the other a collection of abstract rectangles. Carefully preserving whites and using transparent watercolors, I completed each section differently. One section is quite realistic. One is painted in reverse with the flowers in silhouette. Some parts have flat poster-like shapes, while others contain only pure color. All are held together by movement and subject. Cerulean flowers against an Indigo background were added last for drama and flair.

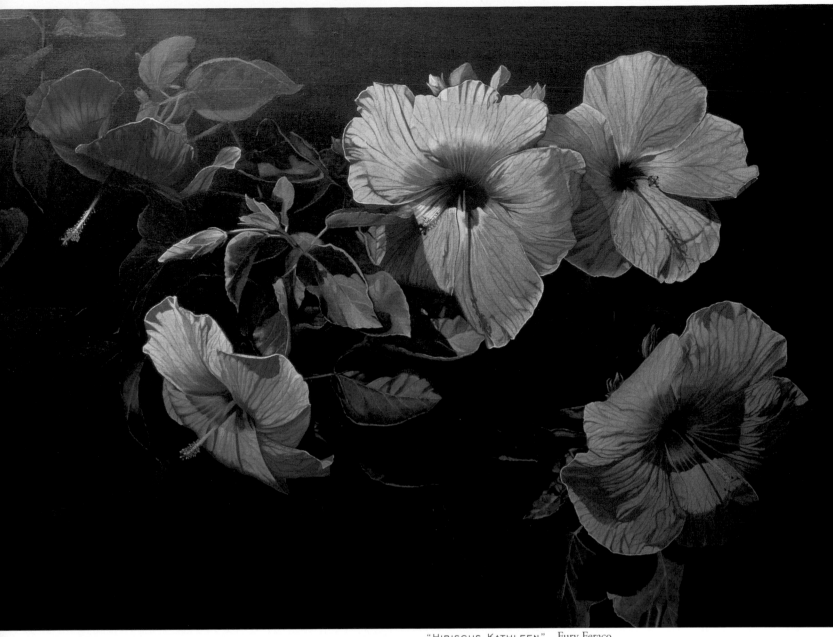

"HIBISCUS KATHLEEN" Fury Feraco
Oil on linen, 22" x 31" (56cm x 79cm)

Fury Feraco

I am an avid gardener and a member of the American Horticultural Society. "Kathleen" is a particular favorite from my collection of hybrid hibiscuses. It was a challenge to capture her radiance in dappled sunlight as the buds opened to reveal her lush tropical beauty.

Hibiscuses are prolific, flowering with immense blooms that last only one day. It would be too frustrating to work totally from life as there are subtle variations in each flower that require many weeks of painting. Therefore, the flowers are painted from a combination of photographs for form, and the actual blooms are used for true color and nuances in veining.

Backgrounds are painted first, leaves next, then petals. Leaf colors include Chromium Oxide Green with Ultramarine Blue, Burnt Umber and Cadmium Yellow Pale. Petal colors are Cadmium Barium Red Light, Cadmium Yellow Orange, Burnt Umber and Titanium White.

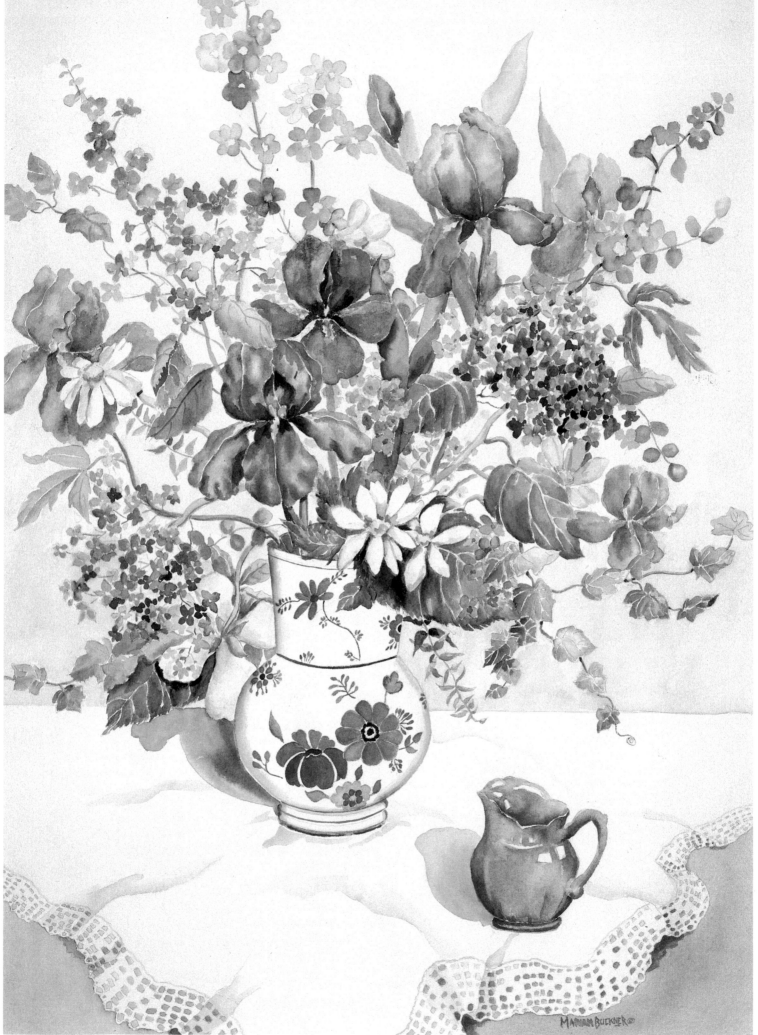

"VICTORIAN BLUES" Marian Buckner, Watercolor on Arches 300-lb. cold-press paper, 27" x 19" (69cm x 48cm)

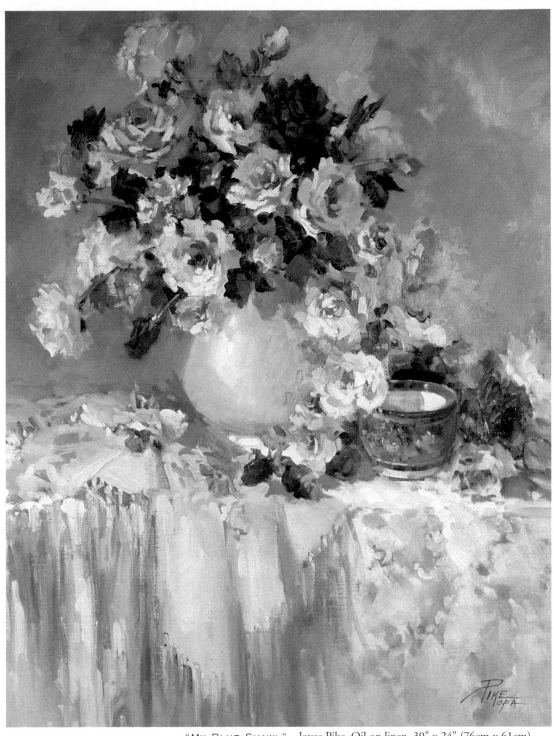

"MY BLUE SHAWL" Joyce Pike, Oil on linen, 30" x 24" (76cm x 61cm)

Marian Buckner

The joyful exuberance of a bouquet of Victorian flowers is the concept for "Victorian Blues." The idea was simple, yet presented challenges. How to direct the eye through the delightful chaos of delphiniums and hydrangeas? How to create color variety when flowers are one color? Indeed, how to convey aliveness and exuberance with my layered, controlled technique?

In meeting the first challenge, I devised a basic framework of iris shapes. Their S-shaped design flows into vase pattern and pitcher shapes. Resting places are provided by an uncluttered background and foreground, and lace redirects the eye.

Four blues—Cobalt, Antwerp, French Ultramarine, and Winsor—provide color variety. Watery washes of transparent and other colors in a high-key value scheme portray the flowers' freshness. Leaves are Sap Green and Raw Sienna with touches of the blues.

Joyce Pike

In most of my floral paintings, I want the flowers to make the strongest statement. In this painting, I chose red, pink and white roses because the color red is so intense against the subtle tones of the pink and white roses.

Color harmony is very important and here I chose violet as the dominant hue, with the adjacent hues of red-violet and blue-violet. Violet-gray in the background emphasizes the color harmony.

Using Alizarin Crimson, I blocked in both the red and pink roses; the pink roses I softened with a tissue to remove some of the paint, since I would later add pink lights. The white roses are actually a gray of Ultramarine, Cadmium Red Light and white, going warmer and lighter on the light-struck side.

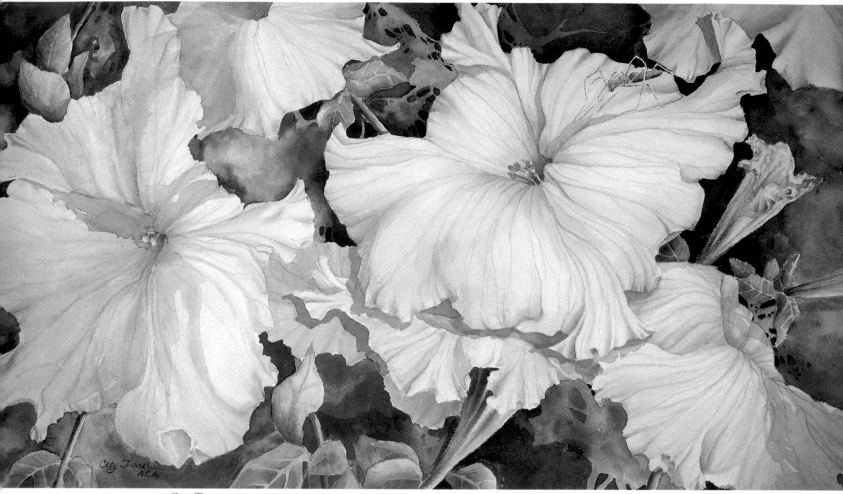

"PETUNIA PARADISE" Cecy Turner
Watercolor on Arches 300-lb. cold-press paper, 15" x 27" (38cm x 69cm)

Cecy Turner

In "Petunia Paradise" small, fragile blossoms become powerful forms
that seem to "grow" off the page. I begin on dry paper with the back-
ground so I can "chisel out" the flower shapes. When painting large
flowers I strive for clean, crisp edges, reserving more lost edges for
masses of flowers. By carefully glazing over the petals and quickly soft-
ening edges, I am able to enhance the delicate folds and ripples as
they turn toward and away from the sunlight. The petals almost begin
to move as they assume various directions. The little green insect in
the upper right affirms that these flowers are indeed alive!

I paint around the large, overlapping shapes I've drawn with a
mixture of Winsor Red, Blue and Green, in varying combinations. I
avoid masking agents so my brush has freedom in defining the petals'
delicate edges. Misting the background while still wet softens edges,
lightens areas and creates interesting effects. Folds in the petals are
suggested by applying a brushstroke of paint, then softening one edge
as it turns back into the light.

Carol Lee Thompson 🐛

My goal was to recreate the atmosphere of the seventeenth century
Dutch florals. The essence of these still lifes is in their illusion of reali-
ty, accomplished through composition, light and refined techniques.
The culmination of this is trompe l'oeil, a piece that "fools the eyes."

There are innumerable interpretations for the still lifes of the sev-
enteenth century. Filled with abundant symbolism, morality and
metaphor, they are fascinating to decipher. I enjoyed incorporating
the various themes into my work: Representing the seasons within the
piece, the temporary nature of life is symbolized in the flowers, and
the allusion to new life in the bird nest.

As a classical realist, I adhere to the practices of the Old Masters.
I prepare my linen canvases with several coats of rabbitskin glue and
lead. My pigments are ground with homemade Black Oil. I also use
the Maroger medium, believed to be the closest to that of the Flemish
masters. It is very viscous and lends itself to glazes, half-pastes and
translucency of color. An umber underpainting establishes the basic
composition.

THE BEST OF FLOWER PAINTING

116

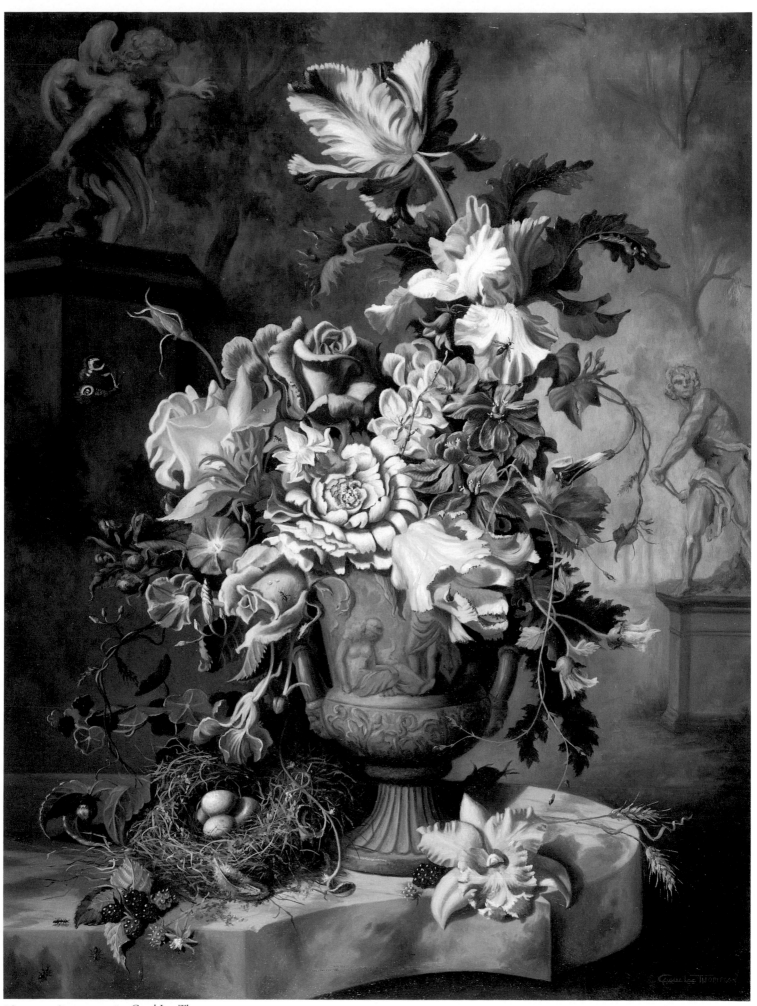

"GARDEN SPLENDOR" Carol Lee Thompson
Oil on linen, 21" x 16" (53cm x 41cm)

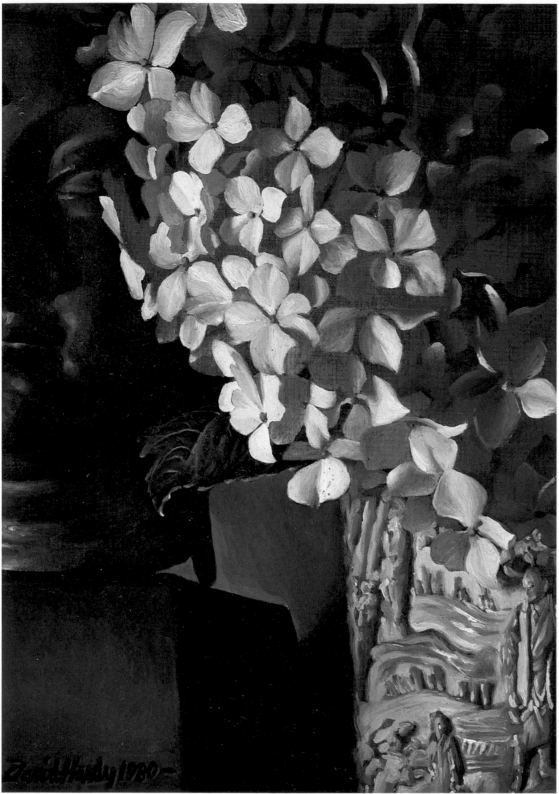

"THE WORLD OF THE BUDDHA" David Hardy
Oil on gessoed panel, 12" x 9" (30cm x 23cm)

David Hardy

Florals give me the opportunity to explore beauty as found in nature. In this painting I chose to bring together the quiet, commanding presence of the old bronze Buddha head and the gentle, even haunting, delicacy of the hydrangea blossoms. The soft lighting reveals but does not invade the dreamy, mysterious mood.

I am attracted to the greater range of subtleness and control I find in layered painting. I maintain transparent shadows by glazing transparent colors on top of each other, thinning down opaque pigments to create translucency in faintly lit areas, and reserving my opaque and thicker paint to describe stronger light.

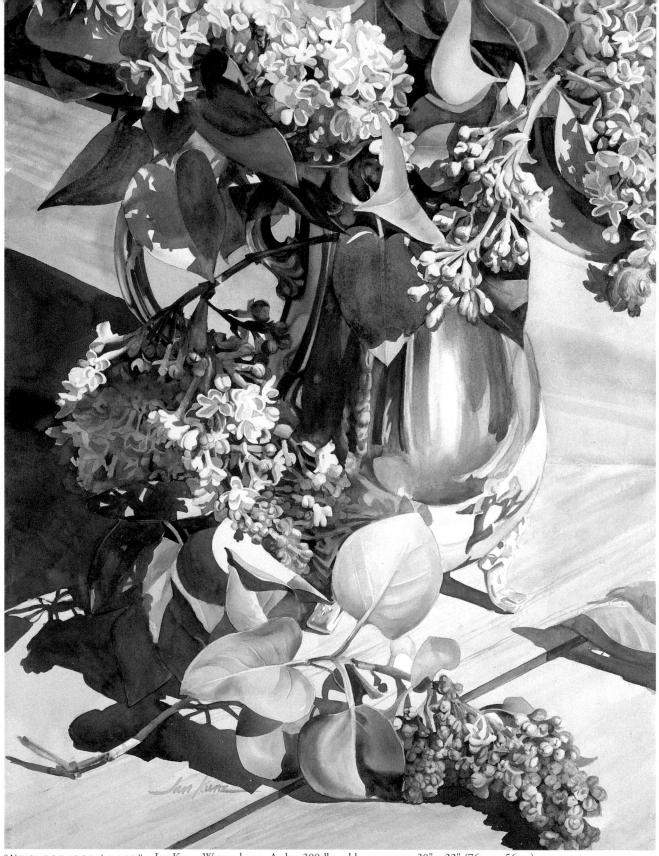

"NEIGHBORHOOD LILACS" Jan Kunz, Watercolor on Arches 300-lb. cold-press paper, 30" x 22" (76cm x 56cm)

Jan Kunz

For years, with the coming of spring, the lilac bush across the street would burst into an incredible cascade of blossoms. The fragrance permeated the air, and neighbors gathered to admire the beauty and reminisce about other lilac bushes they had known from their childhood.

Then we learned that soon the bush would be removed to make way for new construction. One evening, as we were lamenting the approaching loss, the contractor stopped by and offered each neighbor a bouquet of lilacs to remember. I immediately photographed the blossoms before their beauty faded. This painting was done from that photo. For years to come it will remind me of home, good neighbors and the fragrant beauty of the lilac bush across the street.

I used Rose Madder, Permanent Rose, Burnt Sienna and Cobalt Blue to paint the lilac blossoms. Those in sunlight were painted directly on dry paper, while those in shade were first underpainted with a darker wash. Wherever possible I pulled the shade color and value into the foreground blossoms. I used still darker values to paint around the blossoms in shade.

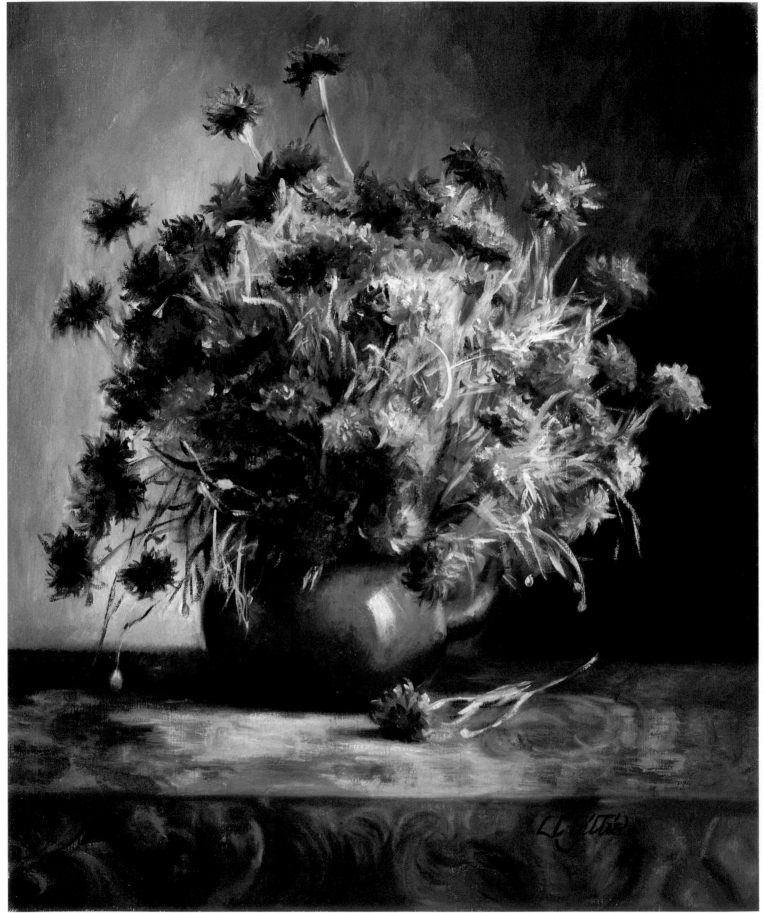

"CORNFLOWERS IN TEAPOT" Louise C. Gillis
Oil on canvas, 24" x 20" (61cm x 51cm)

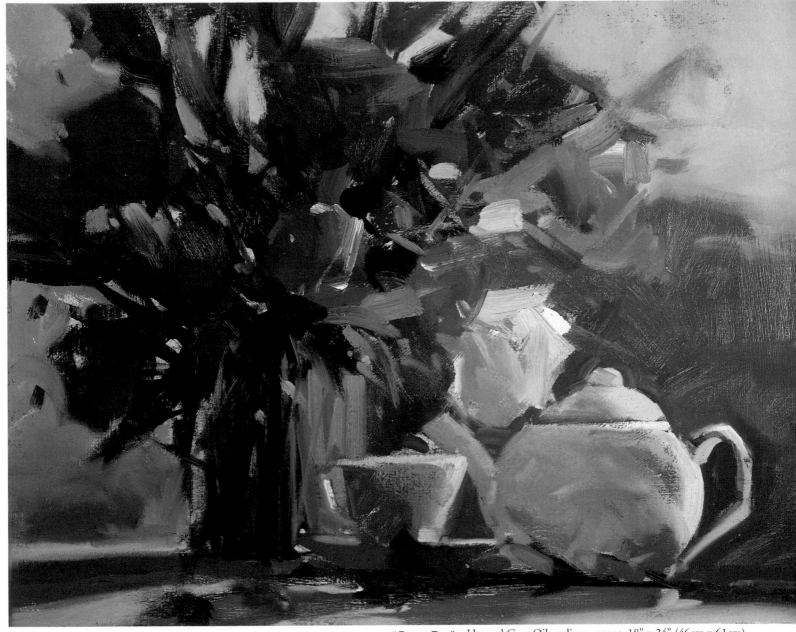

"ROSE TEA" Howard Carr, Oil on linen canvas, 18" x 24" (46cm x 61cm)

Louise C. Gillis

On summer mornings in Minneapolis the Farmers Market provides a taste of an older world. One can walk among stalls of fresh meats and produce, coffees and breads, and bright displays of flowers. Last June, while shopping there, I saw a remarkable bouquet of vivid blue cornflowers. The sight struck me because just a few days before I had seen a painting of cornflowers by the nineteenth century Russian painter Isaak Levitan.

Upon returning to my studio, I found a red copper teapot that would work well with the blue notes of the flowers. I used a tapestry tablecloth to subtly echo all the colors being used.

The flowers feature a strong diagonal and cut the line of the background. A single flower placed on the table distracts from the line of the copper pot. The stem leads the eye deliberately into the compositional arc.

Howard Carr

What usually catches my eye for a good painting is the effect of light on the subject. I prefer early or evening natural sunlight. A limited shot of light hitting a specific area on my floral makes that area a focal point, leaving the rest of the subject more subdued.

"Rose Tea" was exciting for me to paint. The subject not only had strong light but the teapot also showed reflected flower colors. Repeating the dominant flower color in the painting made for great broken color movement, thus unifying the piece.

I start by toning my canvas with a light value of Cadmium Red Light. After it dries I begin sketching my composition directly on the canvas with a small flat bristle brush. I then block in the bigger, dark, transparent shapes. Working wet-into-wet I'll add lighter and warmer paint, working it into the darker colors, using flat hog-hair brushes and, quite often, my fingers. After the entire canvas is covered with paint I'll work the edges, usually softening shadow edges.

Now it's time for the serious paint. A brush loaded with my brightest, thickest and lightest color is placed at the focal area. Except for my signature, the painting's complete.

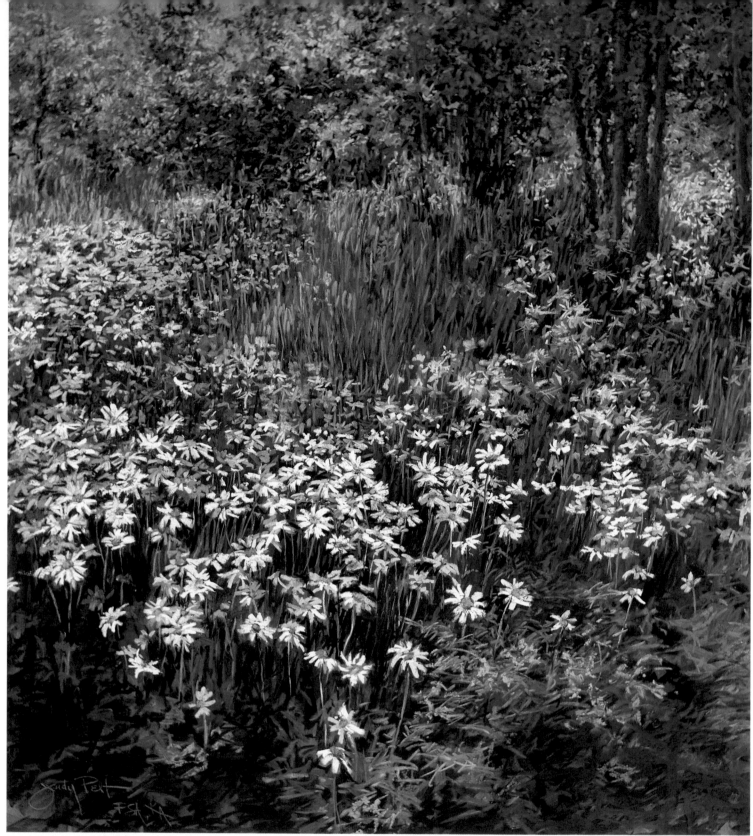

"TAOS GARDEN" Judy Pelt
Pastel on sanded pastel paper
30" x 27" (76cm x 69cm)

Judy Pelt

When I first saw this garden, I was struck with a plethora of feelings . . . elation, thankfulness, refreshment. All of these and more. It was like an unexpected gift and immediately triggered good feelings and a huge smile. It was so free, so untamed by borders, so glorious, a respite from a troubled, busy world.

Working alla prima, I quickly found the shadow shapes and trees with cool, dark greens and violets. I washed the shadow area to soften it, wielding my brush as they do in oriental art. I found the lights and mid-tones with shades of warm green and yellow. Finally, with light blue-violets, red-violets, cool light greens and pinks, I found the petals in the shadows with lilting wind-blown strokes. I found the flowers in the light using warm light pinks and yellows. I painted "Taos Garden" with free abandon just as the gardener sowed the seed.

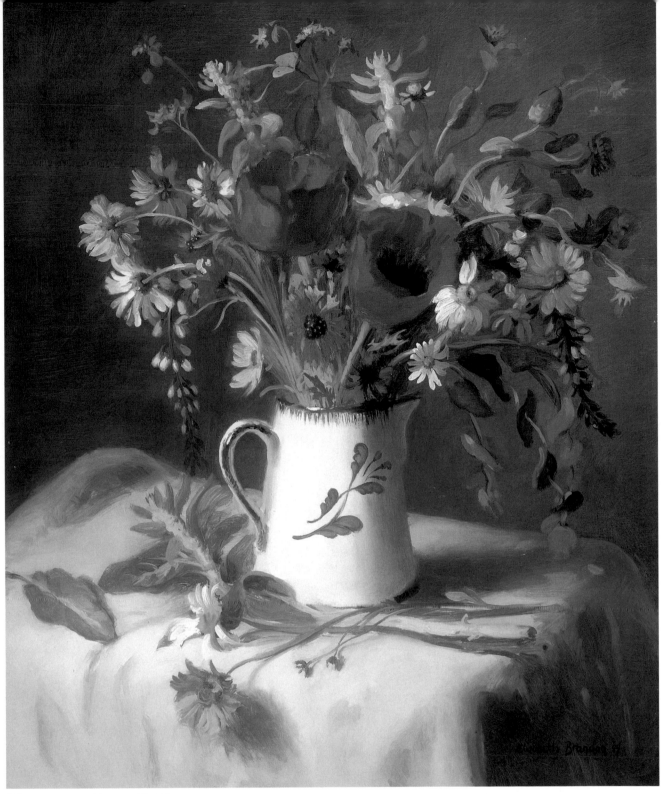

"Poppies in a French Vase"
Elizabeth Brandon, Oil on wood panel
20" x 16" (51cm x 41cm)

Elizabeth Brandon

Several years ago, I painted in Monet's garden in Giverny. I was captivated by the beauty of the fiery red poppies and the splendor of life in Normandy.

Recently my aunt supplied me with some oriental poppies from her garden to paint. I arranged the perennials as naturally as possible, leaving a few flowers lying on the table as if I were still in the process of filling the vase. The French vase had been purchased in Normandy.

The deep crimson poppies were arranged within an ochre background. I added small perennials, combining the yellow coreopsis, violet bachelor buttons and shasta daisies. The soft, fuzzy lamb's ear was added for the gray tone in its leaves, which pulled the other colors together so they remained secondary to the main focus, the deep Cadmium Red poppies.

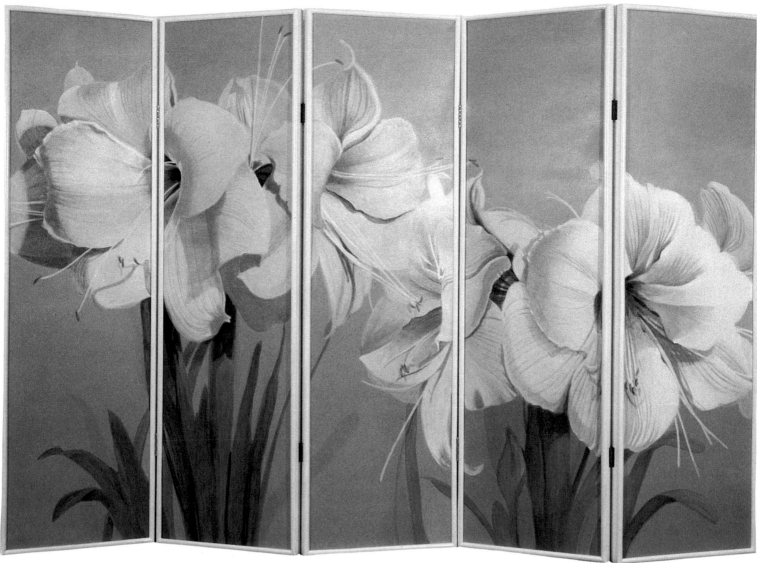

"CELIBACY" Lili Maglione
Acrylics on canvas folding screen, 70" x 100" (178cm x 254cm)

Lili Maglione

I had brought home from the nursery a pot of amaryllis bulbs already starting to sprout. Every day I watched in awe as they grew, and I sketched at each stage of their development. When the white blooms were full and ready at the tops of those sturdy green stems, they seemed almost sensuous but completely pure, virginal and untouchable. I titled this work "Celibacy."

Before the flowers reached full bloom, I had an image of them in my mind on a large, folding screen. I stretched five linen-on-canvas panels, 20" x 100" each, and propped them upright.

I used a very limited palette of Titanium White, Prism Violet, Raw Umber, Sap Green and Yellow Ochre, and worked with layers over layers of thin paint, always wet on dry. The back of each panel is painted solid white, and white is definitely the color I work with most.

Barbara Edidin ✍

I'm sure that many artists have shared the experience I had in a drawing class when I was asked to spend hours carefully rendering a likeness of a pair of pliers. The longer I looked at them, the more beautiful they became. In my floral subjects, I feel that through this kind of concentrated attention, a new appreciation begins to develop. The flowers take on an almost spiritual quality, an auspicious significance beyond their outward life.

I always work from photographs. The best pictures of this still life were the ones with an overhead point of view. With such a tall vase and bouquet, the foreshortening made the subject more compact, and allowed the viewer and the upturned flowers to meet face to face.

"SO VERY MERRY" Barbara Edidin
Colored pencil on Strathmore plate bristol, 31" x 21" (79cm x 53cm)

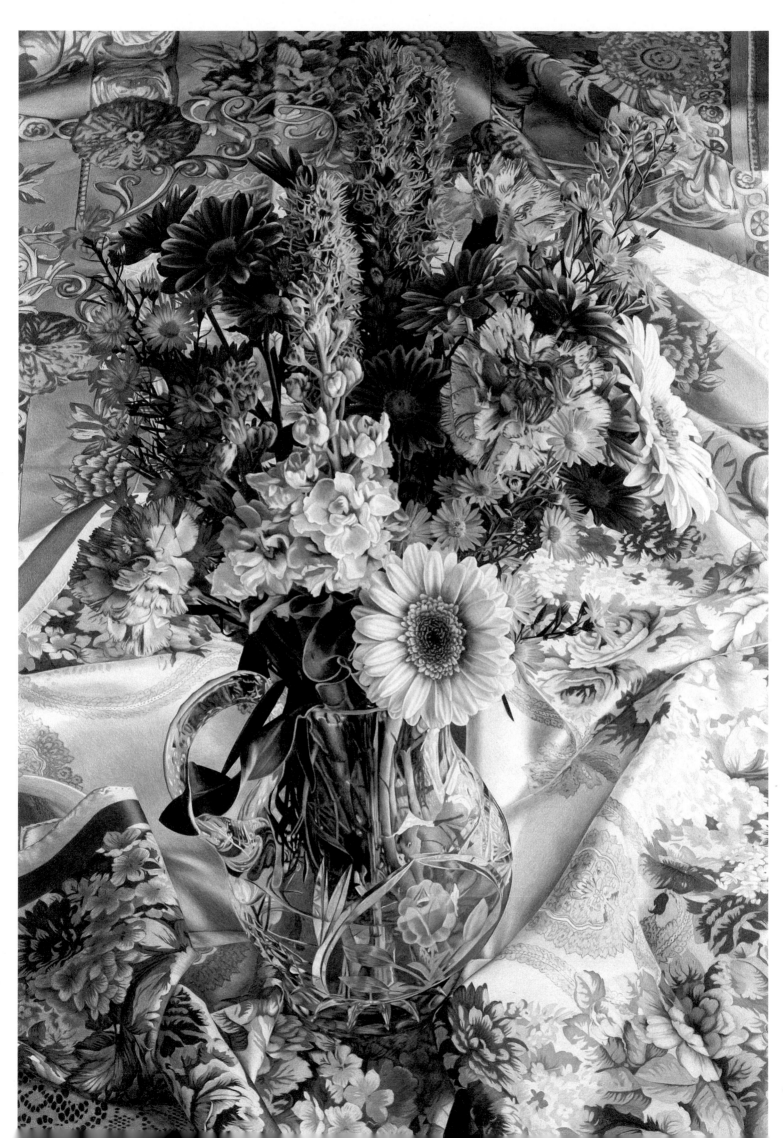

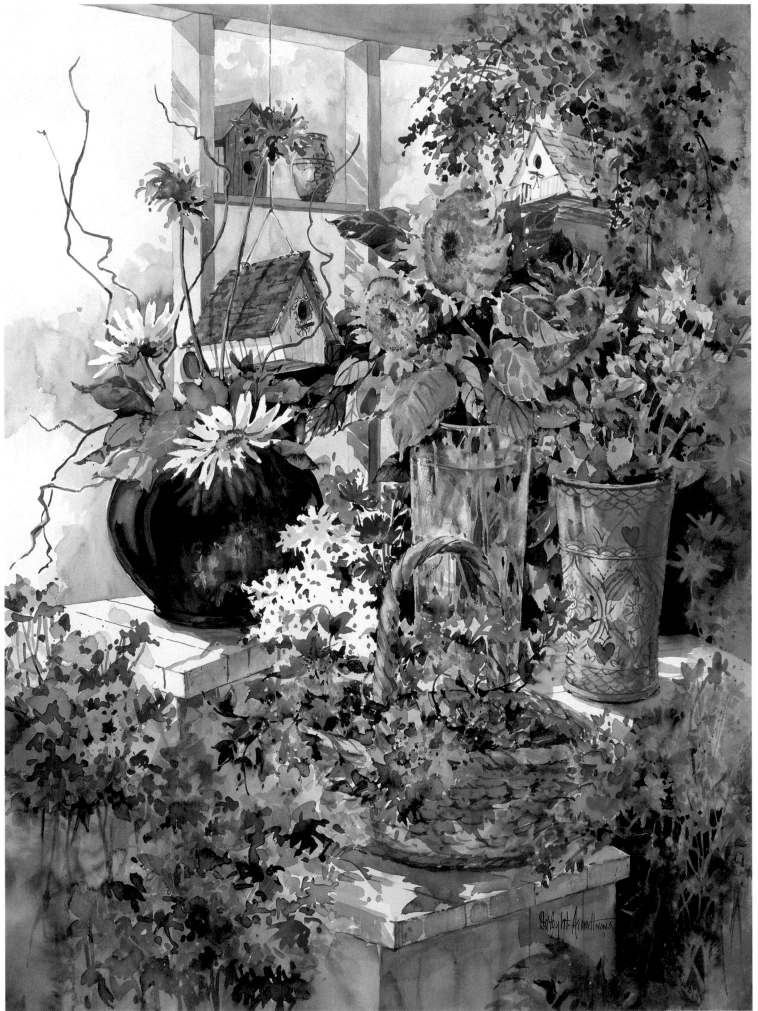

"FLOWERS ETC." DeLoyht-Arendt
Watercolor on Lanaquarelle 140-lb. paper, 30" x 22" (76cm x 56cm)

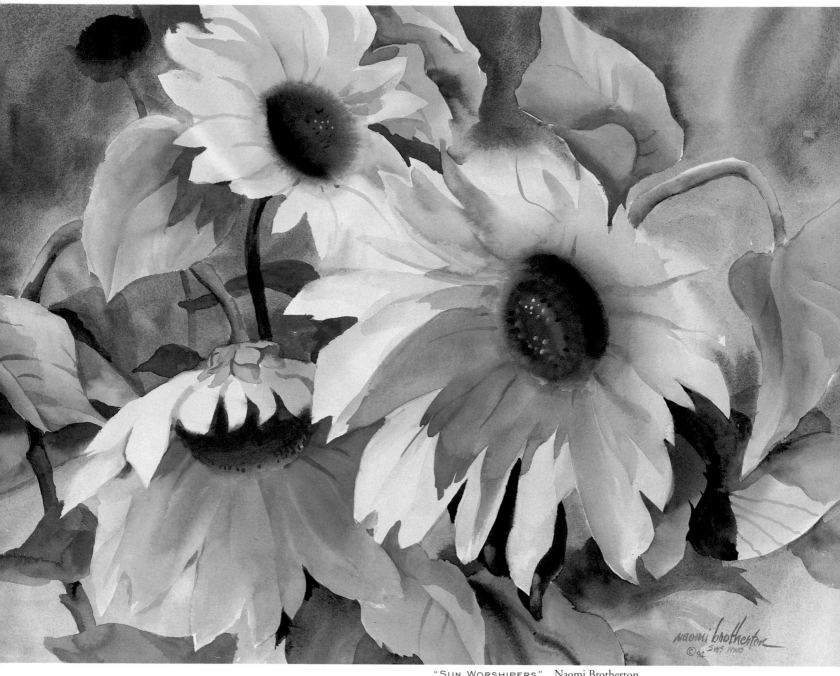

"SUN WORSHIPERS" Naomi Brotherton
Transparent watercolor on Arches 140-lb. cold-press paper
17½" x 23½" (44cm x 54cm)

Naomi Brotherton

Summers, while traveling, I am always amused by the profusion of wild sunflowers bordering the highways. They seem to follow the sun and bob about in the wind. Avoiding fire-ant hills and bees, I cut the flowers, preferably before the sun hits them in the morning, and paint indoors.

To keep the petal color brilliant, I avoid greying the yellow in shadow by using its neighboring colors on the color wheel—yellow-orange and yellow-green. Less intensity in the surrounding hues makes the petal color seem even brighter.

Soft edges are obtained by painting the flower local color and the background wet-into-wet, editing with darks when dry to establish edges, saving the softness where it is most successful.

My palette includes New Gamboge, Winsor Red, Winsor Blue, French Ultramarine, Brown Madder Alizarin and Indigo. (These last two mix for a good gray, and with New Gamboge, a good leaf green.)

DeLoyht-Arendt ✍

Every time I walk into an artistically arranged flower shop, I hear it scream, "Paint me!" This shop in California was no exception. The enormous, perky sunflowers bowled me over while the colors surrounding them complemented the whole setting.

To emphasize the light coming through the windows, I used a 2-inch brush and washed a light wash over all the areas I wanted in shadow. This was done with Indigo, Mountain Blue and a lot of water *after* I had what some might have felt was the finished painting. This lifted and softened the underpainting. After it dried, I painted in negative darks to reestablish lost design.

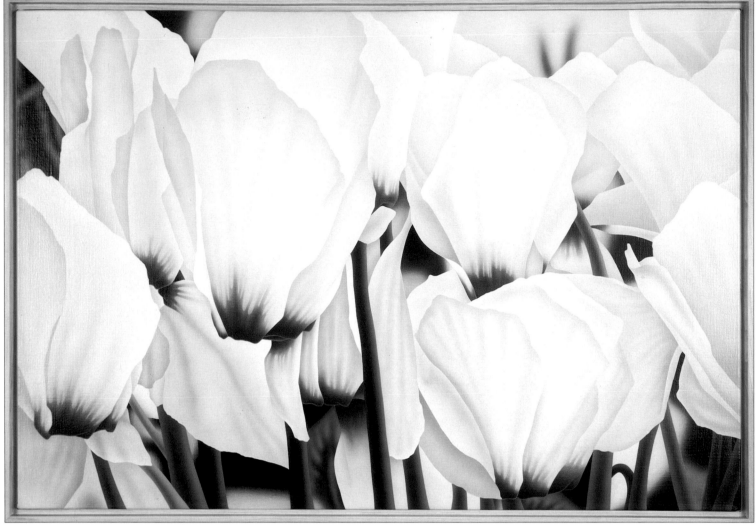

"CLUSTERED CYCLAMEN" Norma Auer Adams
Acrylics and airbrush on linen canvas, 26" x 38" (66cm x 97cm)

Norma Auer Adams

I wanted to examine the subtle differences in shape and form in this closely grown group of cyclamen. Looking at these flowers was like hearing a musical phrase or watching a series of dance steps—each communicates a similar awareness of rhythm, variety and repetition. In my painting, I wanted to endow these delicate white flowers with the graceful movement of dancers and the rhythmic variety of a musical refrain.

"Clustered Cyclamen" was painted with an airbrush and thinned acrylics. I mixed all my colors first, varying them later by airbrushing one color over another—like layering in watercolor. I airbrushed, freehand, areas I wanted soft and blended, and masked areas where precision was needed. I worked in stages, using many layers of thinly airbrushed paint.

Mary Lou Ferbert ❧

The sight of chicory embracing a weathered orange-and-black barrel in Cleveland's industrial valley begged for artistic interpretation. The vibrating intensity of the complements—the blue of the flowers and orange of the barrel—was dynamic.

The interface of the engineered and the natural is the locus of my paintings; the symbol of the natural world I have chosen is the ubiquitous "weed." I have found this survivor in amazing places.

To retain the clean whites of the paper for later use I mask out critical areas with cellophane tape. This permits me to use freer arm gestures with larger brushes in applying initial washes. When this is completed I remove the tape and work into the complex light and dark forms.

"CHICORY AND BARREL" Mary Lou Ferbert
Transparent watercolor on Arches paper
37" x 22⅜" (94cm x 57cm)

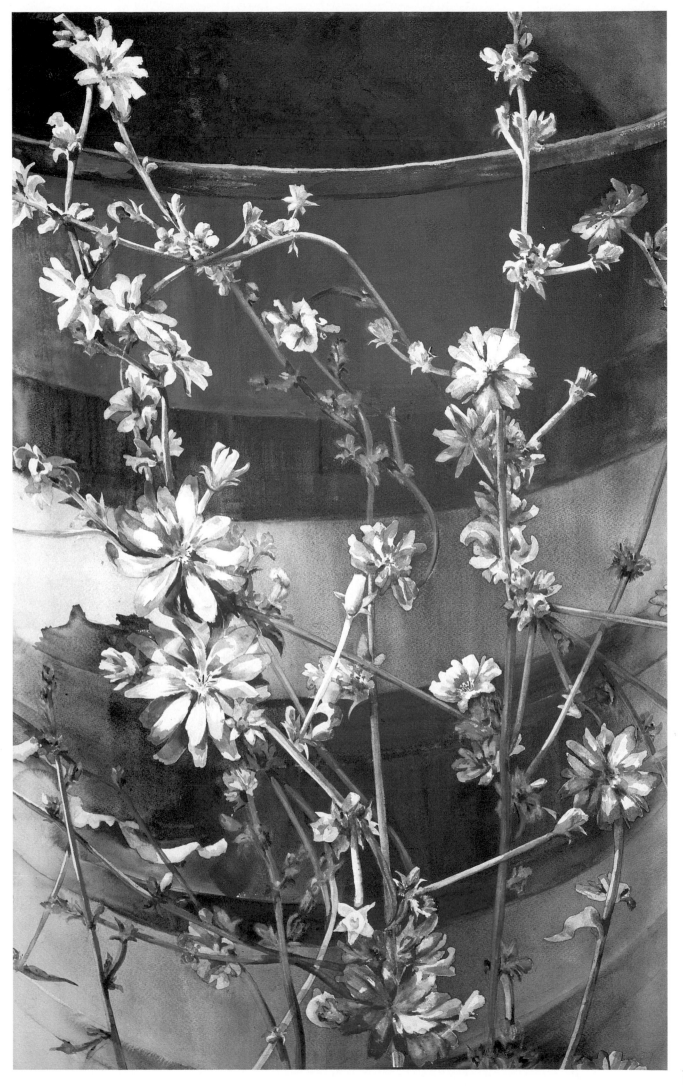

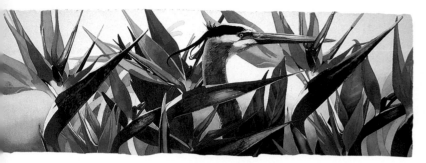

"THE IMPOSTER" Susanna Spann
Watercolor on Arches 300-lb. paper, 17" x 50" (43cm x 127cm)

My Florida studio overlooks a shallow, tidal creek. One balmy summer day, I noticed a large blue heron sauntering from the water's edge into a grouping of bird-of-paradise plants, looking for delicious lizards. The shape of its head and the shape of the blooming flowers were exactly the same! This became the first idea for a series of paintings in which the plant repeats the shape of the bird's head.

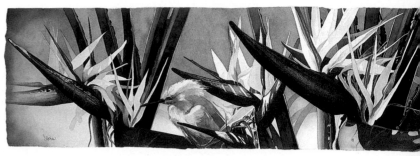

"THE SPY" Susanna Spann
Watercolor on Arches 300-lb. paper, 17" x 50" (43cm x 127cm)

The second bird in my series was a small white egret whose frilled feathers on its head reminded me of the shapes of the flower from the Traveler's Palm, which is called the White Bird of Paradise. This tiny bird almost disappeared in my composition, hence the name "The Spy." I love the gentle, pastel colors on my creek at sunset and painted them in this piece with soft blushes, roses, and muted reds and violets.

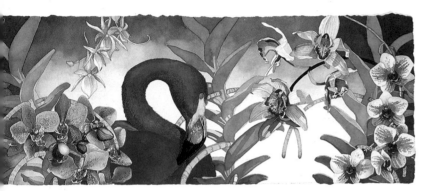

"THE PRETENDER" Susanna Spann
Watercolor on Arches 300-lb. paper, 20" x 50" (51cm x 127cm)

By now I was on a roll and designed two more pieces to accompany the first two. I have a few orchid plants in my yard with curved roots, and added them to examples I had in my orchid books to design a grouping around the curved head of a flamingo. Half circles became the compositional element in this painting. I titled her "The Pretender."

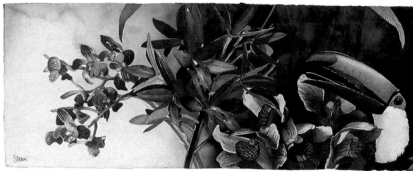

"THE MASQUERADOR" Susanna Spann
Watercolor on Arches 300-lb. paper, 20" x 50" (51cm x 127cm)

The final painting in my "Four Bird" series was a toucan. This piece allowed me to repeat the half-circle shape in the creation of an arc that extends from the toucan's beak like a rainbow down around the flowers on the left. The hook of the beak was also repeated in the hook shapes of the leaves. This charming bird became "The Masquerador" because the toucan always appears to be wearing a mask!

Susanna Spann

When all four of these paintings are placed in a rectangle, as shown above, "The Imposter" and "The Spy" have diagonals that face into one another while "The Pretender" and "The Masquerador" have half circles that face each other. There is a crisscross design of colors as "The Imposter" and "The Masquerador" are in warm colors with their yellows, oranges and reds. "The Spy" and "The Pretender" are in cooler colors with their red and blue-violets, lavenders and rose blushes.

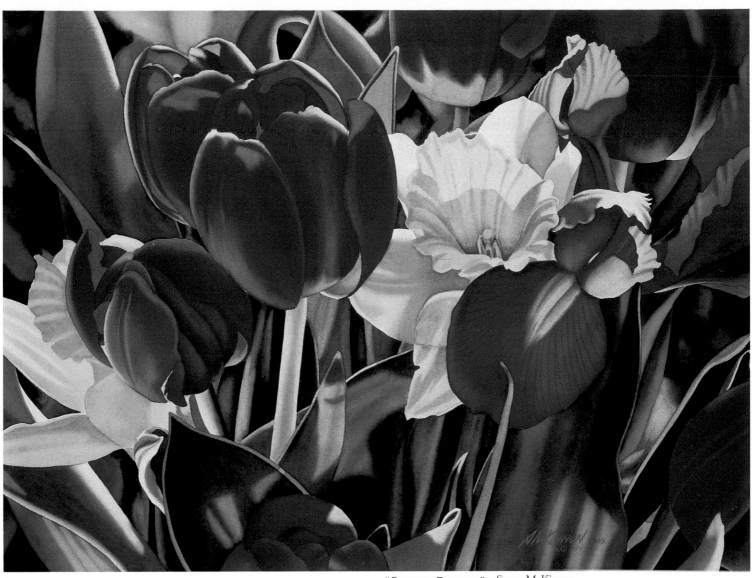

"SPRING PALETTE" Susan McKinnon
Transparent watercolor on Arches 300-lb. cold-press paper
21½" x 29" (55cm x 74cm)

Susan McKinnon

"Spring Palette" is a painting of three separate vases of flowers.
Rotating the flowers around allowed me the flexibility to create a
dynamic composition and viewpoint. To place my viewer in the
"garden," I extended the flowers and foliage beyond the border and
brought the edges of additional ones into the composition. To estab-
lish depth, I overlapped my subjects and painted them in detail in the
foreground while keeping the background out of focus.

Each petal or leaf was painted separately, one layer at a time.
Each glaze added a detail, a shadow, or made a color change. Using all
staining pigments (Winsor Red, New Gamboge, Prussian Blue, Sap
Green, Thalo Crimson and Permanent Violet), I was able to glaze
with confidence, knowing they would stay where I put them. These
transparent colors, like cellophane, allowed me to see the details
through each layer of paint.

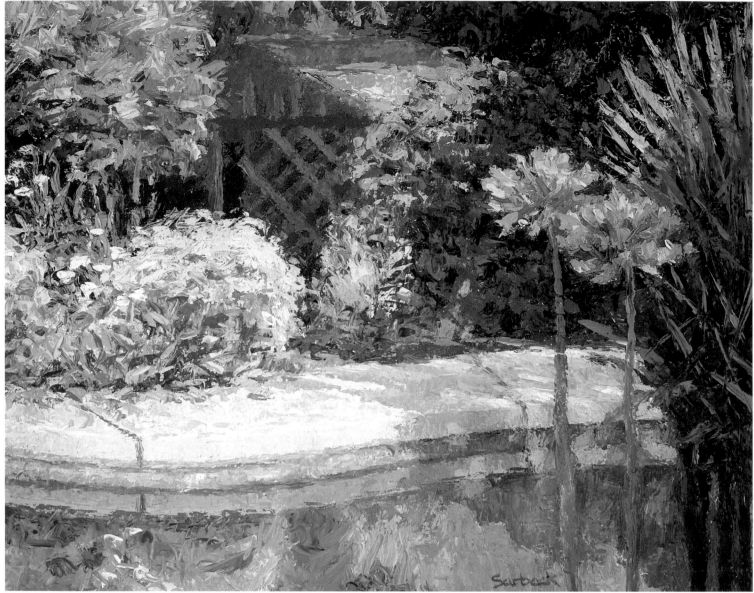

"SUMMER SHED" Susan Sarback
Oil on Masonite panel, 11" x 14" (28cm x 36cm)

Susan Sarback

I painted "Summer Shed" on location on a sunny August day. I did not make a preliminary sketch because I want to capture my original fresh vision. Working with a palette knife and oil paint, I layered and mixed colors directly on my painting to keep the liveliness of the brilliant color.

This scene intrigued me because of the complexity of the lush flowers, bushes and reflections. I made clear distinctions between the areas in sunlight and the areas in shadow. Yet I also tried to see and paint the subtle differences of color variations. For example, the bushes are not just shades of green but variations of violets, blues, blue-greens and reds in the shadows, and oranges, pinks, lavenders and yellows in the sunlight.

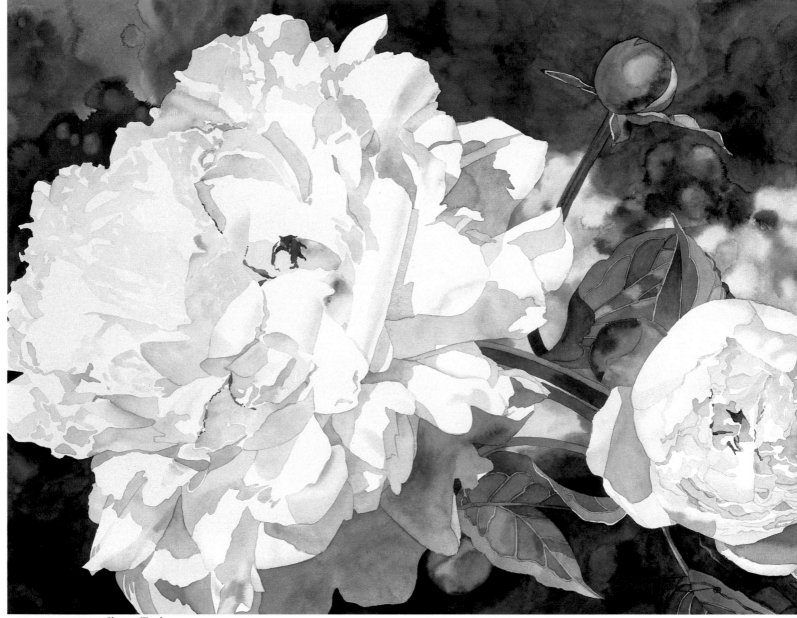

"PEONY MAGIC" Sharon Towle
Watercolor on paper, 22" x 30" (56cm x 76cm)

Sharon Towle

There is nothing quite like the effect of sunlight dancing through flower petals to get the painting juices flowing. This peony jumped out of the shadowy bush and shouted to be painted. The light was right, the shadows were right, the multitudes of colors were all there.

Painting flowers gives me the chance to use lots of wonderful, bright colors. In the case of this painting, it may seem like a chance to use lots of white, but actually it is just a little white and lots of color. Each shadow's intensity brings up a separate color and every reflection creates another color.

To achieve clear, vibrant color, I never, ever use umbers, siennas, grays or black (or white). I supplement my Winsor & Newton paints with Schmincke Orange and Turquoise and Holbein Cadmium Red and Opera Pink. I paint around all the white areas and never mask, as masking leaves an artificial-looking edge. The loose background is achieved using several dark colors, bumping them into the other colors while all are still wet.

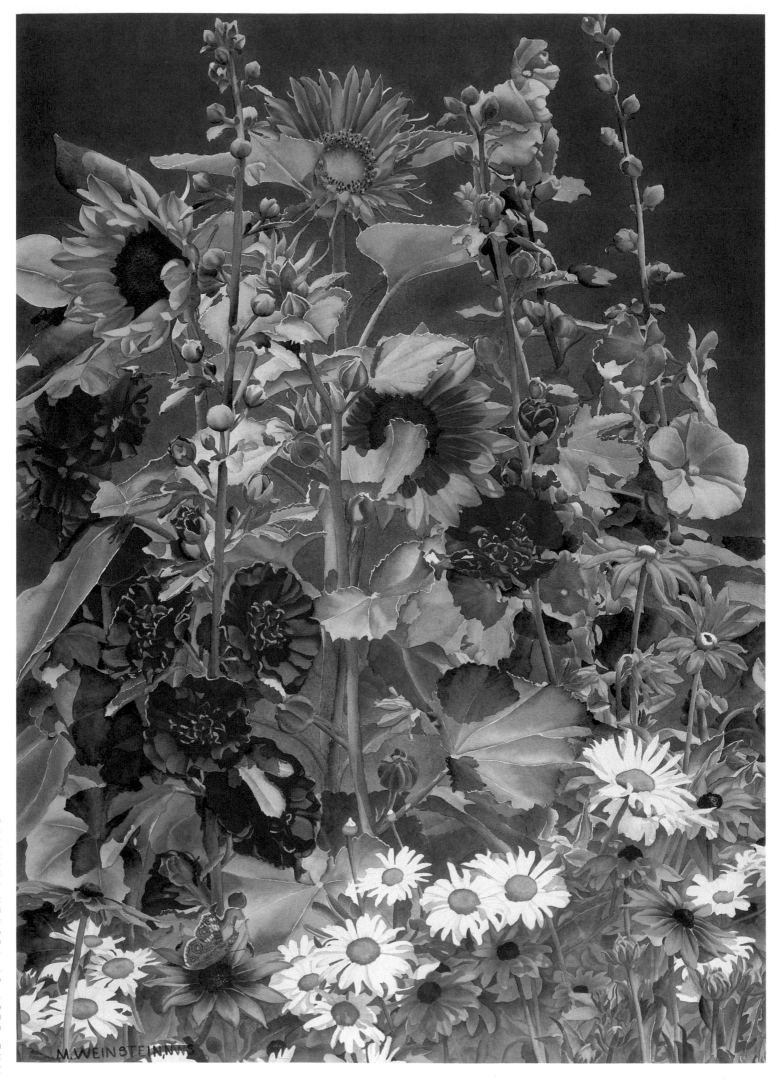

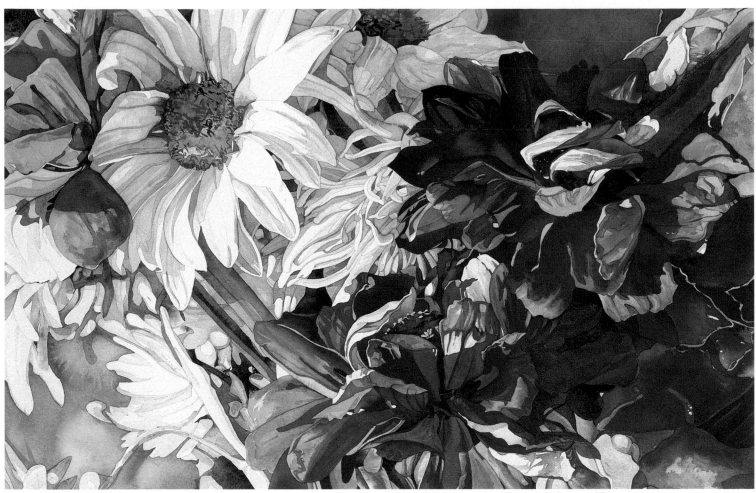

"ORANGE ZINNIAS" Nancy Ann Fazzone-Voss
Watercolor on Arches 300-lb. cold-press paper, 26¾" x 17¼" (68cm x 44cm)

Nancy Ann Fazzone-Voss

People look at flower gardens and notice the panorama of magnificent colors. Often, they don't take the time to see the individual blossoms, the subjects of my paintings. A small cluster of blooms, presented many times its actual size, can have tremendous impact. Diverse colors are placed side by side, some bleed together and others are layered; still others are riddled with backruns or have clear water spots to create more surface interest.

The orange zinnias were painted from photographs using various mixtures of Scarlet Lake, Cadmium Red and Cadmium Orange. While these initial washes were still damp I added drops of Brown Madder, Permanent Magenta and Warm Sepia to achieve darker values, and brushed in water to encourage lighter values. I avoided using any strong blues to keep the oranges intense. Finally, in the deeply shadowed areas, I painted Mineral Violet and Carbazole Violet.

Mary Weinstein ᴿ

Lake Arrowhead, California, is my home and inspiration, and my informal garden of hollyhocks, sunflowers, daisies and petunias is the source of my Garden Series.

I begin by applying diluted tints of watercolor over the entire sheet of dry paper. White shapes are painted around. The sky background is tinted with Cobalt Blue. After all the basic tints are laid down, I switch from watercolor to acrylic and begin to build up the intensity of color. I glaze or layer thin washes of pigment, slowly building up more intense layers of pure color, using direct and wet-into-wet technique.

"FLEURS DU SOLEIL #24" Mary Weinstein
Watercolor and acrylic on Arches 300-lb. paper, 41" x 29½" (104cm x 75cm)

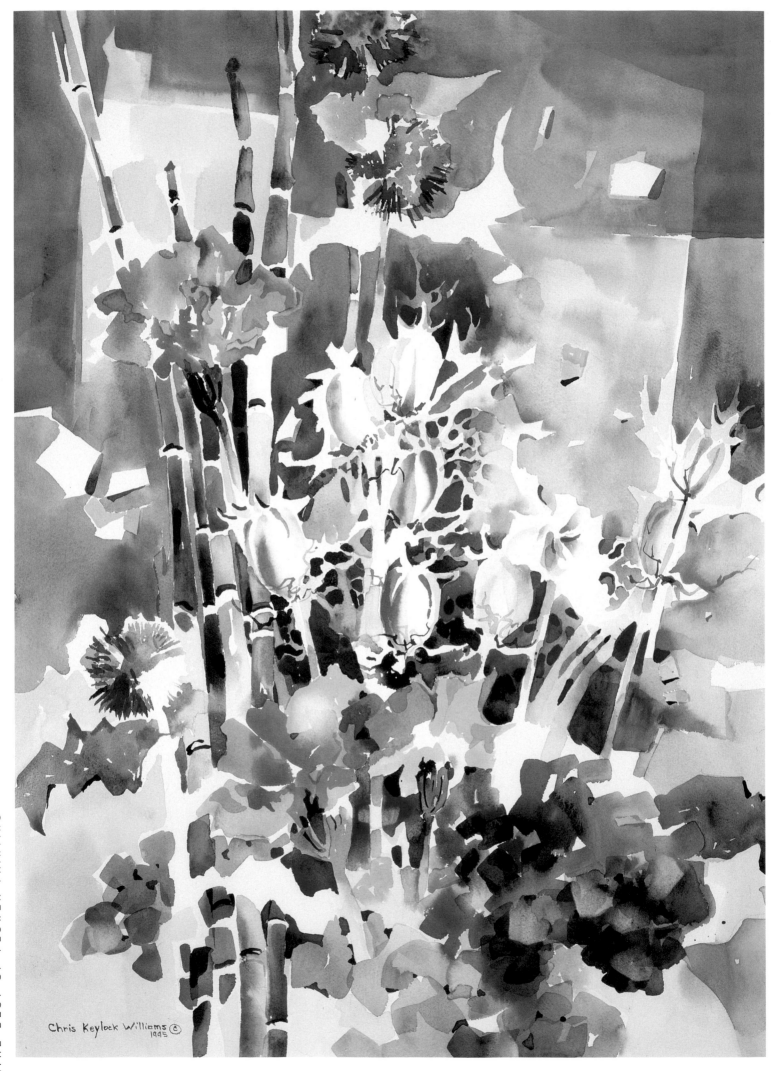

Chris Keylock Williams ©
1995

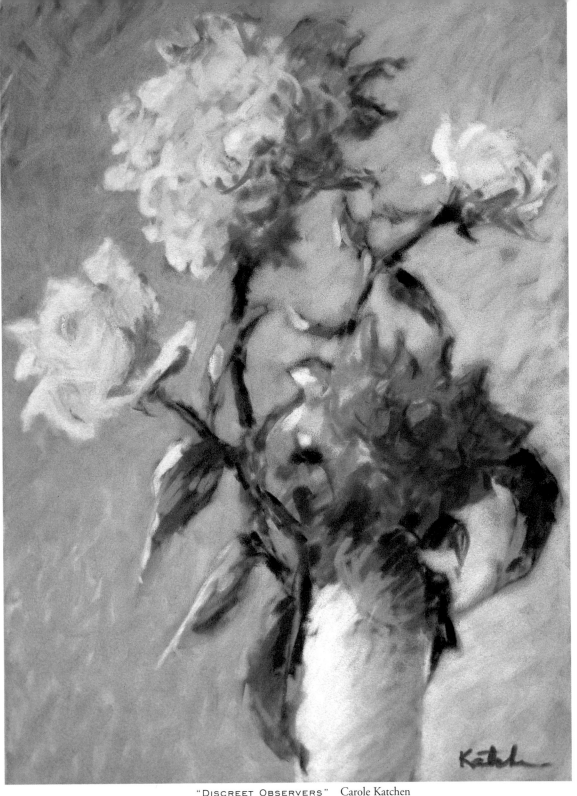

"DISCREET OBSERVERS" Carole Katchen
Pastel on velour pastel paper, 19" x 13½" (48cm x 34cm)

Chris Keylock Williams ✍

In this painting, I was challenged to paint dried and aged flowers, capturing them not as brown, dead, worn-out remnants of their former selves but as exciting, colorful and beautiful floral designs.

The lacy patterns of nigella (love-in-a-mist) seed pods contrast with chunky dried marigolds and multifaceted hydrangea blooms. The tall, linear snake grass and small cymbals of blue globe thistle complete the orchestration. All this is set against curtains of sky blue and sunset scarlet. The confetti-like pieces give a sense of celebration to this grand finale.

"ENCORE" Chris Keylock Williams
Transparent watercolor on Arches 140-lb. rough paper, 29" x 21" (74cm x 53cm)

Carole Katchen

I always paint from real flowers because every blossom has its own unique character. I arranged these roses in this simple composition so that nothing would detract from the flowers themselves. The sensual lines and forms of flowers, stems and leaves make interesting shapes of the negative space so that no additional elements are necessary. I lit the flowers from one side so the flowers and vase would appear more rounded and the color would move from lighter yellows on the left to darker reds and pinks on the right.

The surface used here was a velour pastel paper distributed by Atlantic. The velour grabs the soft pastel pigment and holds it in place like sandpaper. You cannot blend on velour, but because the pigment is absorbed into the fibers, even individual strokes seem to have soft edges.

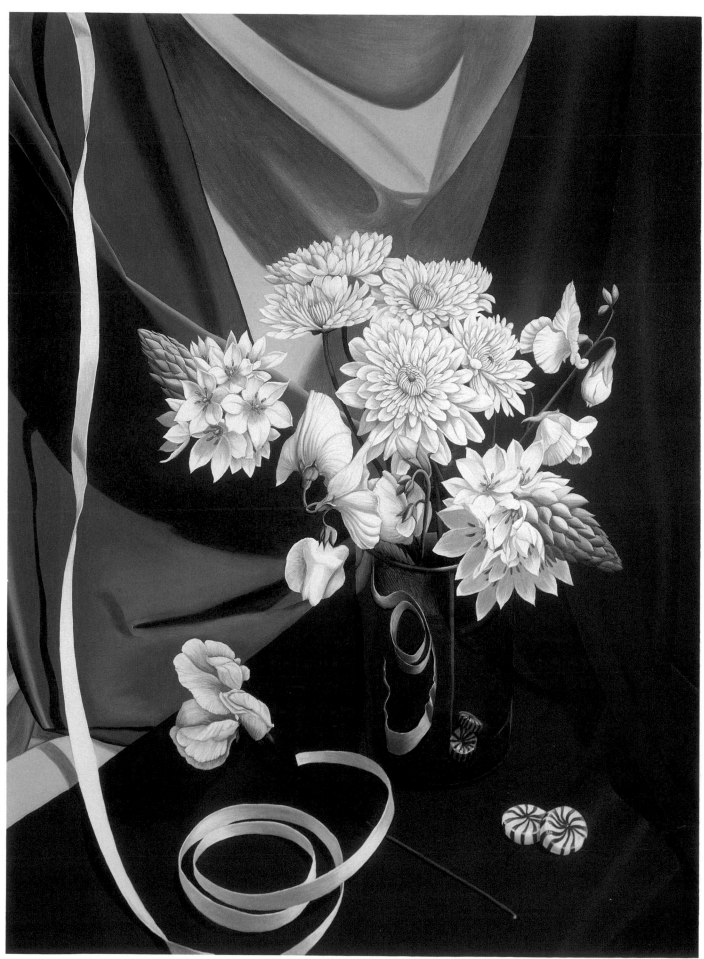

"PRIMARY ARRANGEMENT" Megan Dana, Oil on linen canvas, 18" x 24" (46cm x 61cm)

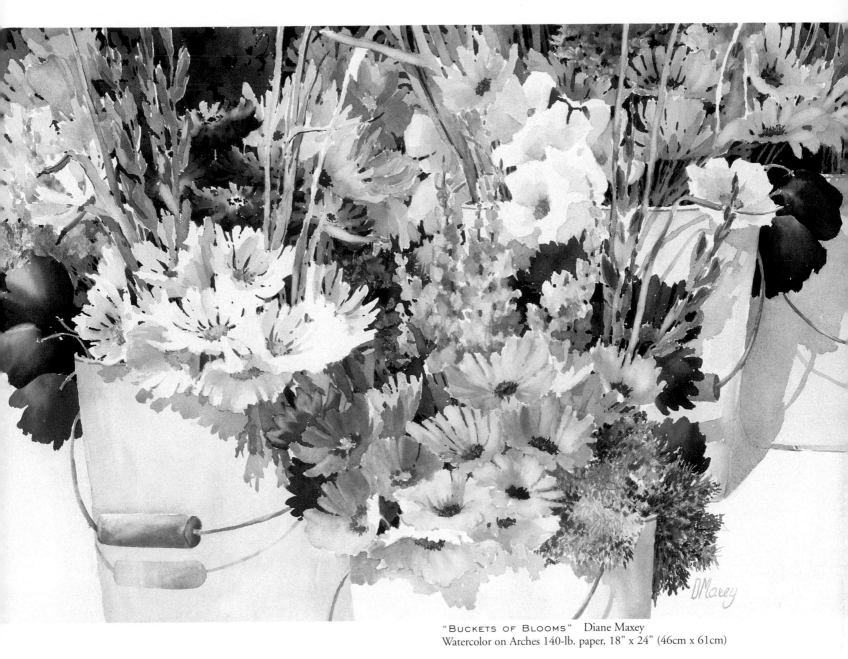

"BUCKETS OF BLOOMS" Diane Maxey
Watercolor on Arches 140-lb. paper, 18" x 24" (46cm x 61cm)

Megan Dana ᷠ

I love high intensity color. When I painted this picture, I was living in Seattle. The bright colors were partly a reaction to the gray Northwest climate.

I chose the strong primary hues of the drapery to create excitement and a feeling of strength not usually found in floral paintings. The white flowers sparkle against the saturated background—white is the only "color" strong enough to do this. The dark blue glass vase with its reflections adds depth and subtlety.

To get pure, intense color, I paint alla prima, using a fifty-fifty mix of oil paint and Liquin. This increases transparency and allows the white of the canvas to make the colors glow. Using small sable watercolor brushes, I work from the background forward, finishing each area before moving on to the next and carefully blending everything so no brushstrokes show.

Diane Maxey

Whenever I'm in need of inspiration, or a way around a creative impasse, a trip to the local flower farms is my favorite "block-buster." Simply seeing those acres of brightly colored blossoms glowing in the brilliant Arizona sunshine can make my soul sing and my brush fly across the paper for weeks.

At the greenhouses, I get a double dose of vitality. Here the gardeners sort, trim and tie the cut flowers for delivery to shops and markets. Whole rooms are filled with utilitarian white buckets overflowing with glowing hues. Through the large windows, sunlight and shadows work their magic. With mind filled and spirits re-energized, I return to my easel.

My composition began with the arrangement of buckets, as I planned a visual path for the viewer to follow through the painting. Along that pathway, I positioned groups of white flowers to deliver the intensity of the sunlight. Positioning light-valued colors beside the whites created a passageway of light for the viewer's eye to travel. Darker, more intense, and complementary hues adjoining this pathway direct the eye into the more interesting and complex mosaic of blossoms.

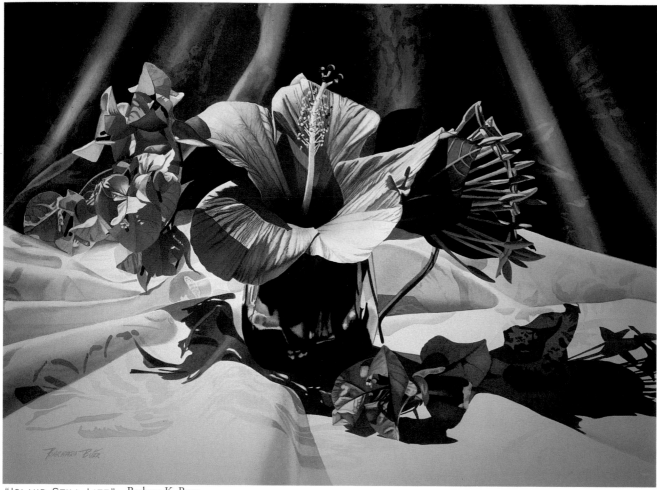

"ISLAND STILL LIFE" Barbara K. Buer
Liquid acrylics on paper, 22" x 30" (56cm x 76cm)

Barbara K. Buer

On a recent holiday to the Virgin Islands, I was so busy enjoying the weather, the water and the way of life, that I never had time to paint the gorgeous flowers, so I arranged and photographed them in numerous still life set-ups to use as reference. The following winter, I painted "Island Still Life" as snowflakes floated down.

Since I wanted to use the island flowers in settings other than those generally associated with Caribbean floral paintings, I chose a white backdrop, an orange hibiscus and yellow bougainvillea instead of the usual aquas, pinks and reds.

I began by painting the hibiscus petals with a thin wash of warm yellow, wiping away the paint where I wanted to preserve the white of the paper. While each petal was wet, I used a pointed knife to incise the veins, which allowed the pigment from additional glazes to fall out of suspension and create the dark vein lines. I used Titanium White instead of masking fluid to preserve the patterns in the background fabric and then applied numerous glazes of Yellow Ochre and black to create the dark background. I painted the bougainvillea with Cadmium Yellow Medium, adding Magenta for the deeper golds.

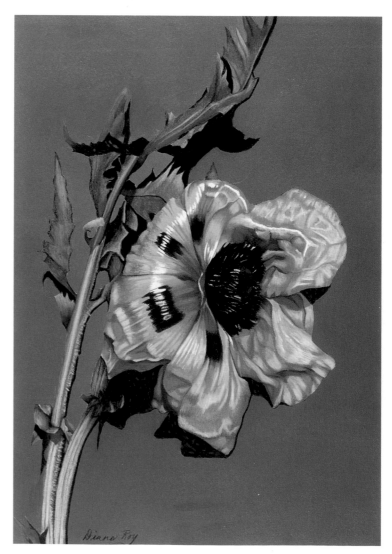

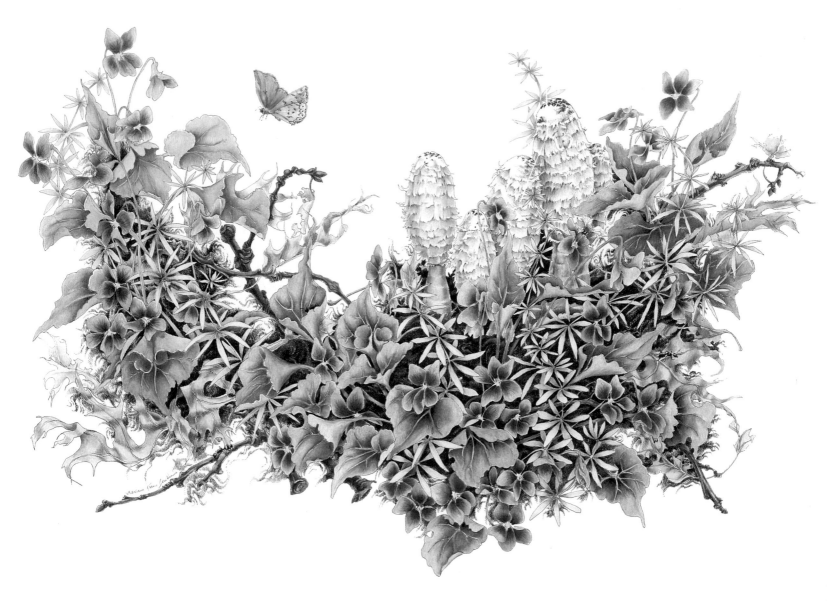

"Violets and Shaggy Mane Mushrooms" Barbara Krans Jenkins
Pen & ink/Colored pencil on Strathmore 100 percent rag hot-press board
14" x 17" (36cm x 43cm)

Barbara Krans Jenkins

The woodlands come to life. Fresh, earthy fragrances flood the senses. A Spring Azure butterfly directs the eye to a spray of blue violets surrounding a cluster of shaggy mane mushrooms. How can anyone overlook this?

Diana Roy

In "Oriental Poppy," I wanted the effect of a single flower beginning to wilt but still brilliant with strong orange and black contrasts. I like to keep the background simple in order for the flower to appear more monumental—almost like an icon.

I began with a simple line drawing in pencil, then applied a light acrylic wash to record colors and form. When this was dry I removed all traces of graphite with a kneadable eraser. This is necessary when burnishing with colored pencils because graphite invariably works its way through the colored pencils if not removed.

Next, I layered the colors lightly, beginning with the darks up to the palest colors. I used a pale orange to burnish all the undercolors. Finally, I heightened the darks.

"Oriental Poppy" Diana Roy
Acrylic and colored pencils on paper, 14½" x 10½" (37cm x 27cm)

Index of Permissions

Spann, Susanna, p. 130
1729 8th Ave. W., Bradenton, FL 34205
"The Imposter" © Susanna Spann, collection of
Donald and Toogie McIntosh, Winter Park, FL
"The Spy" © Susanna Spann, collection of
Nationsbank, Charlotte, NC
"The Pretender" © Susanna Spann, collection of
Tom and Mary Goodnight, Lakeland, FL
"The Masquerador" © Susanna Spann, collection of
Rick and Marie Van Fossen, Maple Shade, NJ

St. Denis, Paul, p. 78
28007 Sites Rd., Bay Village, OH 44140
"White Poppies" © Paul St. Denis

Stewart, Penny, p. 101
6860 Cedar Ridge Court
Colorado Springs, CO 80919
"Flowers To Go" © Penny Stewart

St.Klair, Mitsuyo, p. 103
3600 Luneman Rd., Placerville, CA 95667
"Spirit of Iris" © Mitsuyo St.Klair, private collection

Swindler, Nancy M., p. 83
6953 S. 66th E. Ave., Tulsa, OK 74133-1747
"I Hope You Like Flowers #1" © Nancy M.
Swindler

Szabo, Zoltan, p. 64
1220 Glenn Valley Dr., Matthews, NC 28105
"Mission Torches" © Zoltan Szabo, collection of the
artist

Towle, Sharon, p. 133
2417 John St., Manhattan Beach, CA 90266
"Peony Magic" © Sharon Towle

Tregay, Susan Webb, NWS, p. 54
470 Berryman Dr., Snyder, NY 14226
"I Never Promised You . . ." © Susan Webb Tregay

Tupper, Dani, p. 63
285 28th Lane, Pueblo, CO 81001
"Windows Into Spring" © Dani Tupper, collection
of the artist

Turner, Cecy, p. 116
7824 Glenneagle Dr., Dallas, TX 75248
"Petunia Paradise" © Cecy Turner, collection of the
artist

Verbiest, Claire Schroeven, p. 34
3126 Brightwood Court, San Jose, CA 95148
"Soleil" © Claire Schroeven Verbiest, collection of
the artist. Work is available for purchase, the original
piece and giclés (a.k.a. Iris Prints) are also available.

Wagner, Barbara, p. 112
Leawood, KS
"Summer Silhouette" © Barbara Wagner, collection
of the artist

Waldron, Wayne, p. 52
1205 S. Grant Ave., Crawfordsville, IN 47933
"Red Amaryllis" © Wayne Waldron
"Violet Amaryllis" © Wayne Waldron

Walsh, Janet, p. 53
130 W. 80-2R, New York, NY 10024
"Sunlit Patterns" © Janet Walsh, available at Red
Piano Art Gallery, 220 Cordillo Parkway, Hilton
Head, SC 29928

Weinstein, Mary, NWS, WW, p. 134
P.O. Box 2366, Lake Arrowhead, CA 92352
"Fleurs du Soleil #24" © Mary Weinstein, collection
of Mr. & Mrs. George Fermanian

Wessell, June, p. 86
3411 Gold Nugget Way, Placerville, CA 95667
"Chopsticks" © June Wessell, collection of the artist

Williams, Chris Keylock, NWS, p. 136
6213 SE Main, Portland, OR 97215
"Encore" © Chris Keylock Williams

Wright, William C., p. 37
Box 21, Stevenson, MD 21153
"April Bouquet With Bowl II" © William C.
Wright, private collection

Zalucha, Peggy Flora, p. 106
Zalucha Studio
109 Sunset Lane, Mt. Horeb, WI 53572-1865
"Sprinkler Garden" (diptych part 1) © Peggy Flora
Zalucha, collection of L.R. Nelson Corporation,
Peoria, IL

OILS

Anderson, Kurt, p. 109
275 E. 4th St., Suite 750, St. Paul, MN 55101
"April Blooms" © Kurt Anderson

Arnett, Joe Anna, pp. 60, 92
P.O. Box 8022, Sante Fe, NM 87504-8022
"Kettle of Lilacs and Irises" © Joe Anna Arnett
"Spring/Hydrangea" © Joe Anna Arnett

Bass, Lyndall, p. 8
3741 Altez NE, Albuquerque, NM 87111
"Rose d'Or" © Lyndall Bass, collection of Dr. &
Mrs. John C. Gaudio. Jan Ballew's Northern
Gallery, 806 Old Santa Fe Trail, Sante Fe, NM
87501

Bautzmann, Nancy, CA, OPA, p. 97
7742 N. Harelson Place, Tucson, AZ 85704
"Festiva Maxima" © Nancy Bautzmann

Blish, Carolyn, pp. 2-3
Carolyn Blish Studio
P.O. Box 3660
Greenville, DE 19807-0660
"Heaven Scent" © Carolyn Blish. Reproduction
rights for "Heaven Scent" in limited edition, signed,
numbered, fine art prints, are licensed to Mill Pond
Press, Venice, FL.

Brandon, Elizabeth, p. 123
212 Paddock Lane, Nashville, TN 37205
"Poppies in a French Vase" © Elizabeth Brandon,
collection of Mr. & Mrs. J. Bransford Wallace

Browning, Tom, p. 77
P.O. Box 2193, Sisters, OR 97759
"Summer Wildflowers" © Tom Browning

Butler, Russ, p. 14
Russ Butler Studios
165 Dumond Dr., Laguna Beach, CA 92651
"The Treasures of Venus" © Russ Butler, collection
of Mr. & Mrs. James McDaniel

Carr, Howard, p. 121
P.O. Box 108, Cave Creek, AZ 85331
"Rose Tea" © Howard Carr

Dana, Megan, p. 138
321 S. Main, #544, Sebastopol, CA 95472
"Primary Arrangement" © Megan Dana

Day, Rose Ann, p. 69
8107 E. Del Joya Dr., Scottsdale, AZ 85258
"Quiet Place" © Rose Ann Day

Falk, Joni, p. 100
4750 E. Osborn Rd., Phoenix, AZ 85018
"Morning Sunshine" © Joni Falk, private collection

Feraco, Fury, p. 113
2723 Bay Dr., Fishing Creek, NJ 08251-1210
"Hibiscus Kathleen" © Fury Feraco, limited edition
print (225) available

Gallacher, Susan, p. 84
2233 South 700 East, Salt Lake City, UT 84106
"The Unwritten Letter" © Susan Gallacher

Gillespie, Frances Cohen, p. 57
Box 154A R.D. 3, Greenwich, NY 12834
"John Hope's Cattleya Orchid" © Frances Cohen
Gillespie

Gillis, Louise C., p. 120
Minnesota River Studios
190 South River Ridge Circle
Burnsville, MN 55337
"Cornflowers in Teapot" © Louise C. Gillis

Gish, Anita M., p. 90
11031 W. 96 St., Overland Park, KS 66214-2255
"Garland of Fruit and Flowers" © Anita M. Gish,
presently on view at Blue Valley Arts Gallery,
Stillwell, KS

Gjertson, Stephen, p. 35
3855 Colfax Ave. N., Minneapolis, MN 55412
"An English Table" © Stephen Gjertson, private
collection

Grapp, Jean, p. 66
P.O. Box 1161, Minneapolis, MN 55414-1161
"Lilac" © Jean Grapp, private collection

Griffel, Lois, p. 41
P.O. Box 948, 22 Brewster St.
Provincetown, MA 02657
"Flags and Flowers" © Lois Griffel, collection of
Arlene Gade

Hardy, David, p. 118
4220 Balfour Ave., Oakland, CA 94610-1750
"The World of the Buddha" © David Hardy,
collection of Kay Oberbilling

Hernandez, Gary J., p. 65
7018 Cochran St., Houston, TX 77022-4507
"Orange Cannas" © Gary J. Hernandez, private
collection

Jenkins, Gary, pp. 10, 11
P.O. Box 37, Inverness, FL 34451-0037
"Rose Fairy" © Gary Jenkins. Now being shown in
"It's All Art" Fine Art Gallery in Inverness, FL
"Victorian Roses" © Gary Jenkins. Now being
shown in "It's All Art" Fine Art Gallery in
Inverness, FL

Jones, Jane, p. 39
9141 W. 75th Place
Arvada, CO 80005
"Swirls of Double Delight II" © Jane Jones, Termar
Gallery, Durango, CO

Levin, Steven J., p. 89
6900 Meadowbrook Blvd., #471
St. Louis Park, MN 55426
"Peonies in Crystal Vase" © Steven J. Levin

McMurry, Vicki, p. 85
3112 Eanes Circle, Austin, TX 78746
"A Sentimental Windowsill" © Vicki McMurry,
collection of Jackie and Winston Depew

Moore, Scott, p. 48
1435 Regatta Rd.
Laguna Beach, CA 92651
"Blooms With a View" © Scott Moore, collection of
Mr. & Mrs. Dave Johnson

Moran, Hedi, pp. 5, 16
10135 E. Larkspur Dr.
Scottsdale, AZ 85260
"Cream Pitcher" © Hedi Moran
"Gold & Indigo" © Hedi Moran